DEZIREE SAFARIS

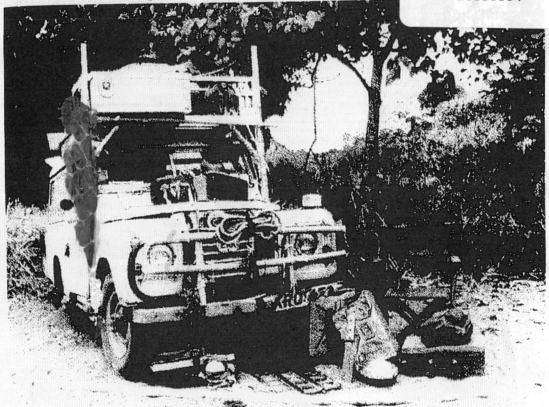

what is the difference between exploring and being lost?

" The Journey is the Destination..."

"free at last" Safari Company...

TEAM DEZIREE

BOX 53441

NAIROBI, KENYA.

New York London Nairobi Rome Yokohama Paris

THE JOURNEY IS THE DESTINATION

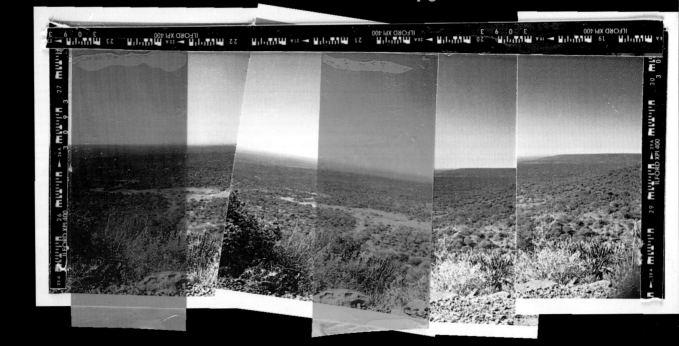

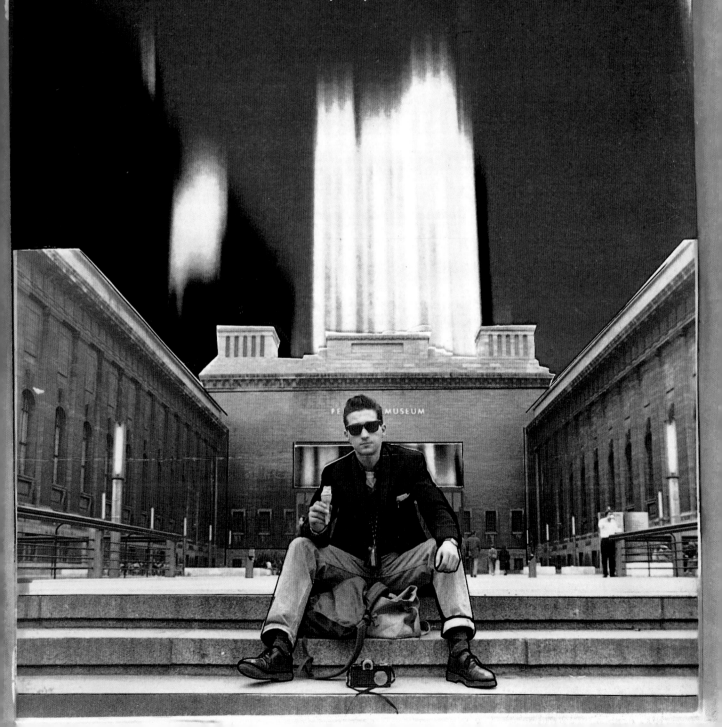

THE JOURNEY IS THE DESTINATION
THE JOURNALS OF DAN ELDON

Edited by Kathy Eldon

THIS BOOK IS LOVINGLY DEDICATED TO MY INSPIRATION,
AMY LOUISE ELDON

First published in the United States by Chronicle Books,
San Francisco, California

ISBN 1-86154-086-8

Designed by Laura Lovett
Printed in Hong Kong

Published in the U.K. and Ireland by Booth-Clibborn Editions
12 Percy Street
London W1P 9FB
info@internos.co.uk

Web Site: http://www.ftech.net/~internos

My son, Dan Eldon, a Reuters photographer, was stoned to death in Somalia in July 1993 by a mob reacting to the United Nations bombing raid on the suspected headquarters of General Mohammed Farah Aidid. Only twenty-two when he died, Dan had already achieved prominence for his work as a war photographer. But his photographs told only half the story. The other half lay hidden away in seventeen black-bound journals filled with collages, writings, drawings, and photographs.

I was intensely proud of what I was allowed to see in the pages of Dan's journals, but I could never understand why he confined his artistic expression to the inside of books. Often I would ask him to produce works I could put on my walls. But Dan would always refuse, sometimes

INTRODUCTION

quite indignantly, and return to his black-bound journals, books he shared with only the closest of friends or family. By the time of his death, Dan had filled seventeen volumes, creating thousands of pages reflecting his own peculiar perspective on life. Layered like an archaeological dig, the pages are bizarre and colorful relics of a multifaceted civilization, intensely personal though inhabited by many different people.

Dan was born in England in 1970. (His father, Mike Eldon, is British. I am American.) From the very beginning of his life, his world was filled with color, pictures, and excitement: I dangled homemade mobiles above his cradle and surrounded him with an ever-changing display of greeting cards and drawings. Later, I stitched books and toys out of cloth and designed little puzzles, which Mike helped me cut out of wood for Dan and his little sister, Amy, born in 1974.

When our son was two and a half, we enrolled him at a Rudolph Steiner School, which emphasized the importance of music and art for young children. I remember one day standing at the door, rapt, as Dan and his tiny friends, engulfed in navy blue smocks, silently swirled watercolors on wet paper, swaying in time to classical music.

When Dan was seven, we moved from the orderly gray streets of suburban London to the chaos and riotous color of Nairobi. Under a spreading jacaranda tree in our garden, the children and I hammered together a playhouse out of a packing crate and painted dazzling flowers and animals on the sides. Our first houseguest helped draw a huge map of the world on Dan's bedroom wall, and Dan spent hours adding lions, elephants, and wildebeests onto the continent of Africa.

During our early days in Kenya, I led the children on magical safaris in the long grass of our garden, pointing out imaginary animals and people as we created whimsical stories which left us in fits of giggles.

Although oppressed by his British prep school, where errant boys were beaten with an old shoe, Dan was able to roam free with his friend, Lengai Croze, a white Kenyan who taught Dan to understand Africa. Lengai lived with his brother Anselm and sister Katrinika in a jumble of mud domes near the Nairobi Game Park. His mother, Nani, was a mural and stained glass designer with an incurable urge to decorate everything in sight. Even their minibus was covered with outrageous mythical creatures. An exotic menagerie, including geese and vultures, a colobus monkey, various iguanas, a herd of ostrich, and a pair of camels, lived in the Croze compound. Lengai and Dan loved exploring the bush around their *boma* like their heroes, Burton and Speke. The boys dangled from vines over the gorge that cut through the land and made friends with Masai children living nearby. On one of his walks, Dan encountered a buffalo. He escaped being gored by climbing a tree, but from that day on, a buffalo was his symbol of ultimate evil.

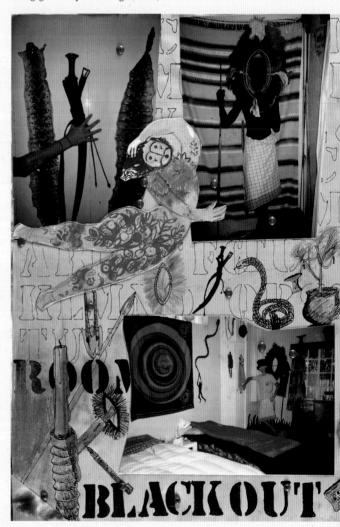

Meanwhile, Amy had found her own best friend, Lara Leakey, granddaughter of the great paleontologists Louis and Mary Leakey. Lara lived with her parents—and the threat of marauding lions—in a tiny mud house miles from the next neighbor. Marilyn Kelly, half-Kikuyu and half American, lived in town and went to ballet with Amy. The three little girls spent much of their time trying to trick Dan and Lengai into letting them climb into a massive treehouse we built in the backyard.

At the age of eleven, Dan refused to return to the English academy. We transferred him to the more informal International School of Kenya, set on a rambling campus high in the coffee fields outside Nairobi. With students from forty-six nations, it seemed that nearly every one of Dan's new friends was from a different country. Each child shared a new perspective of the world with his or her classmates, creating a dynamic atmosphere that encouraged curiosity and creativity.

When Dan was fourteen, his class went on an outing to the Loita Hills, home of the Loita clan of the Masai tribe of Kenya. Asked to produce a scrapbook of the adventure, he returned home with photographs and

drawings of the Masai warriors and their wives and children. In addition, he had filled his pockets with shreds of feathers, ostrich shell fragments, old coins, beads, jewelry, leather thongs, and other treasures. Using everything he had collected, Dan produced a magical scrapbook in which each element found a place in an integrated whole. But nothing was as it had been. The photographs were cut into pieces, the drawings reassembled, feathers trimmed to fit the borders of the pages, and the beaded jewelry shaped to create whimsical frames for the images. Each page was overlaid with watercolors, markers, ink, even smudges of blood. The effect was dazzling. It was as though his spirit had been released in his art.

His next book was hardbound, retrieved from a heap of my old drawing books. The work in this book was bigger and far bolder. Dan experimented with every kind of material he could lay his hands on, working the pages over and over to achieve the effect he wanted, then starting over again on the next page with a completely new technique. The pages are luminous, filled with light and color, but using almost exclusively the African motifs he saw around him. Amy and Marilyn made their first appearance in this book, and soon earned their status as Dan's favorite, and most compliant, models.

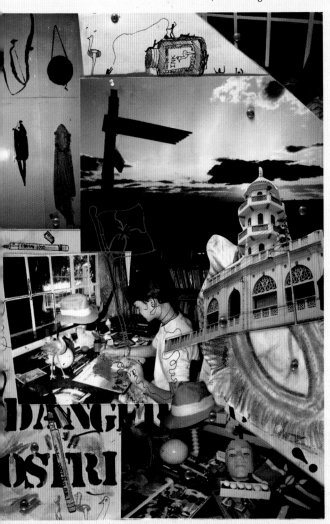

Dan made friends with a Masai family who lived twenty miles outside Nairobi on a barren, windy ridge nestled on the edge of the great Rift Valley. Kipenget, the mother of the family, struggled to feed her children by making beaded jewelry. Dan became her biggest buyer, hitching rides to visit her hut, always bearing gifts of sugar and tea. He wandered the hills with his young Masai "age-mates" before returning to town, arms filled with bags of jewelry. No one was safe for the next few weeks. Soon, every teacher and student at his school wore Kipenget's bracelets and necklaces, and I was pressed into service selling the jewelry to tourists and overseas visitors. Dan was always working to help other people, finding new and unusual ways to offer support. When Dan was fourteen, he learned that a young Kenyan child had a serious heart condition and required surgery. Immediately, he organized his friends to raise money, designing boxer shorts and tee shirts, and setting up bake sales and a series of wild dances in a hut in our back garden. The operation was successful, but the child, Atieno, died after contracting malaria in the local government hospital.

7

Throughout Dan's school years, I worked as a free-lance journalist for the *Nation*, the largest English language newspaper in Kenya. Dan often accompanied me on my interviews, and received the first of many photo credits in the paper at the age of fourteen. I encouraged him to find his own important stories to tell, both in words and pictures. Eventually, Dan's drawings and photographs threatened to overtake nearly everything in our house: the walls of his room, the margins of his homework, shirts, hats, cupboards, even a refrigerator door. As a senior in high school, he became the art director for the stodgy school newspaper, transforming it into a witty, avant-garde publication which narrowly missed being shut down by the school administration.

When Dan was seventeen, I left home and moved to London. Dan also left Africa to work as a design intern at *Mademoiselle* magazine in New York. His journal reflects his confusion at our family's dissolution, his resulting distrust of women, and the extreme sense of alienation he felt in the city. His images are hard-edged, cold and industrial, bustling and cynical, though sometimes nostalgically overlaid with lyrical silhouettes of dancing figures, buffaloes, and wildebeest. In New York his 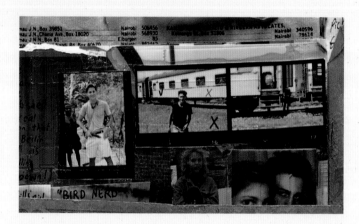 darker side emerged, and he often flirted with danger in the rougher parts of town, where he liked to photograph homeless kids, street people, and gang members, with whom he had an immediate rapport. Our relationship was difficult. He worried about me, but always told me he was proud that I had been brave and did what I knew I had to do.

Three months later, Dan fled back to Nairobi, where he bought a seventeen-year-old Land Rover from an Australian traveler. He named the rusting hulk Deziree, paying tribute to the memory of a wild Italian girlfriend, and together with his friends Lengai and Patrick Falconer, set off on a great safari through Kenya, Tanzania, Malawi, Mozambique, and Zimbabwe. The intrepid explorers photographed themselves with Pygmies, battled impossible roads, sampled dried rats, bribed hostile border guards, and endured the threats of guerrillas. Their journey was a rollicking adventure—until they chanced upon a vast camp for displaced Mozambiquan refugees in Malawi. Stunned by the poverty and inspired by the irrepressible spirit of the people, who had virtually nothing, they vowed to return one day with tools for the refugees to help themselves.

Patrick and Lengai abandoned the safari at Victoria Falls to return to their universities, while Dan traveled alone from Malawi to Cape Town, taking advantage, as he wrote in his journal, of the "hospitality of South African jails" for accommodation. His journey is recorded in what has come to be called "Book Eight," a fat, mysterious volume of many layers, which begins with his analysis of the external world around him, and moves inexorably to an internal evaluation of his

role as both observer and creator. This journal, above all others, is a private book. To make it difficult to read his words, he sometimes wrote in black ink on black paper, or red ink on a red background. He glued sheets of paper over great chunks of writing, leaving future readers only a few clues as to what he was thinking.

Dan and Lengai traveled together to Berlin shortly after the fall of the Berlin Wall, after which Dan flew to California, where he finally began his formal education by enrolling in the first of four colleges he was to attend over the next few years. He studied philosophy, Japanese, English literature, and Spanish. He picked up desktop publishing and grappled with macroeconomics and history. In one of his few forays into photography, his teacher gave him a C, complaining that he hadn't done the assignments properly. He was always afraid to take math, worried that he would fail due to his dyslexia. His West Coast journals are filled with cartoons, mock advertisements, and pages of lurid color, mirroring his fascination with American pop culture, fast food outlets, blondes, surfers, and sun.

In Dan's first term at Pasadena Community College, he and several friends founded a charity, Student Transport Aid, dedicated to helping the refugees fleeing Mozambique. Through a variety of ingenious (mostly legal) means, the group managed to raise $17,000. The following summer, together with thirteen young people, aged fifteen to twenty-two, he headed back to Africa. There, the group, representing seven different nationalities, purchased a Land Cruiser (named Arabella) to supplement Deziree on their safari. Their objective: the refugee camp in Malawi. Traveling south in Deziree and Arabella, the students encountered more challenges than rough roads, mercenaries, and bad maps. They had to learn how to get along together. Dan and Lengai fell in love with the same girl, beautiful Marte from Sweden, a devastating affair that he recorded with his usual ironic wit in a series of pages exploring "Agony and Remedy." Dan outlined his objectives—high and low—for the trip:

Team Deziree: Free at Last Voyages, the Search for Clean Water in a Swamp: Mission Statement for Safari as a Way of Life

To explore the unknown and the familiar, distant and near, and to record, in detail with the eyes of a child, any beauty of the flesh or otherwise, horror, irony, traces of utopia or Hell.

Select your team with care, but when in doubt, take on new crew and give them a chance.

But avoid at all costs fluctuations of sincerity with your best people.

In the margins he penciled a few more thoughts:

Look for solutions, not problems.

It is therapeutic to apply a well toned naked body to one's flesh at least once a day in tropical and non-tropical climes.

The most important part of vehicle maintenance is clean windows, so if you are broken down you will enjoy the beauty of the view.

The group arrived intact at the refugee camp. The students donated Arabella to the Save The Children Fund, gave money for two wells, and bought tools and blankets for the refugees. Each person was transformed by the safari, but no one was affected more than Dan, then aged nineteen.

Always restless, he plotted more safaris, and with each trip developed a greater proficiency in manipulating and distorting their record in his journal. He worked with glue, ink, photocopied images, and anything he could pick up along the way. Even without the benefit of computer tech-

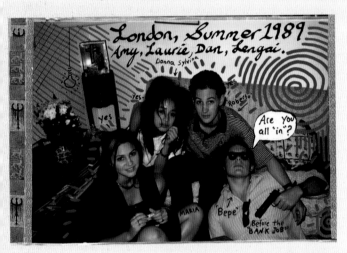

nology, his images are startlingly multi-layered. In Japan he explored eroticism in ways he had never attempted before. His Moscow pages are hard and angry. In Marrakesh, he went slightly mad while waiting weeks for spare Land Rover parts, a state of mind reflected in the murky gray depths of his pages and the strange characters he photographed in the back streets, where few tourists ven-

tured. Constantly his pages asked and answered questions; the power of good versus evil, the role of violence in society, and the effect of war on humanity were recurring themes for him.

In April of 1992, Dan joined me to work as a third assistant director on a film set in Kenya, eagerly soaking up information from the Hollywood crew. He shot his own stills, among them surreal images of an achingly beautiful ash-daubed young Somali woman set against a stark background of black volcanic lava. The camera crew urged him to enroll in film school, recognizing in his photographs a potential director. I encouraged him to return to UCLA in the autumn and get a degree. Instead, he started a photography business in Nairobi, shooting ads for local newspapers and magazines. In his spare time he made a film, and always, he explored the world around him, hurriedly documenting everything he experienced. One girlfriend complained that he spent more time recording their relationship than actually enjoying it. He packed his hours with life, seemingly afraid to miss even a moment. Many people wondered then why he was always in such a hurry.

It was during that summer that Dan heard rumors of a famine in the Somali town of Baidoa. Together with a friend from the *Philadelphia Inquirer,* he drove north to see if there was any truth

to the stories, discovering on their arrival that the famine was far worse than anyone had realized. Horrified, the pair photographed scores of dead babies, skeletal children, and hundreds of starving men and women. No longer speculating on the nature of man from a safe distance, Dan had to confront reality firsthand. His pictures were featured on the front pages of newspapers and magazines in many places, and were among the first to trigger the conscience of the world.

Something happened during that journey to irrevocably change Dan. He returned again and again to Somalia, inexorably drawn to the unfolding human drama he felt compelled to document. In a book about his experiences that he later self-published:

"After my first trip to Somalia, the terror of being surrounded by violence and the horrors of the famine threw me into a dark depression. Even journalists who had covered many conflicts were moved to tears. But for me, this was my first experience with war. Before Somalia, I had only seen two dead bodies in my life. I have now seen hundreds, tossed into ditches like sacks. The worst things I could not photograph.

"One Sunday morning, they brought in a pretty girl, wrapped in a colorful cloth. I saw that both her hands and feet had been severed by shrapnel. Someone had tossed a grenade in the market. She looked serene, like she was dead . . . but the nurse said she would survive. It made me think of the whole country. Somalia will survive, but what kind of life is it for a people that have been so wounded. I don't know how these experiences have changed me, but I feel different."

As the conflict intensified, Dan found himself in increasingly dangerous situations, but, having grown up in Kenya, he was aware of the risks, knew how to maneuver, and took great care, both for himself and others. In November of 1992, in an article entitled "Photography in Danger Zones" published in *Executive* magazine in Kenya, he wrote:

"The hardest situation to deal with is a frenzied mob, because they cannot be reasoned with. I try to appeal to one or two of the most sympathetic and restrained looking people with the most effective looking assault rifles, but I have realized that no photograph is worth my life."

With each trip back to Somalia, Dan grew closer to the people. Mischievous, cheerful, and very good at his job, he seemed to know everyone—aid workers, Marines, diplomats, and thieves. The locals dubbed him "the Mayor of Mogadishu," and children followed him down the potholed streets like the Pied Piper.

But he was increasingly frustrated with the tragic events unfolding before him, and he confessed to his friends that he was weary of the violence and killing.

I spoke to Dan when he called on my birthday, June 26. He was in Nairobi for a brief rest before returning to Mogadishu, where eighteen Pakistani peacekeepers had recently been murdered. I tried not to sound too anxious, but of course I was worried about his safety. I asked him if it wasn't time to come home.

"Please don't ask me to leave," he said. "My job isn't done. I have to stay." I remembered how he had supported me when I made the difficult decision to leave my home in Africa.

"Okay," I said. "I'm proud of you. No matter what, you're leading the life of your choice and I'm proud of you." We hung up quickly. Two minutes later, the telephone rang again. "I love you, Mum," he said hoarsely. "It's been too long. We need to talk."

Seventeen days later, on July 12, 1993, Dan and three colleagues, Hansi Krauss of the Associated Press and Anthony Macharia and Hos Maina of Reuters, were called to the scene of a brutal bombing by United Nations forces of a house believed to be the headquarters of General Aidid. When the photographers arrived at the compound and began shooting the bloody carnage, the crowd, enraged at the death or mutilation of over a hundred people, including religious leaders and respected elders of the community, turned on the journalists, stoning and beating them to death. In a moment of horrific irony, Dan and his friends were murdered by the very people they were trying to help.

One week later, we gathered together on Kipenget's land to celebrate Dan's life. Billowy clouds hung in a perfect sky as a crowd of many hundreds found places on the grass before a makeshift altar decorated with flowers, African cloth, and one of Dan's collection of funny hats. Dan's friends of every shade and color, religion and creed, joined together in a ceremony of peace in a place more beautiful than any cathedral on earth.

There were many tears that day when Dan's journalist colleagues struggled to find words for their horror. As people talked, we could hear the sound of cattle and goats being herded back to their homes by young Masai children and watched the occasional Land Rover hug the narrow road along the edge of the Ngong Hills.

The sun was setting when Amy stood to read a letter from Lengai. Amy was determined to get through the letter, though she said later that she felt as though the light of her life had gone out.

After Amy read Lengai's words, we then lit ten torches to set alight a fire to commemorate the sparks Dan lit in others, as an African choir sang, "Let there be peace on earth . . . the peace that was meant to be." People cried again, not just for Dan, but for a world gone wrong.

Not long afterwards someone brought us a rucksack of Dan's belongings, retrieved from his hotel room in Mogadishu. In it we found Dan's last journal. Whereas all the books he had kept before included collages, whimsical drawings, and fanciful images, the Somali journal is stark and simple, nothing but photographs stuck on pages. Like his life, it is unfinished, the photographs standing as mute but powerful reminders of a life that ended too soon.

Kathy Eldon
Los Angeles, 1997

12

Spent the night with my friend
Senga who lives just outside of
the game park. I drove out there
after school with his mother. We
rode his new motorbike and looked
at his animals. He has a serval
cat, two vultures, a horse, lots
of dogs and cats and a crested
crane. Their generator was broken
so I had to do my homework
with a ~~candle~~. lantern.

Don Eldon
No. 13

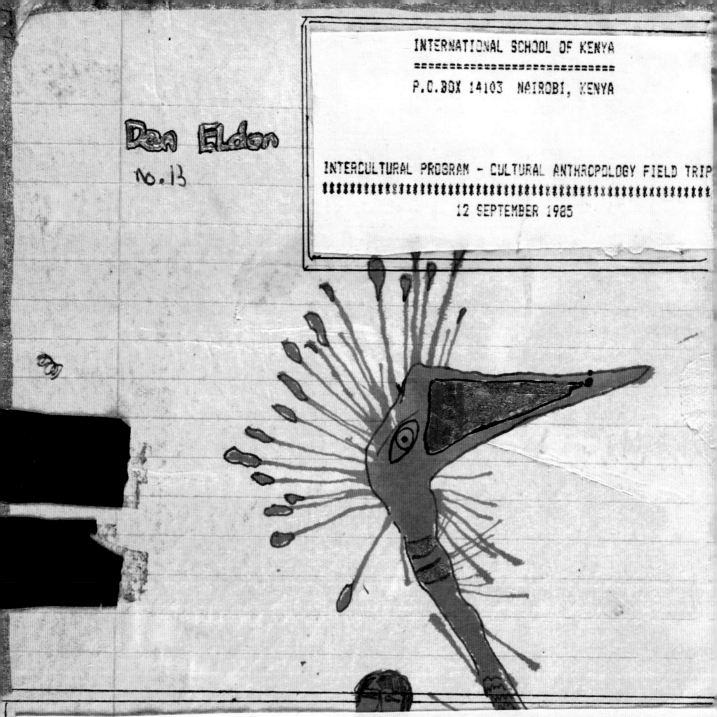

INTERNATIONAL SCHOOL OF KENYA
========================
P.O.BOX 14103 NAIROBI, KENYA

INTERCULTURAL PROGRAM - CULTURAL ANTHROPOLOGY FIELD TRIP
##
12 SEPTEMBER 1985

"WHENEVER POSSIBLE THE ETHNOLOGIST BECOMES ETHNOGRAPHER BY GOING OUT TO LIVE AMONG THE PEOPLE UNDER STUDY. BY EATING THEIR FOOD, SPEAKING THEIR LANGUAGE, AND PERSONALLY OBSERVING THEIR HABITS AND CUSTOMS, THE ETHNOGRAPHER IS ABLE TO UNDERSTAND A SOCIETY'S WAY OF LIFE TO A FAR GREATER EXTENT THAN ANY "ARMCHAIR ANTHROPOLOGIST" EVER COULD; ONE LEARNS A CULTURE BEST BY LEARNING HOW TO BEHAVE ACCEPTABLY ONESELF IN THE SOCIETY IN WHICH ONE IS DOING FIELDWORK. THE ETHNOGRAPHER TRIES TO BECOME A PARTICIPANT-OBSERVER IN THE CULTURE UNDER STUDY. [THIS DOES NOT MEAN THAT MILK MIXED WITH BLOOD HAS TO BE DRUNK IN ORDER TO STUDY THE MAASAI. BUT BY LIVING AMONG MAASAI, THE ETHNOGRAPHER SHOULD BE ABLE TO UNDERSTAND THE ROLE OF THE BLOOD/MILK MIXTURE IN THE OVERALL CULTURAL SCHEME.] HE OR SHE MUST BE A METICULOUS OBSERVER IN ORDER TO BE ABLE TO GET A BROAD OVERVIEW WITHOUT PLACING UNDUE STRESS ON ANY OF ITS COMPONENT PARTS. ONLY BY DISCOVERING HOW ALL SOCIAL INSTITUTIONS - POLITICAL, ECONOMIC, RELIGIOUS - FIT TOGETHER CAN THE ETHNOGRAPHER BEGIN TO UNDERSTAND THE CULTURAL SYSTEM."

I mix them with my brains, sir.
John Opie, when asked
with what he mixed
his colours.

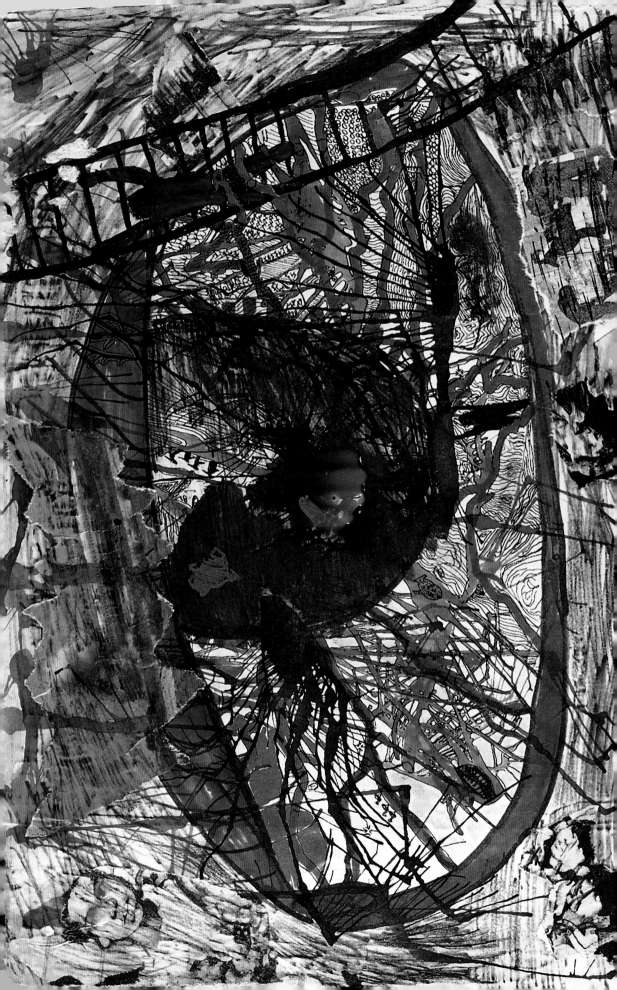

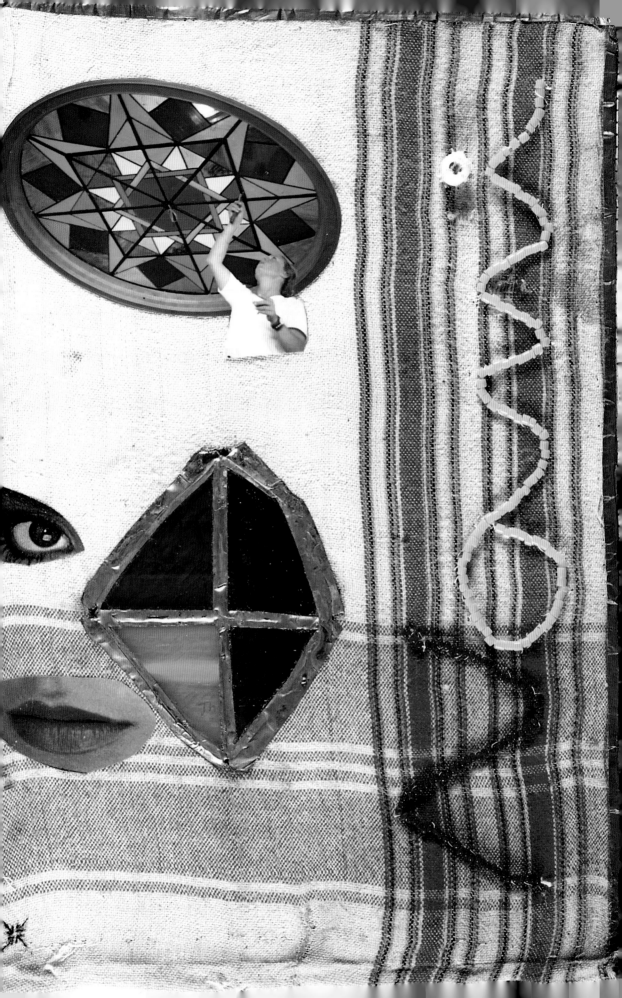

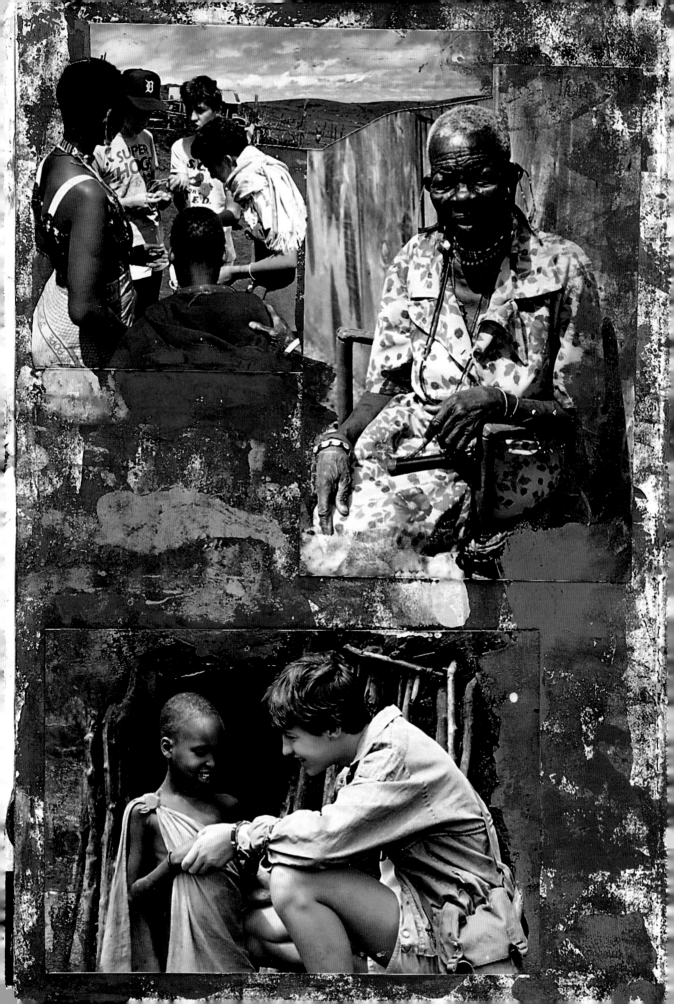

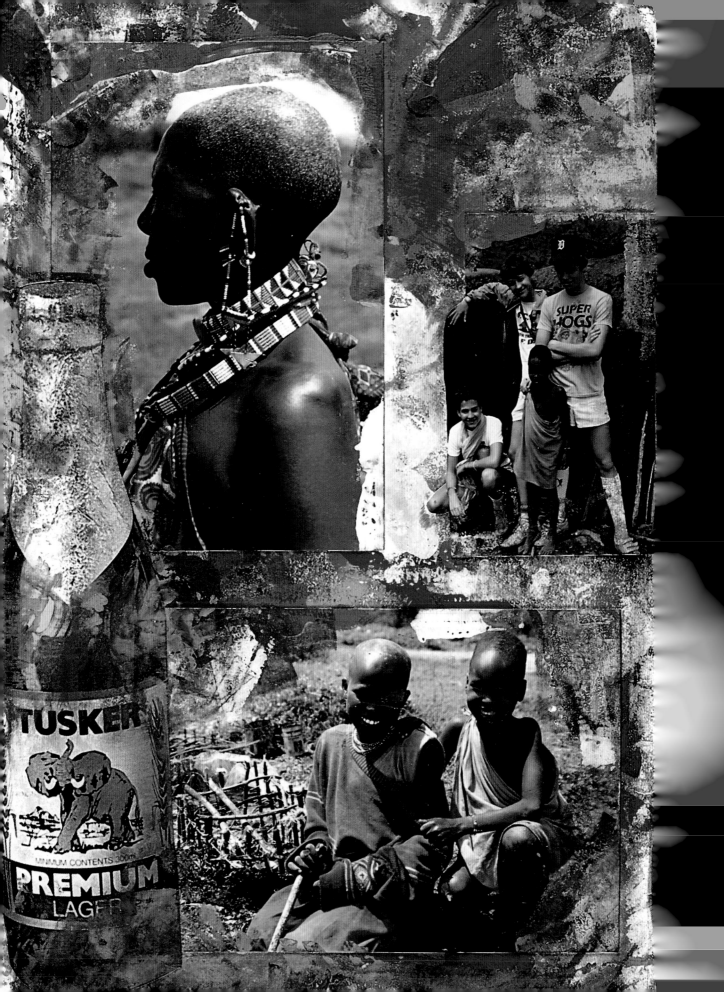

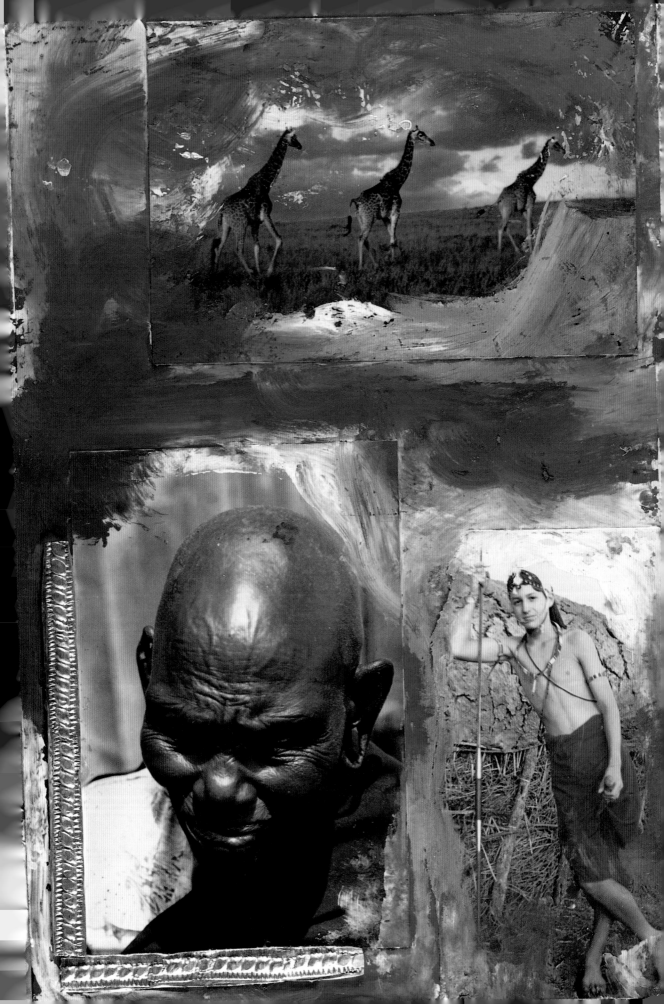

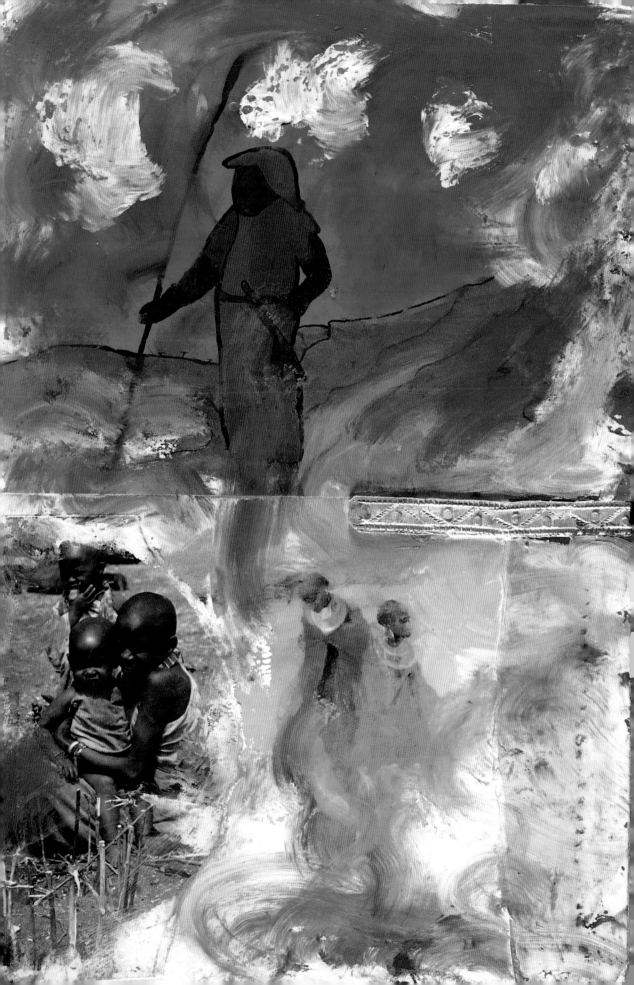

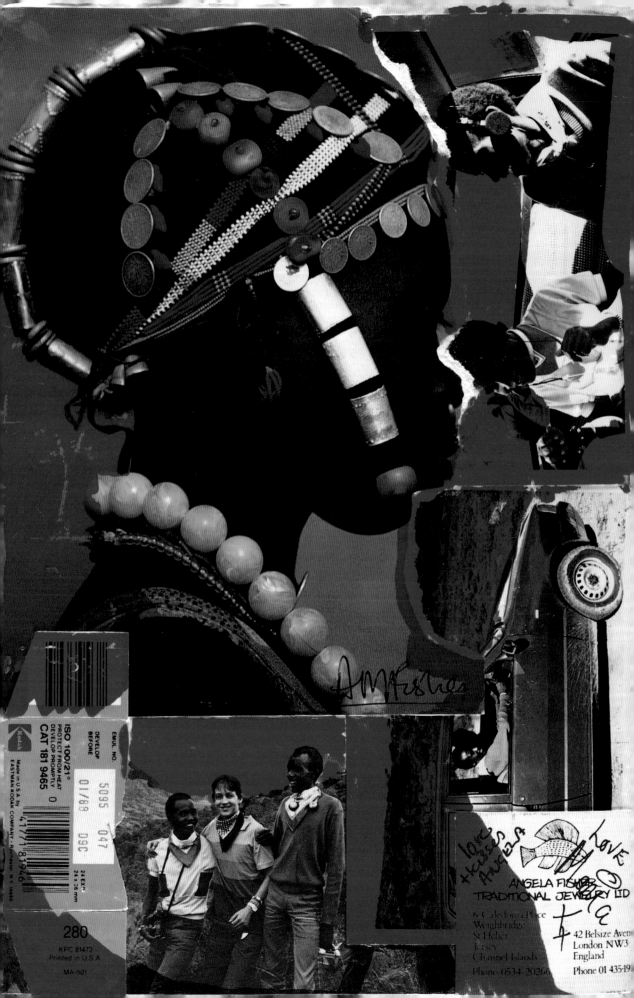

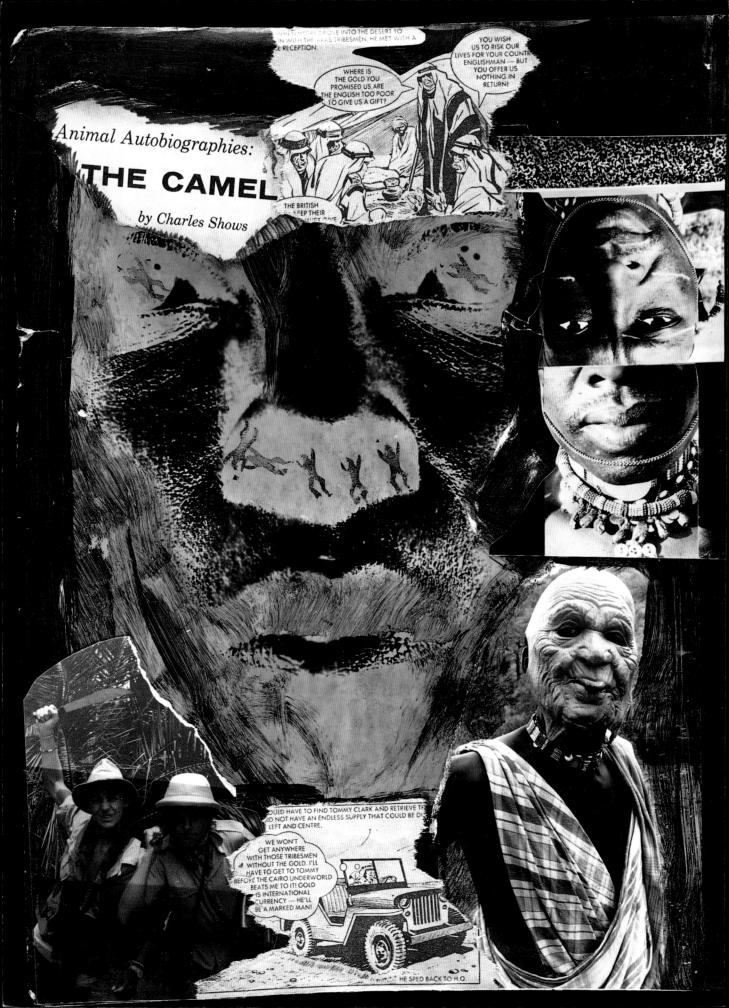

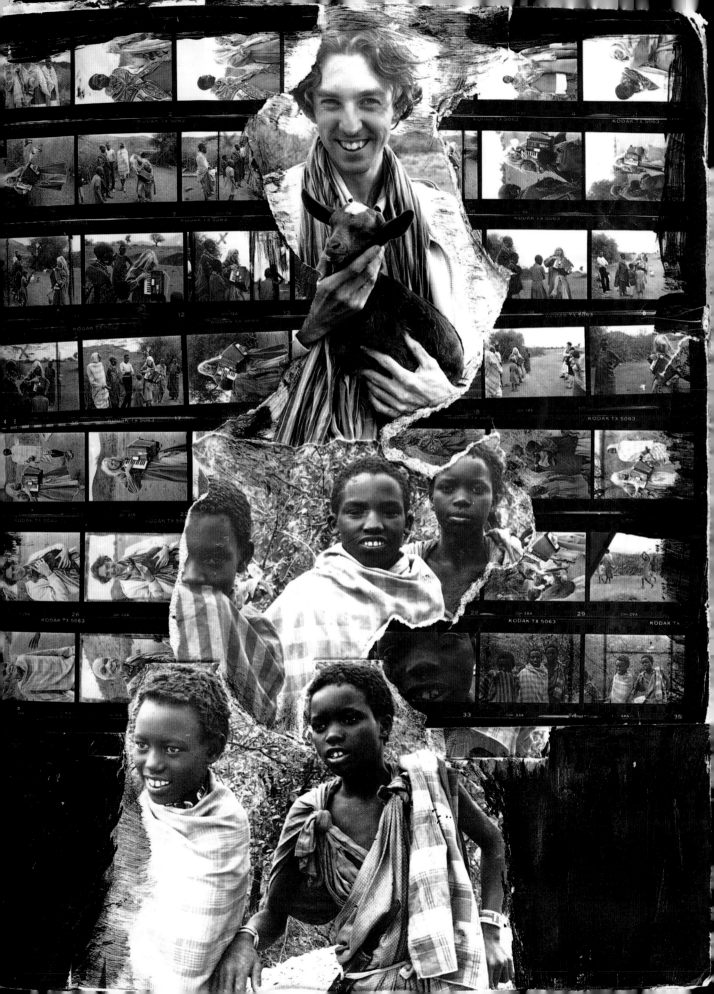

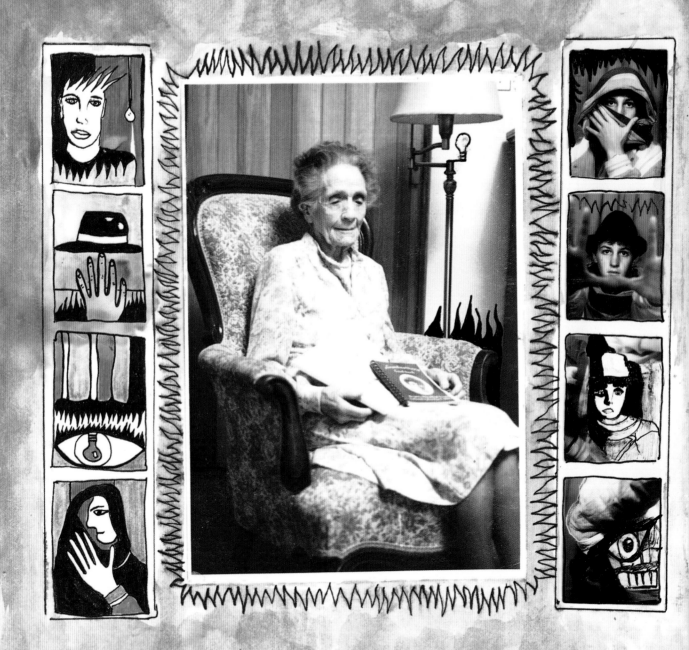

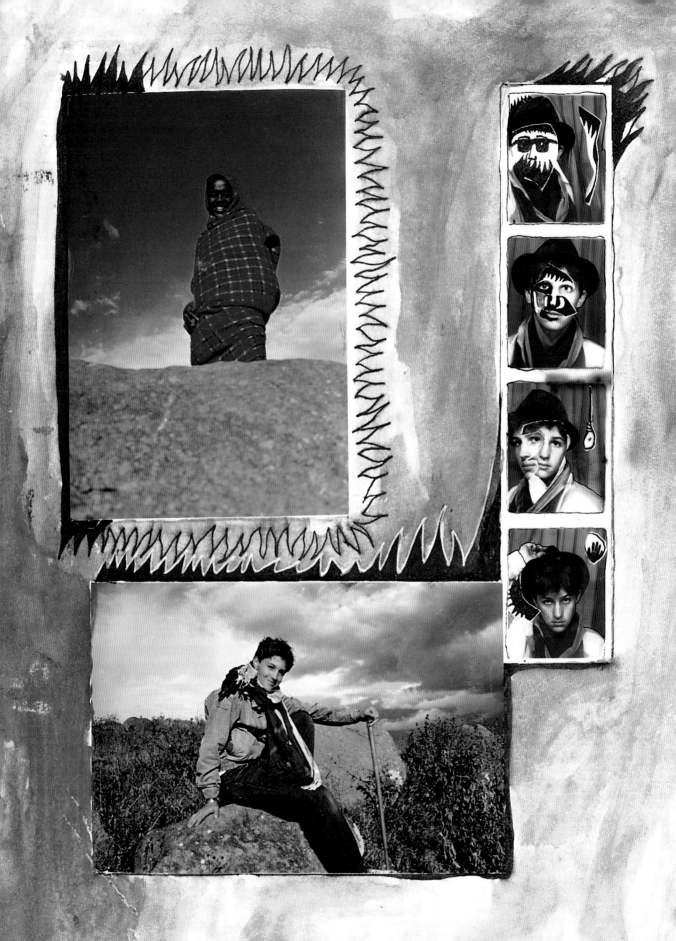

MORE VOLUME ON THAT SPEAKER, MIKE! IT GONNA NEED IT!!!

TOWN
HURLINGHAM
ADAM ARCADE
ROAD
SECOND GATE ON RIGHT, OFF NDEMI CLOSE
NGONG
NDEMI RD.
ELDON
Kingara
St. Austins

FROM EIGHTISH TO ONEISH
FOOD: ONE MKEBE
HAPPY MEAL
FREE

50/-

MARCH 17

MIKE AND JOHN'S MKEBE MIX

BIG AUDIO VISUAL DYNAMITE

aMORPhOuS ?!D'

ANARCHY IN THE MKEBE
(WITH CLAUDIUS GELDOF!) !?%$

EXPERIENCE!!

THANKYOU LE MKEBE

THANK YOU FOR BUYING AN INVITATION TO THE MKEBE. THE MONEY THAT WE RAISE, WILL BE USED TO PAY HOSPITAL BILLS FOR ATIENO GABRIEL, A 17 YEAR OLD GIRL, WHO URGENTLY NEEDS SURGERY ON HER HEART. YOUR DONATION WILL BE OF GREAT IMPORTANCE DURING THE TIME THAT SHE STAYS IN NAIROBI HOSPITAL AFTER THE OPERATION, AND WHILE SHE REGIANS HER STRENGTH AND STAMMINA.

MKEBE

IN THE RAIN

THE MKEBE

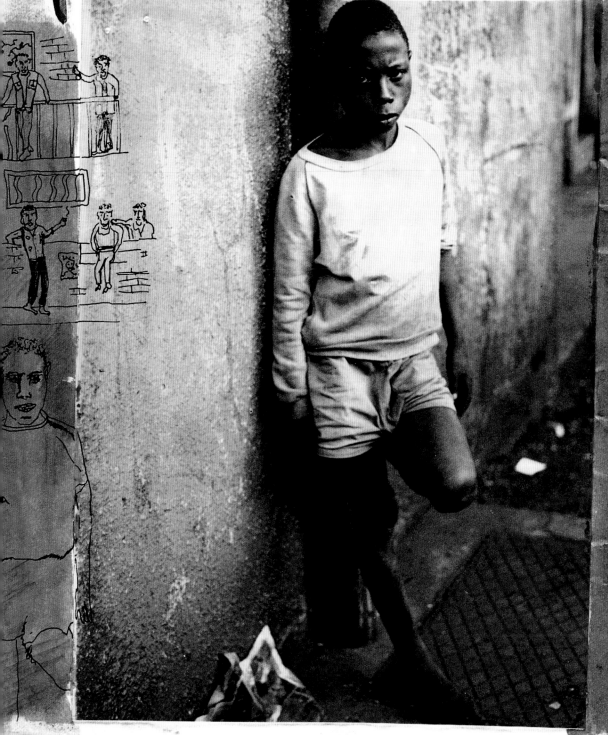

MAGENDO

BROTHERS

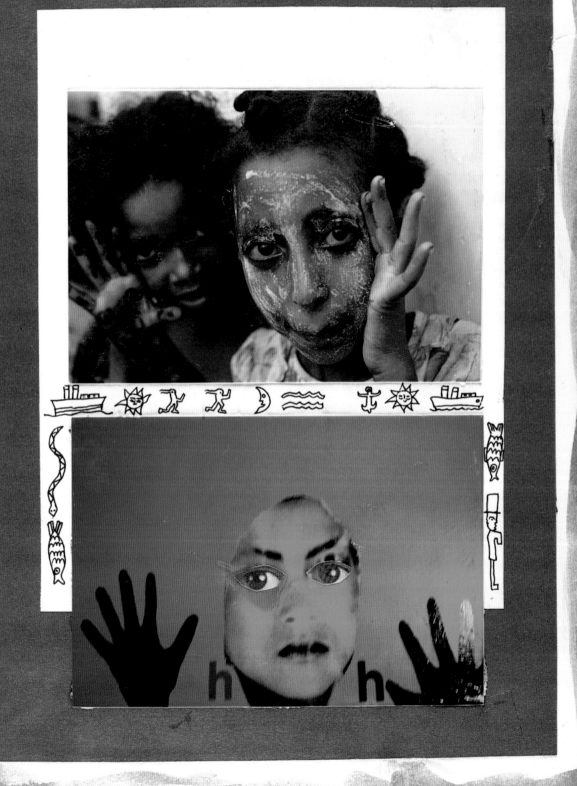

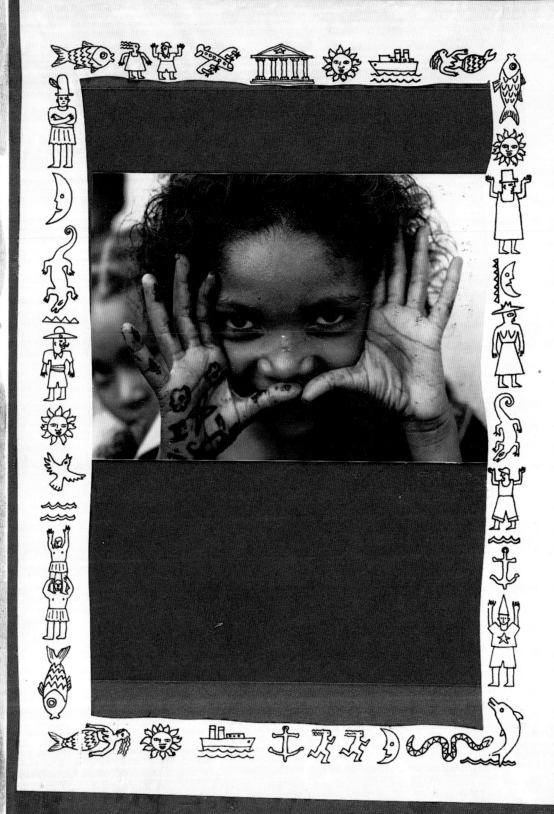

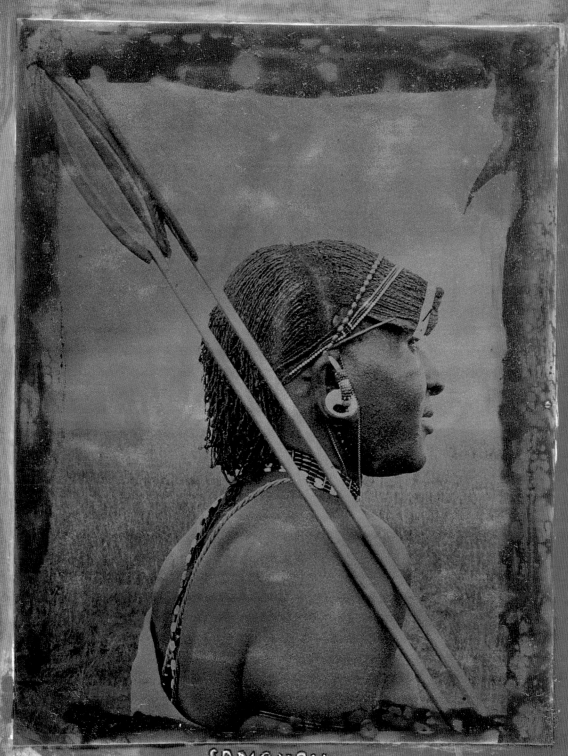

SAMBURU

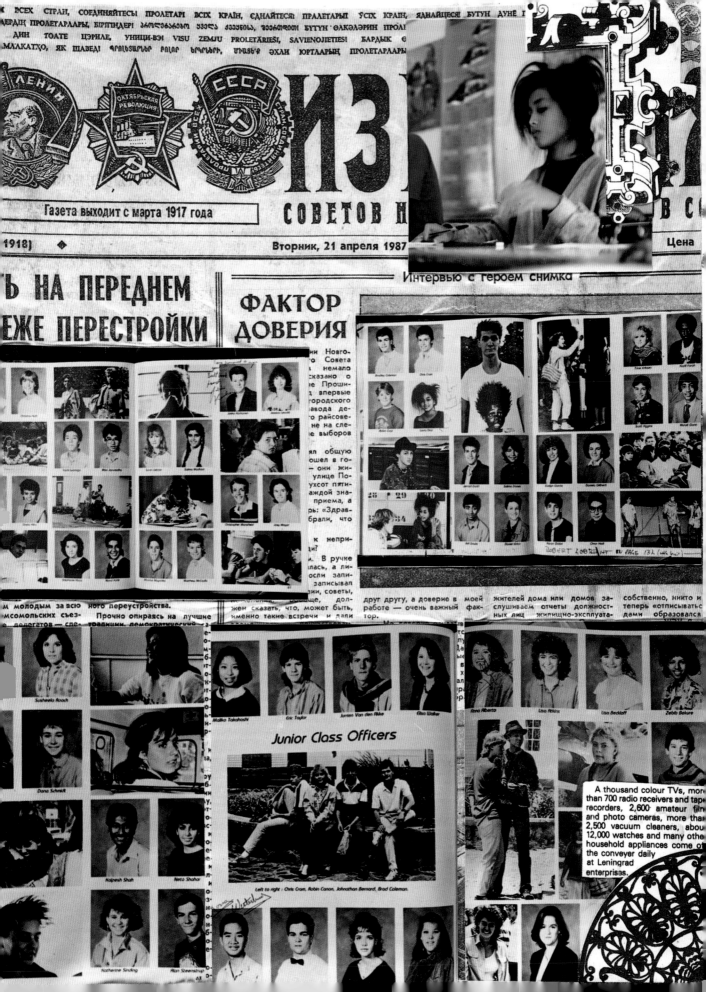

ВСЕХ СТРАН, СОЕДИНЯЙТЕСЫ ПРОЛЕТАРІ ВСІХ КРАЇН, ЄДНАЙТЕСЯ ПРАЛЕТАРЫ ЎСІХ КРАЇН, ЯДНАЙЦЕСЯ БУГУН ДУНЁ
ЕРДІҢ ПРОЛЕТАРЛАРЫ, БІРТПГІДЕР! პროლეტარებო ყველა ქვეყნის, შეერთდით БУТУН ӨЛКӘЛӘРИН ПРОЛ
ДИН ТОАТЕ ЦЭРИЛЕ, УНИЦІ-ВӘІ VISU ZEMJU PROLETĀRIESI, SAVIENOJIETIES! БАРДЫҚ Е
МЛАКАТХО, ЯК ШАВЕД! ԲՈԼՈՐ ԵՐԿՐՆԵՐԻ ЮРТЛАРЫҢ ПРОЛЕТАРЛАРЫ

Газета выходит с марта 1917 года

1918]

Вторник, 21 апреля 1987

Цена

ИЗ
СОВЕТОВ Н

Ь НА ПЕРЕДНЕМ
ЕЖЕ ПЕРЕСТРОЙКИ

ФАКТОР
ДОВЕРИЯ

Интервью с героем снимка

м молодым за всю ного переустройства.
мсомольских съезд—
делегатов — спе— Прочно опираясь на лучшие
традиции, демократический

ни Новго—
то Совета
немало
сказано о
е Проши—
д впервые
городского
завода де—
то райсове—
е выборов

л общую
шёл в го—
они жи—
улице По—
ухсот пяти—
аждой зна—
приема, а
рь: «Здрав—
брали, что

к непри—

. В ручке
лась, а ли—
оли запи—
записывал
ще, долж—
щие, советы,
жен сказать, что, может быть,
именно такие встречи и дали

друг другу, а доверие в моей
работе — очень важный фак—
тор.

жителей дома или домов за—
слушиваем отчеты должност—
ных лиц жилищно-эксплуата—

собственно, никто и
теперь «отписыва—
дами образовался

Junior Class Officers

Left to right: Chris Cram, Robin Canon, Johnathon Bernard, Brad Coleman.

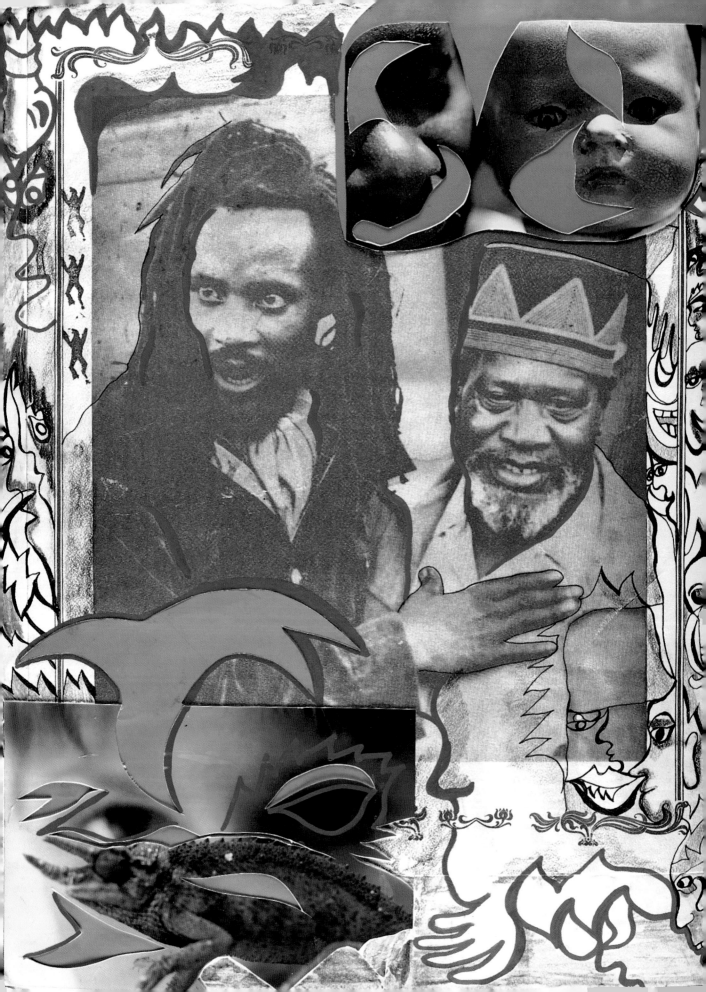

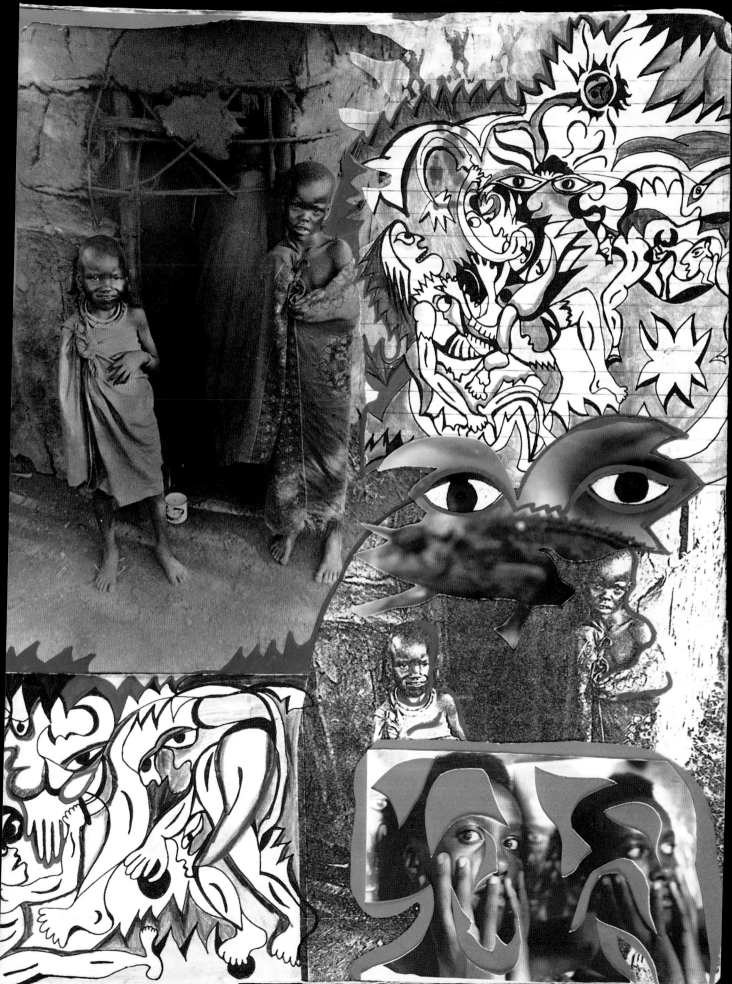

5 months in Kenya

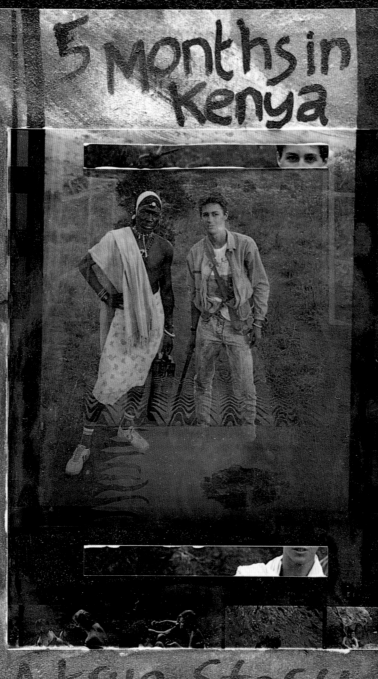

Nkwe Story

too true to be good.

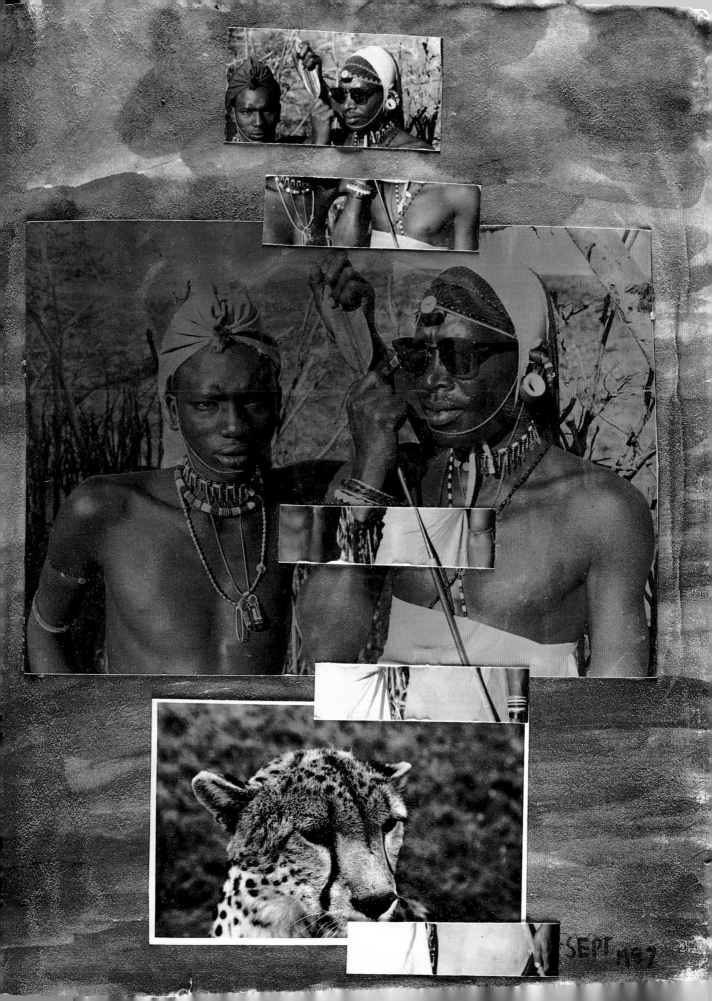

SEPT 1987

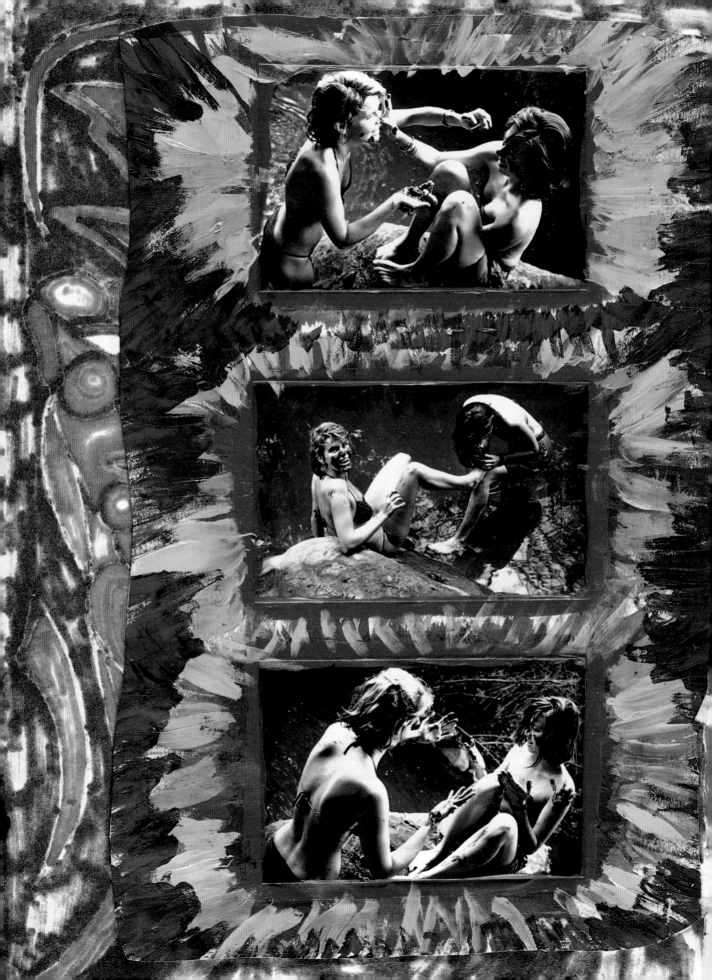

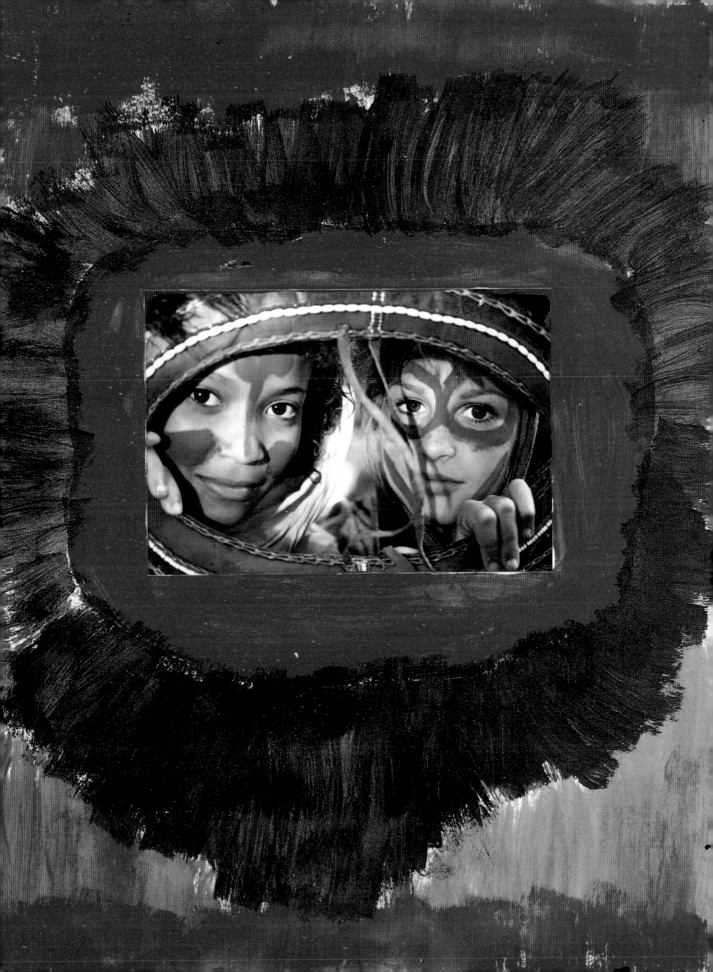

Lawrence of Arabia
5 foot 2 inches.

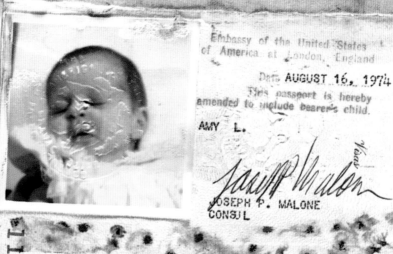

Embassy of the United States of America at London, England

Date AUGUST 16, 1974

This passport is hereby amended to include bearer's child.

AMY L.

JOSEPH P. MALONE
CONSUL

Nevada in
a mist

when all
the thorns
fall
off
the
cacti

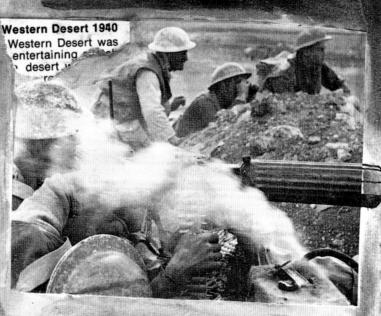

Western Desert 1940
Western Desert was
entertaining
desert

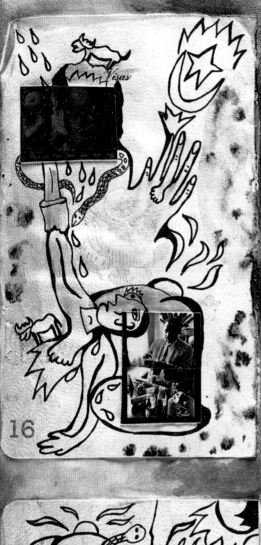

16

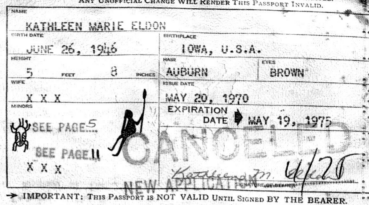

NAME
KATHLEEN MARIE ELDON

BIRTH DATE
JUNE 26, 1946

BIRTHPLACE
IOWA, U.S.A.

HEIGHT
5 FEET **8** INCHES

HAIR
AUBURN

EYES
BROWN

WIFE
X X X

ISSUE DATE
MAY 20, 1970

MINORS

EXPIRATION DATE ▶ **MAY 19, 1975**

SEE PAGE 5
SEE PAGE 11
X X X

CANCELED

NEW APPLICATION

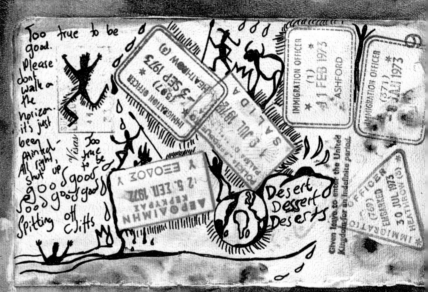

Too true to be good. Please don't walk on the horizon – it's just been painted – All right, shut up – good good good good good Spitting off cliffs

Too true to be good

Visas

Desert Dessert Deserts

Given leave to enter the United Kingdom for an indefinite period.

IMMIGRATION OFFICER (1) 11 FEB 1973 ASHFORD

IMMIGRATION OFFICER (371) JAN 1973

IMMIGRATION OFFICER (76) 30 JUL 1973 HEATHROW (5)

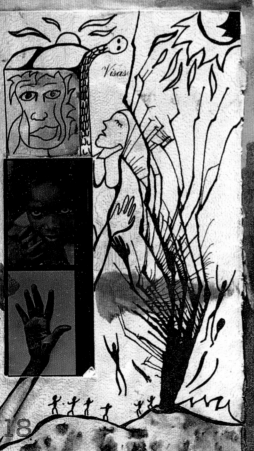

Visas

18

Baby

Embassy of the United States of America at London, England

Date NOVEMBER 12, 1970

This passport is hereby amended to include bearer's child.

DANIEL ROBERT

E.T. Vangas

E. T. VANGAS
AMERICAN CONSUL

daniel Robert eldon (by his mother Kathleen M. Eldon)

5

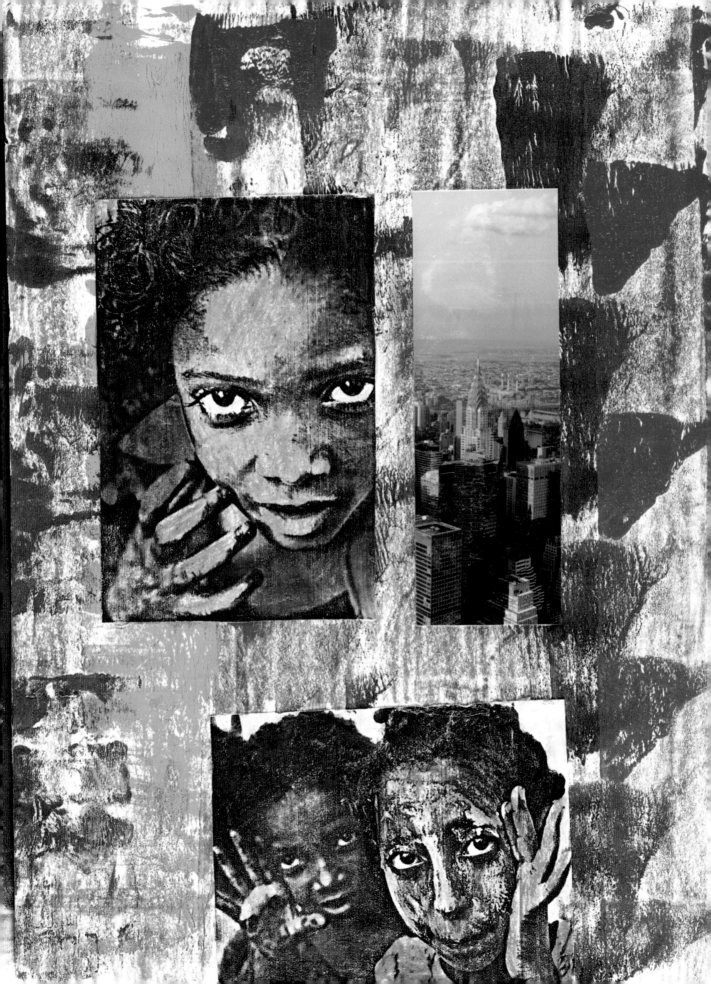

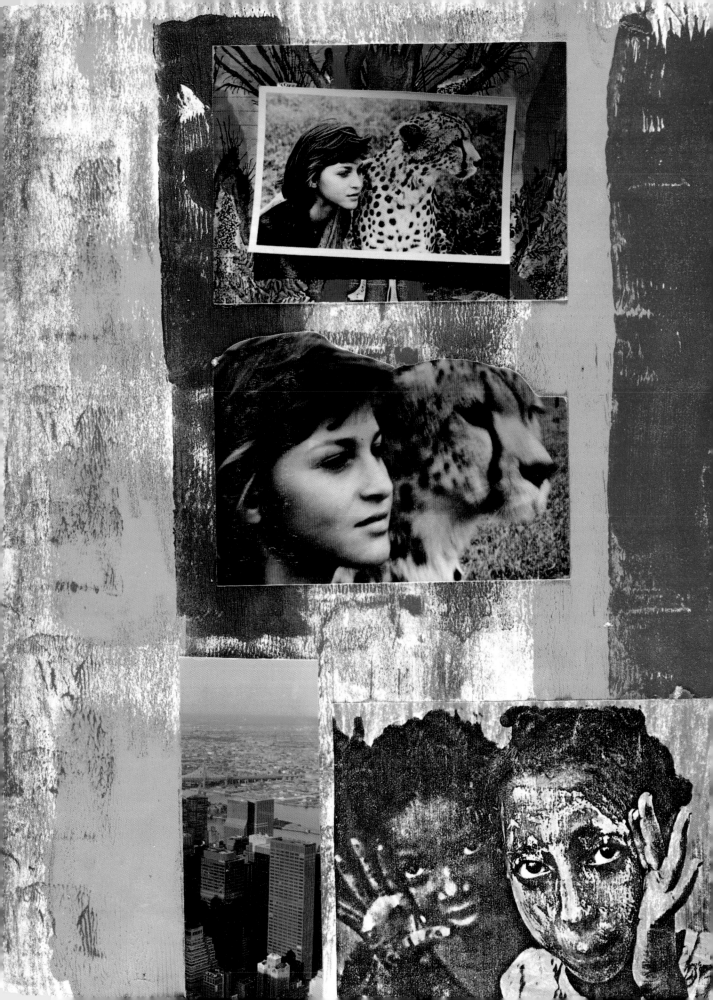



October 3rd 1914

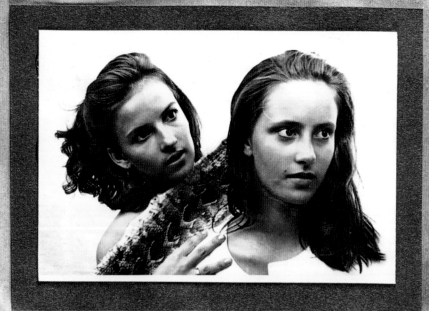

extract from the Koran. page 73 —the bit about topless sun-bathing.

Last photograph of Baron Von Grangers daughters before their execution. Frauline Darla (left) comforts her sister Dawn (right) moments before she is taken to be beheaded. October 3rd 1914. 5p.m. – My film was removed after I took this picture and was only returned after I gave the sentry my pocket watch.

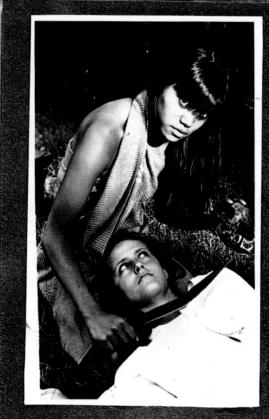

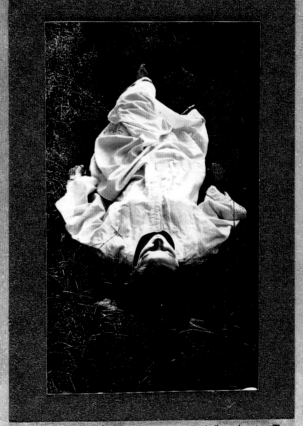

Frauline Dawn Von Granger is prepared for the execution by a palace slave. I was unable to aid her as she was under constant supervision from palace guards at all times.

Dawn lies fallen but head still intact. It took 17 blows to dislodge her head from the neck.

account of the raid on detach... said before proceeding at 1600... would never ai...

Daughter of the sheikh and slave october, 1914

Photographs taken in Royal tent before the camel races and sheep eye feast.

Note short curved dagger- rhino horn handle

Coins presented to me by the sheik himself before cutting my hand off. note rare islamic markings on outer ridge of coin. These coins were minted by Sheikh Abu Kamu in 1512 to commemorate his twenty fifth wife.

Bridge crossin... Before anyone could fire a shot, the men decided to

continued →

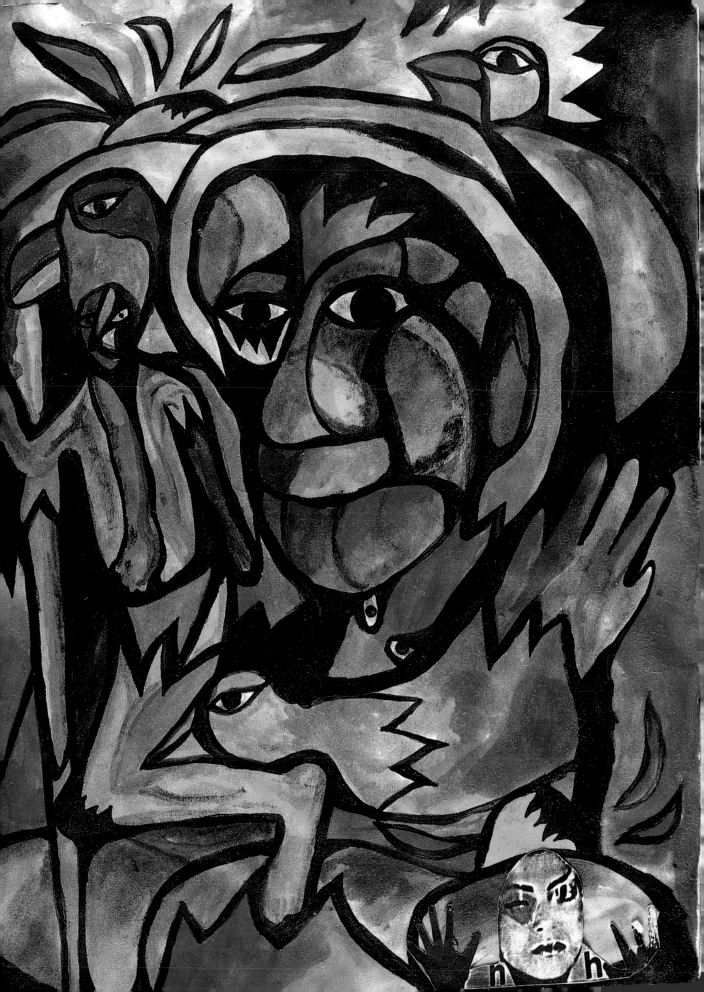

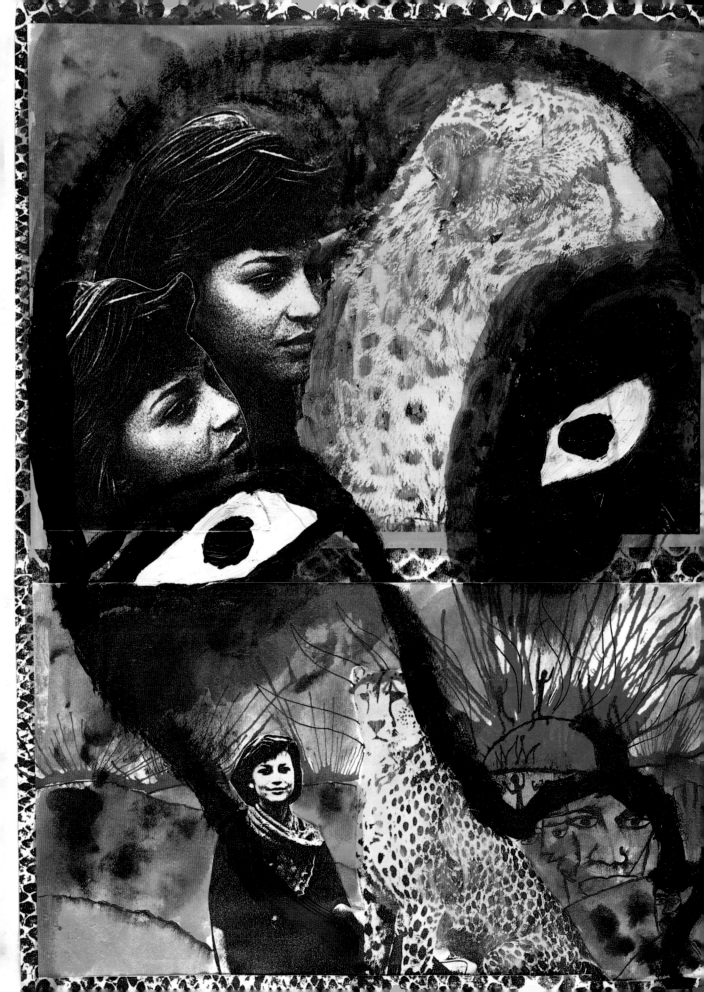

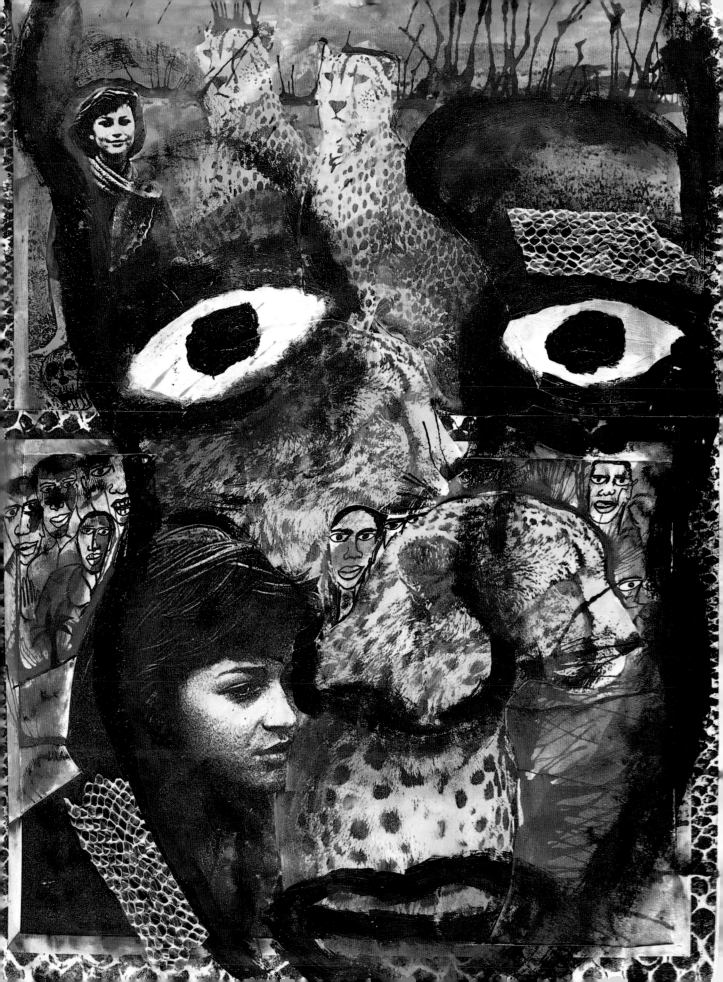

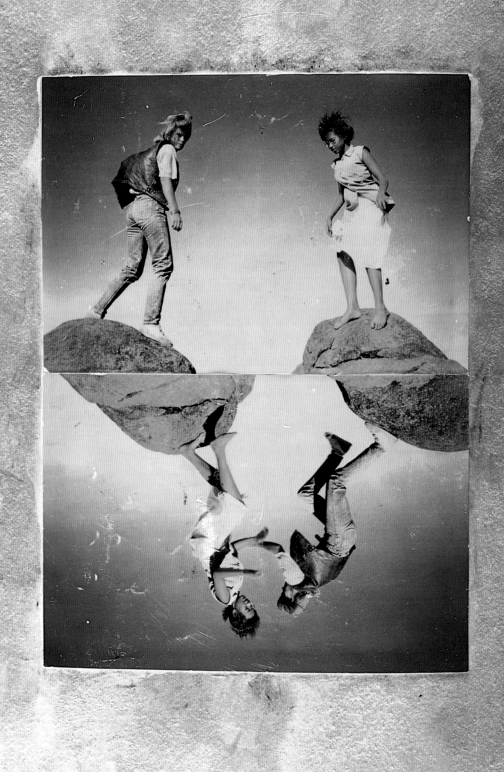

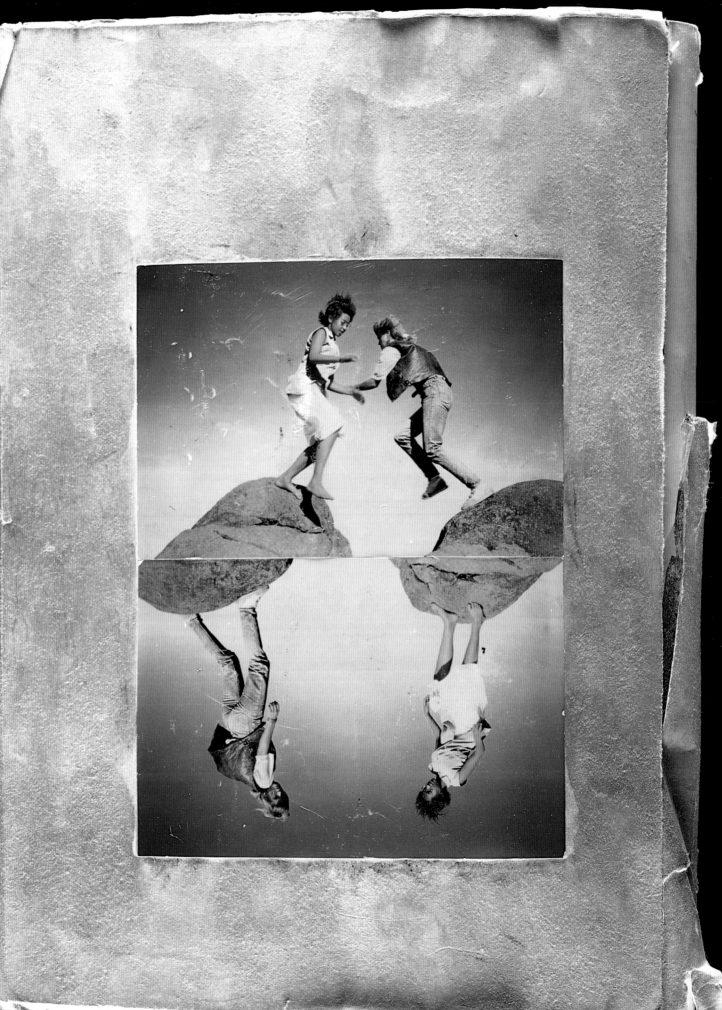

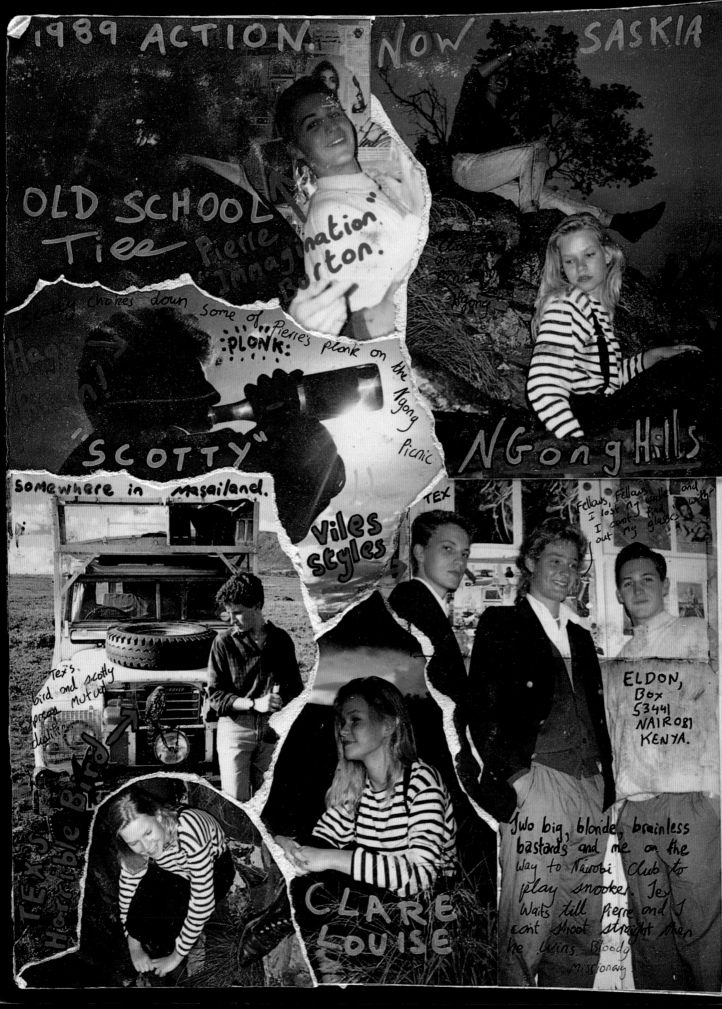

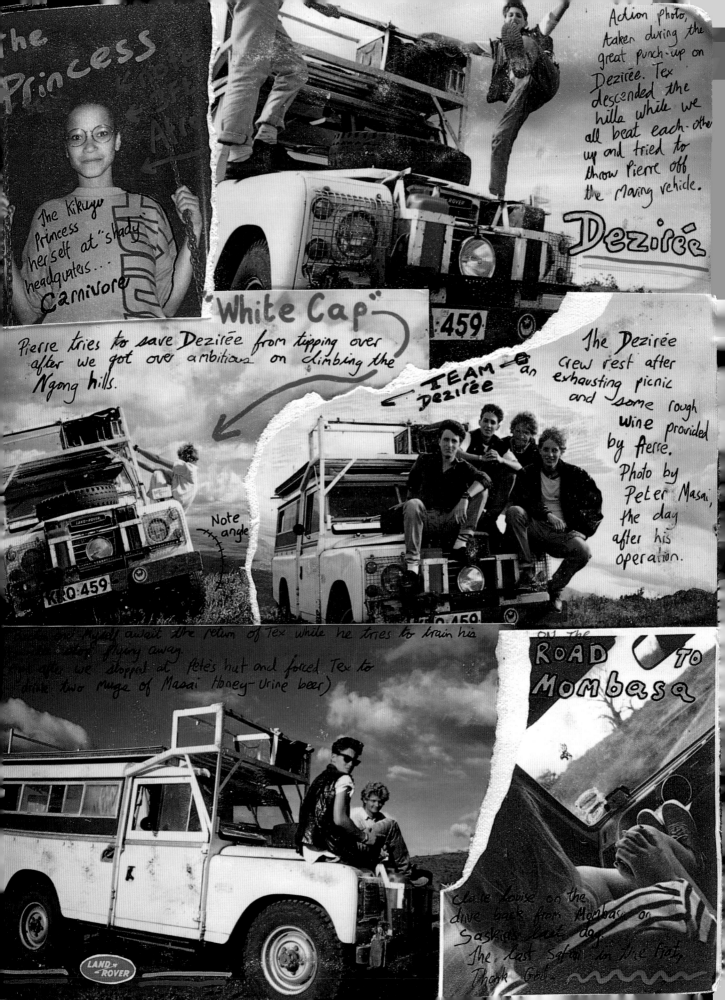

the Princess ...Arg

The Kikuyu Princess herself at "shady" headquarters... Carnivore

Action photo, taken during the great punch-up on Dezirée. Tex descended the hills while we all beat each-other up and tried to throw Pierre off the moving vehicle.

Dezirée

"White Cap"

Pierre tries to save Dezirée from tipping over after we got over ambitious on climbing the Ngong hills.

Note angle

TEAM Dezirée

459

KRQ 459

The Dezirée crew rest after an exhausting picnic and some rough wine provided by Pierre. Photo by Peter Masai, the day after his operation.

____ and myself await the return of Tex while he tries to train his ____ flying away. ____ after we stopped at Pete's hut and forced Tex to drink two mugs of Masai Honey-urine beer)

ON THE ROAD TO MOMBASA

Claire Louise on the drive back from Mombasa on Saskia's last day. The last safari in the ____ Thank God.

LAND ROVER

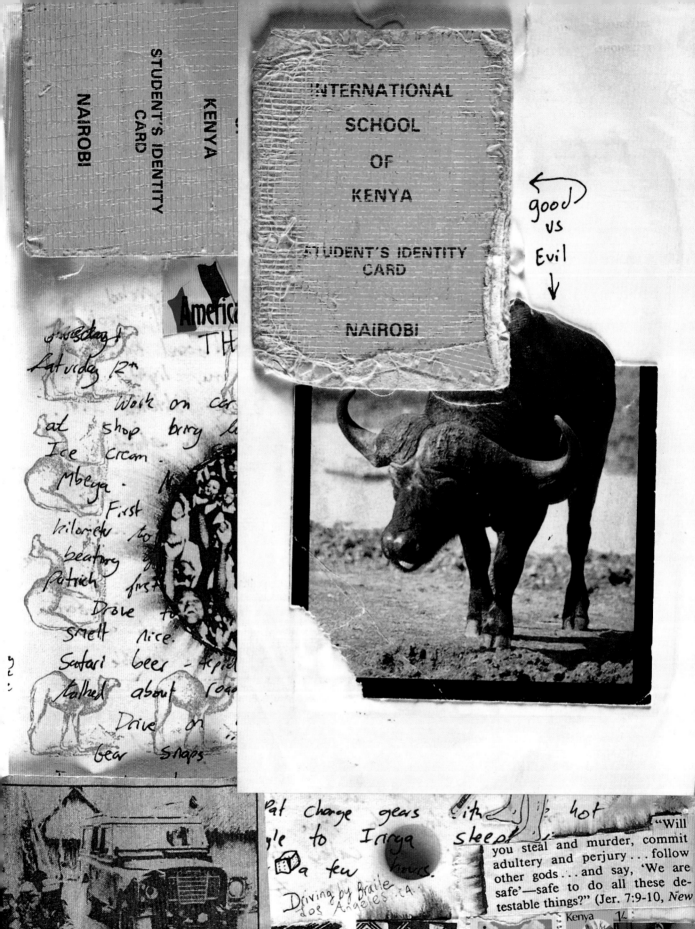

NAIROBI

STUDENT'S IDENTITY
CARD

KENYA

INTERNATIONAL

SCHOOL

OF

KENYA

STUDENT'S IDENTITY
CARD

NAIROBI

good
vs
Evil

America
TH

Saturday 12th

Work on car
at shop bring
Ice cream.
Mbeya.
First
kilometer
beating
Patrick first
Drove
smell nice.
Safari beer -
talked about road
Drive on
bear snaps

Pat change gears hot
to Inraga sleep
a few hours.
Driving by Braile
los Angeles. CA.

"Will
you steal and murder, commit
adultery and perjury...follow
other gods...and say, 'We are
safe'—safe to do all these de-
testable things?" (Jer. 7:9-10, New

son's bullet-torn vehicle

Kenya 14

USA 25

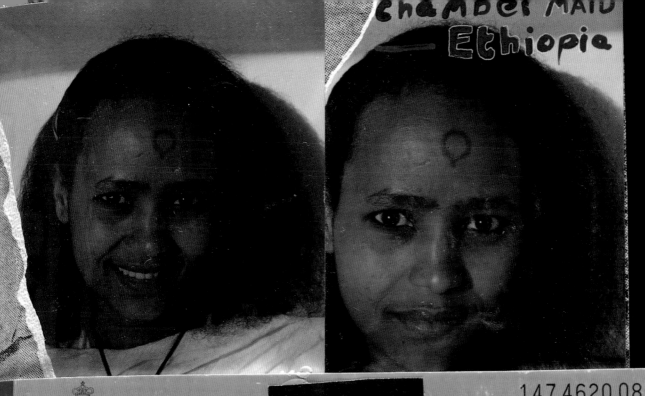

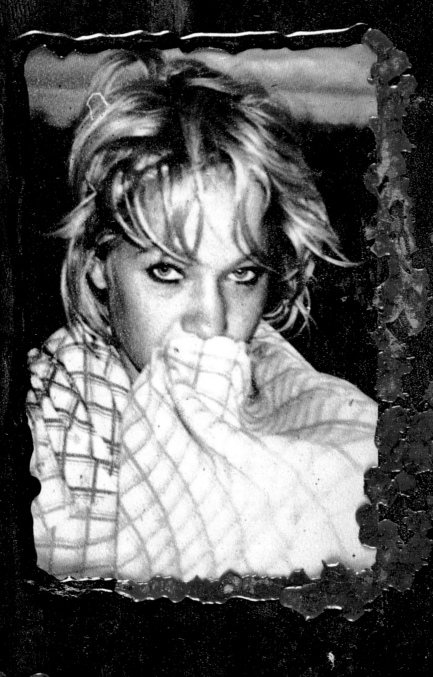
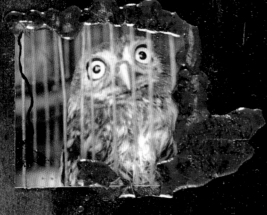

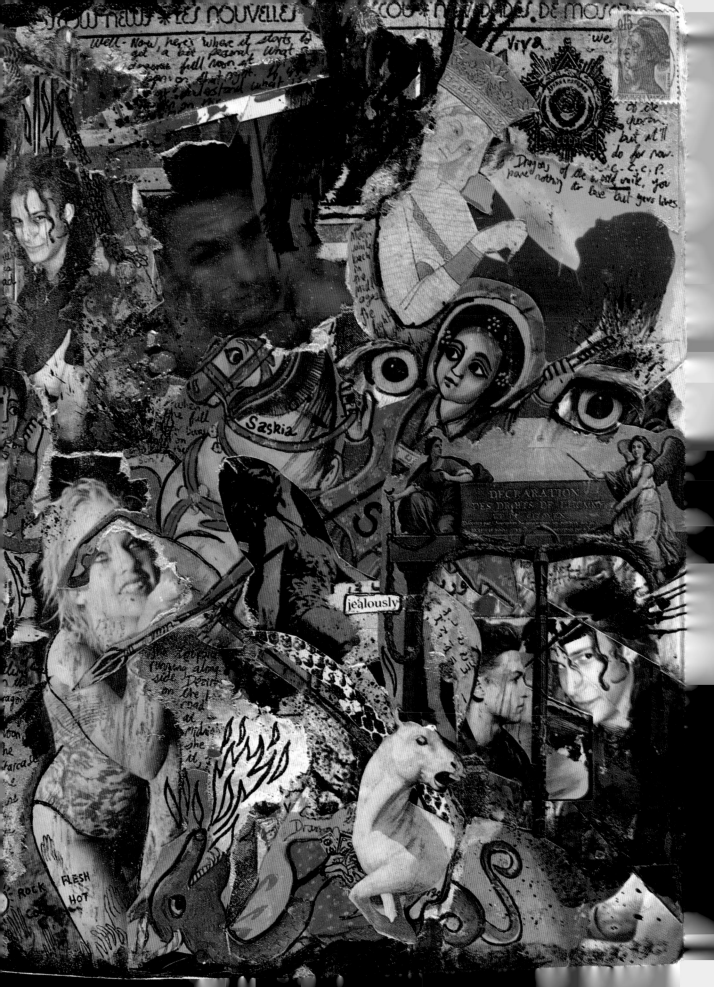

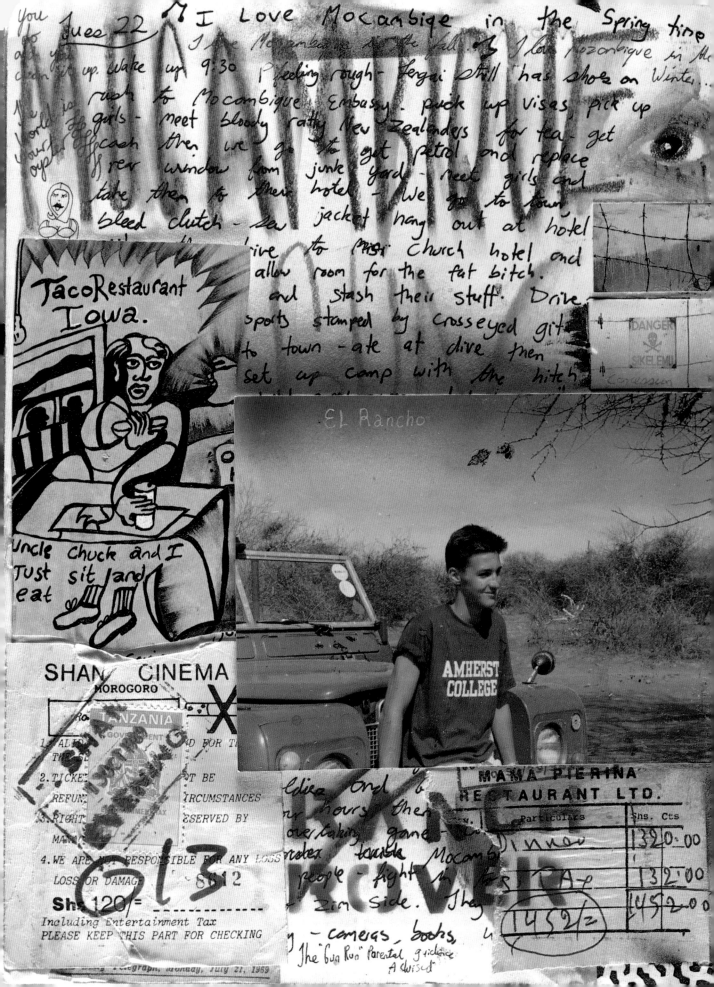

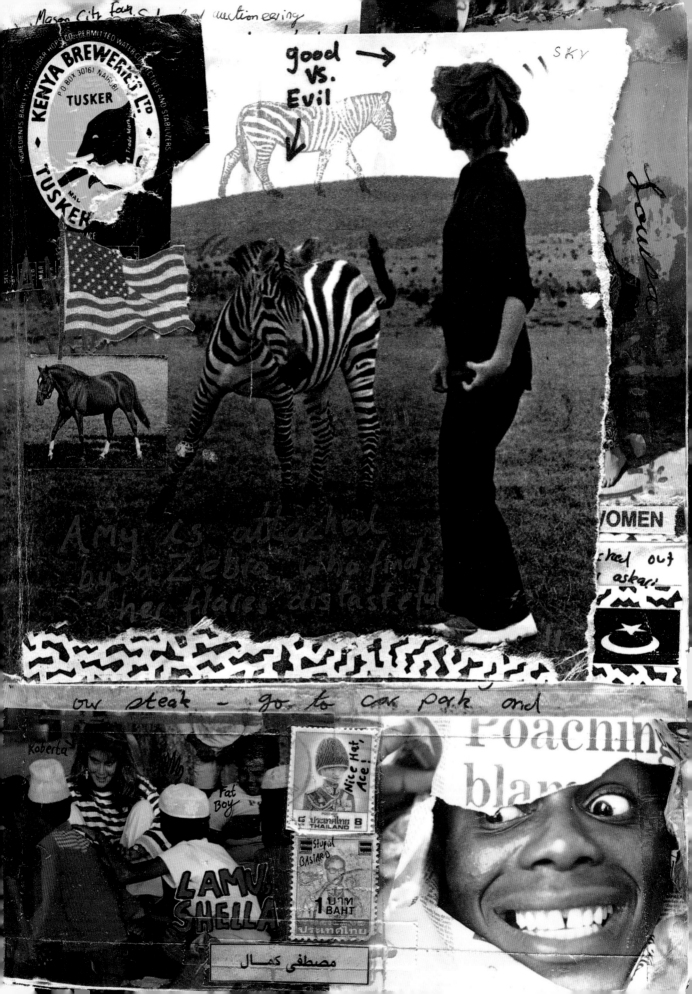

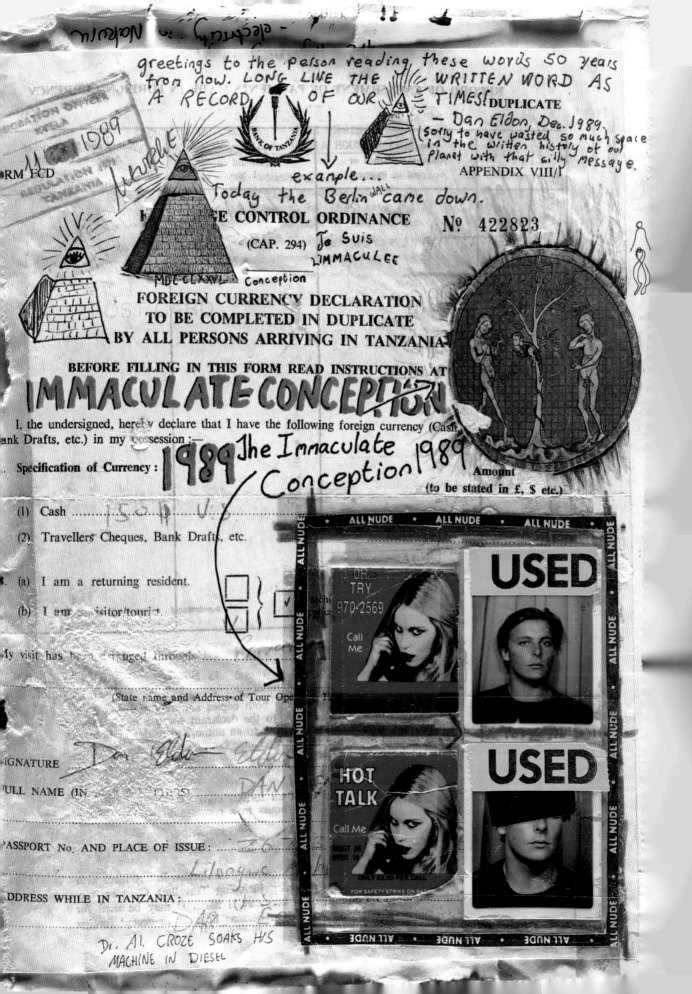

greetings to the person reading these words 50 years from now. LONG LIVE THE WRITTEN WORD AS A RECORD OF OUR TIMES! DUPLICATE

— Dan Eldon, Dec. 1989. (sorry to have wasted so much space in the written history of our planet with that silly message.

APPENDIX VIII/1

example...

Today the Berlin WALL came down.

EXCHANGE CONTROL ORDINANCE Nº 422823

(CAP. 294) Je Suis L'IMMACULEE

MDCCLXXVI Conception

FOREIGN CURRENCY DECLARATION TO BE COMPLETED IN DUPLICATE BY ALL PERSONS ARRIVING IN TANZANIA

BEFORE FILLING IN THIS FORM READ INSTRUCTIONS AT

IMMACULATE CONCEPTION

I, the undersigned, hereby declare that I have the following foreign currency (Cash, Bank Drafts, etc.) in my possession:—

1989 The Immaculate 1989 Conception

Specification of Currency: Amount (to be stated in £, $ etc.)

(1) Cash 150 h U.S.

(2) Travellers Cheques, Bank Drafts, etc.

(a) I am a returning resident. ☐

(b) I am a visitor/tourist. ☑

My visit has been arranged through

(State name and Address of Tour Operator)

SIGNATURE Dan Eldon

FULL NAME (IN LETTERS) DAN

PASSPORT No. AND PLACE OF ISSUE:

Lilongwe

ADDRESS WHILE IN TANZANIA :

Dr. Al. CROZE SOAKS H/S MACHINE IN DIESEL

BANK OF TANZANIA

ALL NUDE · ALL NUDE · ALL NUDE

OR TRY 970-2569 Call Me

USED

HOT TALK Call Me

MUST BE OVER 18 ONLY $3.50 PER CALL FOR SAFETY STRIKE ON BACK

USED

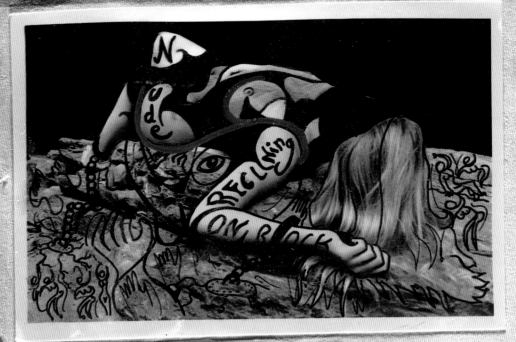

Men travel miles to glimpse the notorious golden nude.

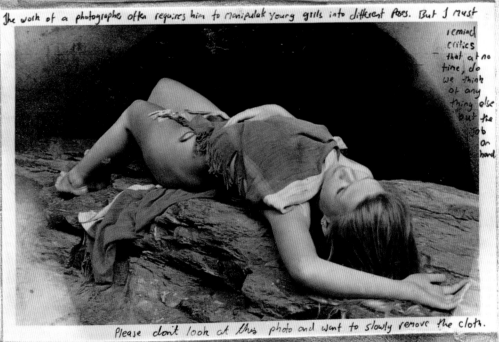

The work of a photographer often requires him to manipulate young girls into different poses. But I must remind critics that at no time, do we think of anything else but the job on hand.

Please don't look at this photo and want to slowly remove the cloth.

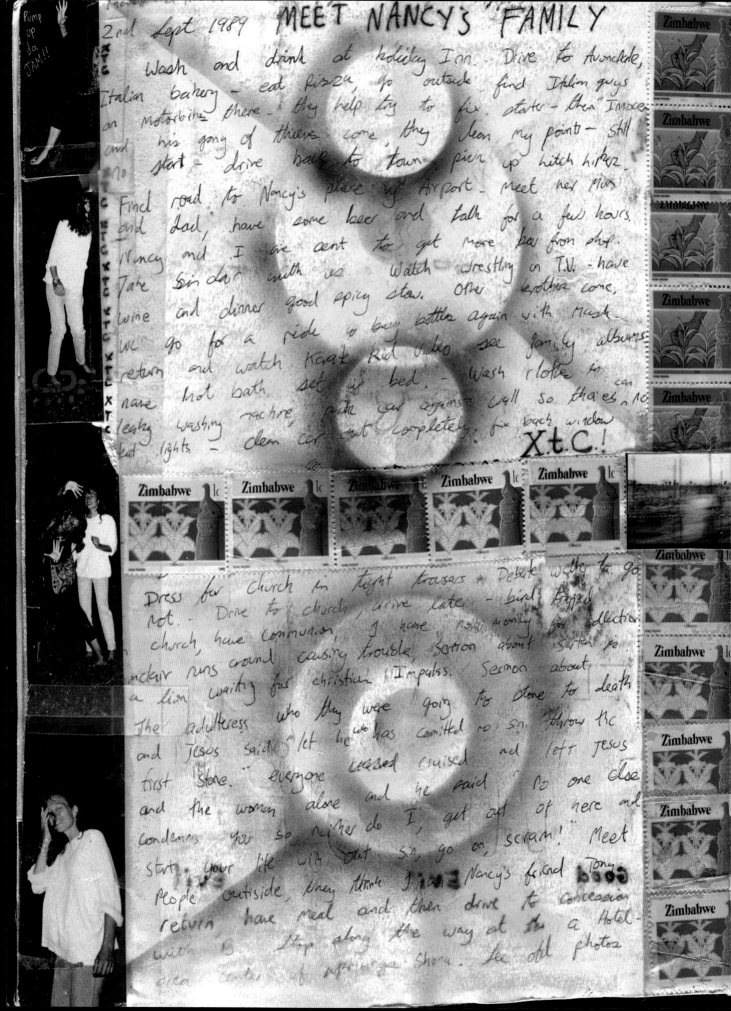

MEET NANCY'S FAMILY

2nd Sept 1989

Wash and drink at holiday Inn. Drive to Avondale, Italian bakery – eat pizza, go outside, find Italian guys on motorbikes there – they help try to fix starter – then "Innocent" and his gang of thieves come, they clean my points – still no start – drive back to town, pick up hitch hiker. Find road to Nancy's place by Airport – meet her Mum and Dad, have some beer and talk for a few hours. Nancy and I are sent to get more beer from shop. Take Sinclair with us. Watch wrestling on T.V. – have wine and dinner good spicy stew. Other brother come, we go for a ride to buy bottles again with Mush. return and watch Karate Kid video, see family albums, have hot bath, set up bed. – Wash clothes in leaky washing machine, push car against wall so thieves can't. clean carb out completely, fix back window, fed lights – clean car.

X.t.C!

Dress for church in tight trousers – Delete we have to go not. Drive to church, arrive late – bird trapped in church, have communion, I have no money for collection. Sinclair runs around causing trouble. Sermon about sister, a lion waiting for christian impalas. Sermon about The adulteress who they were going to stone to death and Jesus said "let he who has committed no sin throw the first stone." everyone teased cruised and left Jesus and the woman alone and he said no one else condemns you so neither do I, get out of here and start your life with out sin, go on, scram!" Meet people outside, they think ____ Nancy's friend Tony return have meal and then drive to concession. Stop along the way at a Hotel. see old photos

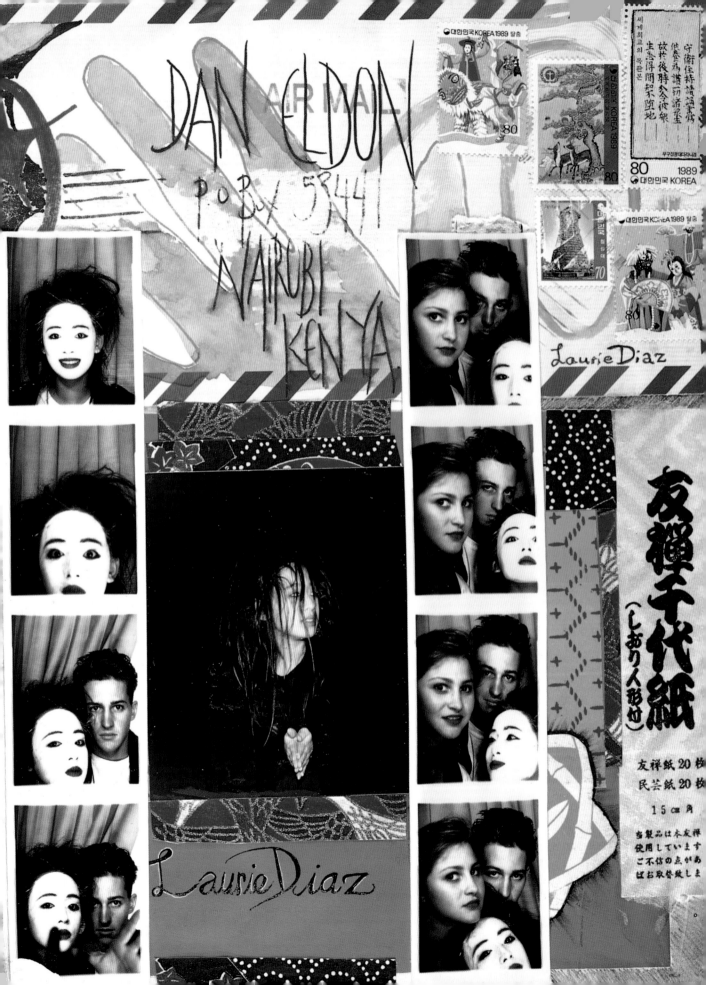

OFFICE OF THE PRESIDENT

Telegrams: "PROVINCER", Nairobi
Inquiries and all other offices—
Telephone: Nairobi 333551
When replying please quote

Ref. No. CER 2/28 VOL II
and date

PROVINCIAL COMMISSIONER
NAIROBI AREA
P.O. Box 30124
NAIROBI

.........24th MAY..., 19..89

A.D'Cunha,
P.O. BOX 53441,
NAIROBI.

RE: STAFF DINNER PARTY

Permission is hereby granted to you to hold the above mentioned party
on 26th May,1989 at your residence, Laikipia road, Kileleshwa
starting from 6.00 P.M. to midnight.

Ensure law and order is maintained.

703 7316143

F. T. KIMEMIA
FOR: PROVINCIAL COMMISSIONER
NAIROBI AREA

cc.

The District Officer
Parklands Division
NAIROBI.

The O.C.S,
Kilimani police station
NAIROBI.

"Hey, G.I., you WANT JAPANESE
Girl Frein'?"

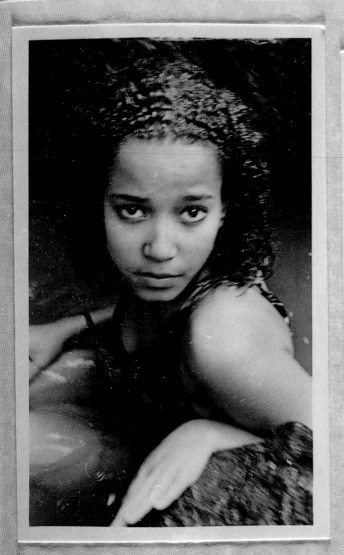

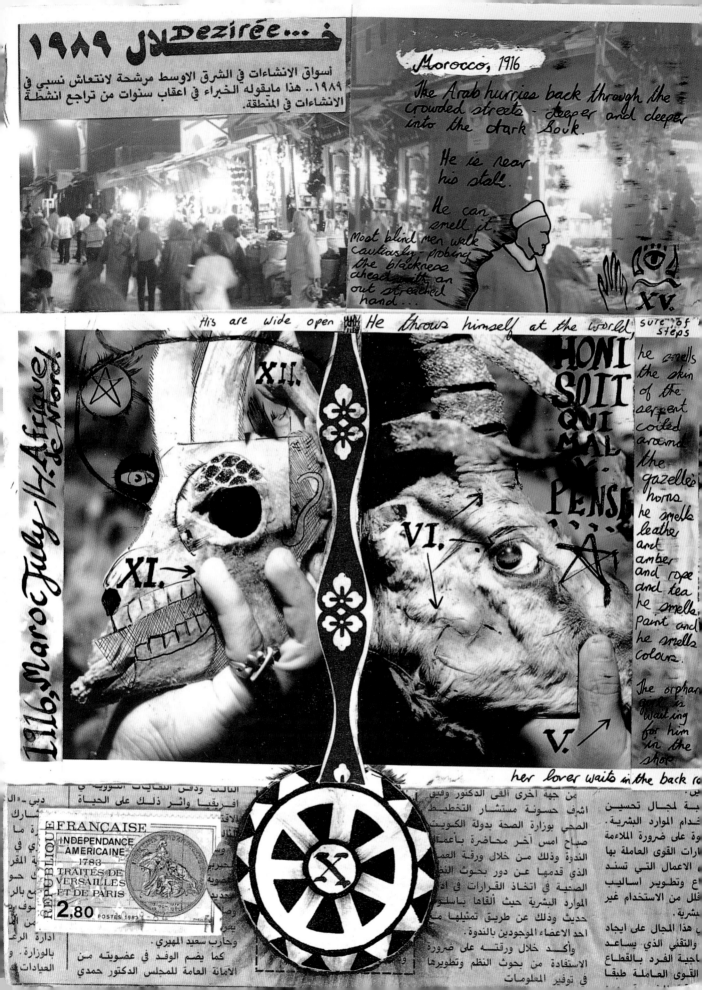

Dezirée... خلال ١٩٨٩

أسواق الإنشاءات في الشرق الاوسط مرشحة لانتعاش نسبي في
١٩٨٩.. هذا مايقوله الخبراء في اعقاب سنوات من تراجع انشطة
الانشاءات في المنطقة.

Morocco, 1916

The Arab hurries back through the crowded streets - deeper and deeper into the dark Souk.

He is near his stall.

He can smell it. Most blind men walk cautiously - probing the blackness ahead with an out stretched hand...

XV.

His are wide open He throws himself at the world sure of steps

XII.

XI.

VI.

V.

HONI SOIT QUI MAL Y PENSE

he smells the skin of the serpent coiled around the gazelles horns he smells leather and amber and rope and tea he smells paint and he smells colours.

The orphan girl is waiting for him in the shop.

her lover waits in the back room.

1916, Maroc July 14, Afrique de Nord

RÉPUBLIQUE FRANÇAISE
INDEPENDANCE
AMERICAINE
1783
TRAITÉS DE
VERSAILLES
ET DE PARIS
2,80 POSTES 1983

The young girl watches the stall during the day. She waits for the old man and he gives her a coin. They do not talk. An old man and a young girl have nothing to talk about.

The young love creeps out from his hiding place. He is holding a goats head in front of his face and dances a silent, mocking dance in-front of the old man's unseeing eyes.

The old man gropes for the long hook for reaching hanging items. He grips it tightly and smashes it down on the boys elbow - he cries out and drops the goat head - its glass eye is forced out of the pocket and rolls out into the street. "Don't bring your boyfriend here" he tells the girl. The boy slinks out, nursing his elbow. He bends down and pockets the shiny eye ball. The girl follows him out. She is crying.

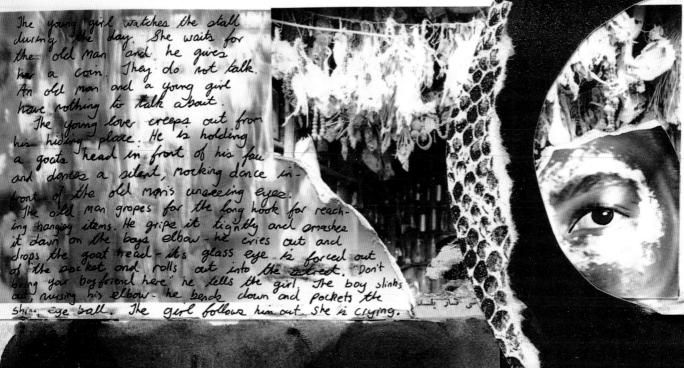

The Baby Owl is the blind man's only friend. He puts his hand on the cage and whispers "you have eyes enough for both of us my friend." The baby owl has been in the shop since the old man settled there - over twelve years - When customers ask "How can a bird be a chick for its whole life?" the wise, old man always replies "how can a man be blind for his whole life?"

"all is not as it looks"

The owl is kept in a cage with a curtain. The bark... been... end... bird to... easing.

X.

Y.

Deziree.

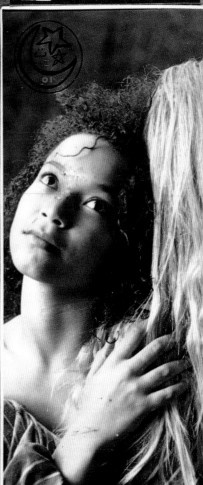

I had been following the blind man since he left the Mosque. I have a obsession with the blind be-cause my world is 100 percent visual. I allways follow a blind person if I have time. I enter his shop...

GEMS

THE GLOBAL ENVIRONMENT MONITORING SYSTEM
PROGRAMME ACTIVITY CENTRE

Your Reference:

Our Reference:

8 August 1989

To Whom It May Concern

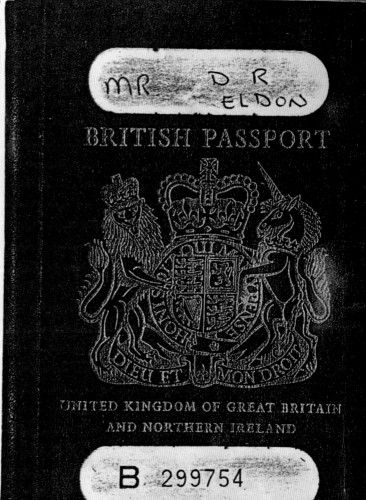

EMBASSY OF THE
UNITED STATES OF AMERICA

P
Lil

To Whom It May Concern:

Mr. Daniel Robert Eldon,
holder of regular passpo
American Embassy in Lilo
to Kenya via Tanzania.
border post in Mbeya and

MR D R ELDON

BRITISH PASSPORT

UNITED KINGDOM OF GREAT BRITAIN
AND NORTHERN IRELAND

B 299754

I approached Dr. Croze in London and suggested that we meet in the city to discuss what I called a "matter of some interest". Dr. Croze was free from academic responsibility because the silly bastard had just been booted out of school for climbing on the roof.

We agreed to meet at Pizza Hut and it was there that I proposed the idea of an expedition penetrating deep into the African bush. Dr. Croze was immediately receptive to the idea of another Pizza Americano but was hesitant to respond to my proposition. "Good Lord, Eldon, do you know what you're suggesting? Are you serious." he queried.

"My dear boy" I responded, "I have never been more serious in my entire life." Croze sensed the urgency in my tone of voice... the time was right. I withdrew the map of Africa from my tunic and slapped it down on the pizza in front of Dr. Croze. He slowly inserted the monicle into his eye and unfolded the enormous map onto the table and onto the table of the six skin-headed gentlemen adjacent to ourselves. "Oi, watch yourself bogey face" they quipped as they stabbed a fork into the head of Dr. Croze. Dr. Croze, being a serious academic and a man of the church, was unused to such strong language and after smashing up the young hooligans we sat back down... Croze's face grew pink with glee as his pale, watery, onion coloured eyes traced the route that my long, elegant, aristocratic fingers pointed to. In fact it was after looking at the waitress that we got back to the map.

The plan was to drive my recently purchased Land Rover from Nairobi to as far south as humanly possible in a clapped out old Land Rover that was, in fact the same Land Rover that Napoleon used in the Battle of Midway Island in 1066.

We shook hands and Croze earnestly pledged that no matter what happened, I would pick up the bill for the pizzas.

We then proceeded to the bank where Dr. Croze grappled with the automatic cash machine. You must understand that Dr. Croze is very much an old world gentleman and unused to such modern affairs.

All we had to do now was to convince Lengai's dad to shell out the cash that would make the epic voya Possible

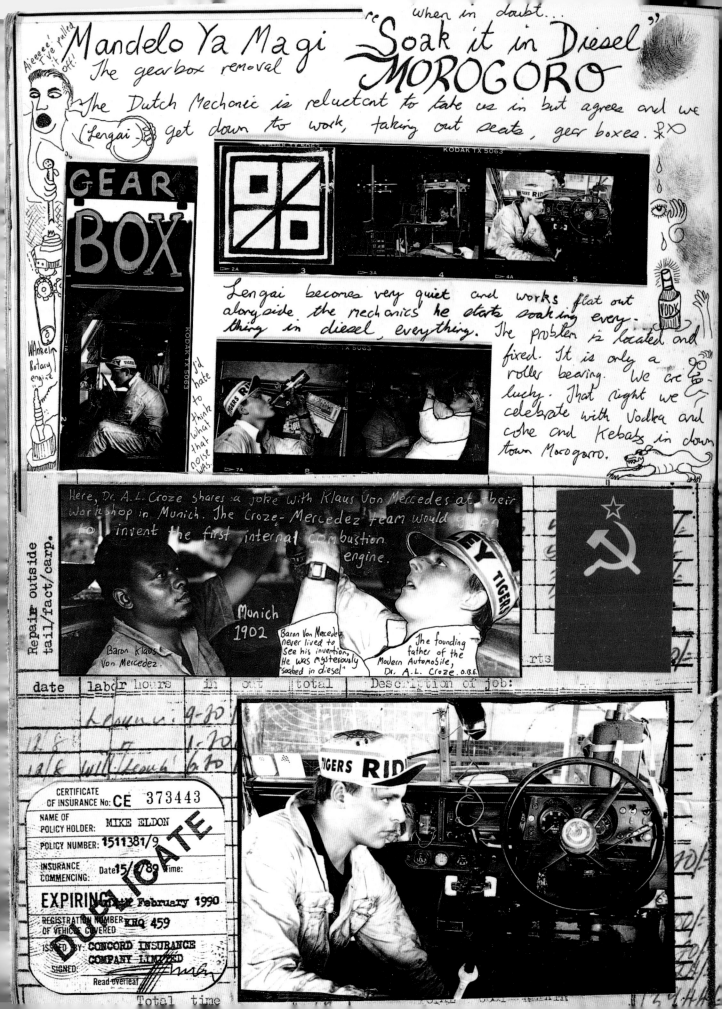

Aieeeee! I've pulled it off!

Mandelo Ya Magi
The gearbox removal

when in doubt...
re "Soak it in Diesel"
MOROGORO

The Dutch Mechanic is reluctant to take us in but agrees and we (Lengai) get down to work, taking out seats, gear boxes. ❋❀

GEAR BOX

WAnkeln Rotary engine.

I'd hate to think what that noise was.

Lengai becomes very quiet and works flat out alongside the mechanics. He starts soaking everything in diesel, everything. The problem is located and fixed. It is only a roller bearing. We are lucky. That night we celebrate with Vodka and coke and Kebabs in down town Morogoro.

Repair outside tail/fact/carp.

Here, Dr. A.L. Croze shares a joke with Klaus Von Mercedes at their workshop in Munich. The Croze- Mercedez team would soon invent the first internal combustion engine.

Munich 1902

Baron Von Mercedez never lived to see his invention. He was mysteriously "soaked in diesel"

Baron Klaus Von Mercedez.

The founding father of the Modern Automobile, Dr. A.L. Croze. O.B.E.

date	labor hours	in	out	total	Description of job:

Lengai 9-30

1-30

late will through 6-30

Total time

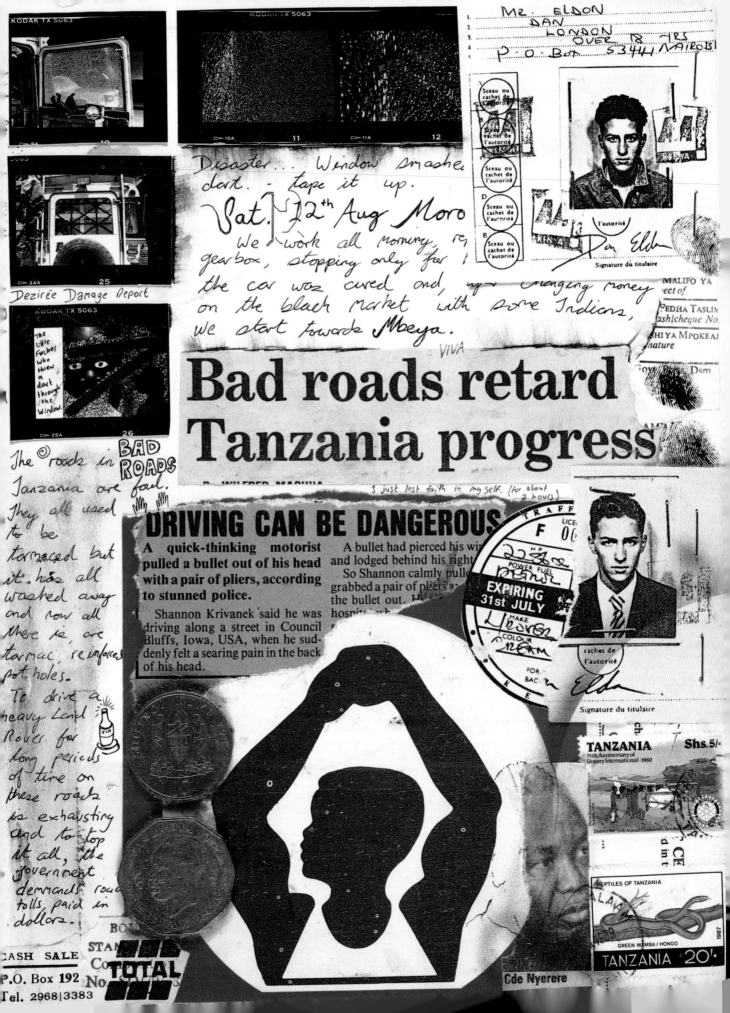

KODAK TX 5063

KODAK TX 5063

Deziree Damage Report

KODAK TX 5063

the little Fucker who threw a dart through the window

The roads in **BAD ROADS** Tanzania are foul. They all used to be tarmaced but it has all washed away and now all there is, are tarmac reinforced potholes.

To drive a heavy Land Rover for long periods of time on these roads is exhausting and to top it all, the government demands road tolls, paid in dollars.

Disaster... Window smashed dark. - tape it up.
Sat. 12th Aug Moro
We work all morning, re gearbox, stopping only for the car was cured and, changing money on the black market with some Indians, we start towards Mbeya.

VIVA

MR. ELDON
DAN
LONDON
OVER 18 YRS
P.O. Box 53441 NAIROBI

l'autorité
Dan Eldon
Signature du titulaire

MALIPO YA

FEDHA TASLIM
ash/cheque No.

HIYA MPOKEAJ

Bad roads retard Tanzania progress

By WILFRED MACHUA

I just lost faith in myself (for about 2 hours)

DRIVING CAN BE DANGEROUS

A quick-thinking motorist pulled a bullet out of his head with a pair of pliers, according to stunned police.

Shannon Krivanek said he was driving along a street in Council Bluffs, Iowa, USA, when he suddenly felt a searing pain in the back of his head.

A bullet had pierced his wi and lodged behind his right

So Shannon calmly pulle grabbed a pair of pliers the bullet out.

hospit wh

TRAFFIC LICE
F 06
POWER FUEL
EXPIRING
31st JULY
MAKE
COLOUR
FOR BAC
cachet de l'autorité
Eldon
Signature du titulaire

TANZANIA
75th Anniversary of
Rotary International-1980
Shs.5/-

REPTILES OF TANZANIA
GREEN MAMBA / HONGO
TANZANIA 20/-

CASH SALE
P.O. Box 192
Tel. 2968|3383

TOTAL

Cde Nyerere

Under Article 29 a candidate shall be nominated for election as an Officer in the same manner as a Member of the Club is nominated for election to the Committee provided that any such candidate is, or shall have been, a serving member of the Committee or a former Officer.

immediately woke Lengai from his dreams of Angle Face and presented him
with the snapped gear. He
since I was in rea...
...ally stray from the...
several hours, so I ...
patrick and dove ont...

In the next few ...
the cover of the gea...
into position with a ...
this and by the e...
white hot and inde...
moment for patrick ...
and slept there at ...
scalded fingers. It ...

Deziree,
North Africa
1944, while on
use as Rommel's
staff car.

Sunday 13th Aug Lingu, NIGHT of the LIVING GEARBO

After three hour sleep. Lengai decided that it was time to
wake up. We ... Deziree into second gear. By this time
we had ...
the engine a...
This involve ...
or some insi...
in the engin...
We drove ...
some welders ...
gear. This ...
expect. It ...
the drivers ...
ventilation ...
glass window...
We drov...
marsh, untill ...
series of va... ... made of pink, crumbly stone.

Arusha - Mombo The great Trek
All Night

We went off the road and bush-wacked down to the
edge of a cliff. The car was parked at a very
vakish angle. We proceeded to set up the most comprehensive
campsite. We set up our tables, chairs, tarp, lights, fire and patrick
whipped up a rather tasty spagetti which we
ate in between many sips of rum and coke
which eventualy purged our camp of sobriety.
It was time to explore the cliffs and caverns
below.

Wednesday
16th Aug
Livingstonia
— Northern —
— Malawi

We awake to
see a beautiful
panorama below us.
The lake glows in
the early morning
sun.

Sengai discovers
that our cold box
(that we had left
outside due to
its poisonous odour)
had been robbed of
cheese and bacon and
the suspects were narrowed down to either the askari or the
dogs. We decided not to go and burn down his village
or anything, but instead to let the matter drop.

After breakfast, we (ourselves and the Canadian blokes) lashed
the bamboo that we had acquired onto the metal bumper
and cross sections of Deziree's body. This was to reinforce
the car in case collision or rolling took place. The bamboo
was not,
I repeat
not, applied
to enhance
or glamouri__
the appeara__
of the
automobile
in any
way shape
or for
form.

Sengai de__
the stereo.
We all ra__
the car.
Things are
beginning t__
fit in ni__
now and al__
everything h__
a perfect
except for Leng__
parachute sized
bag.

We ate rice
pudding with
the canadians.
then we began
the descent
of the narrow
hill. Things
went smoothly
and we were soon at the bottom. We had almost no fuel now but
somehow we managed to limp to a petrol station 20km away.
There the stingy Canadians wanted us to reimburse them the three
Kwacha for the rice pudding. Livingstonia — Central Africa

SYNOD OF

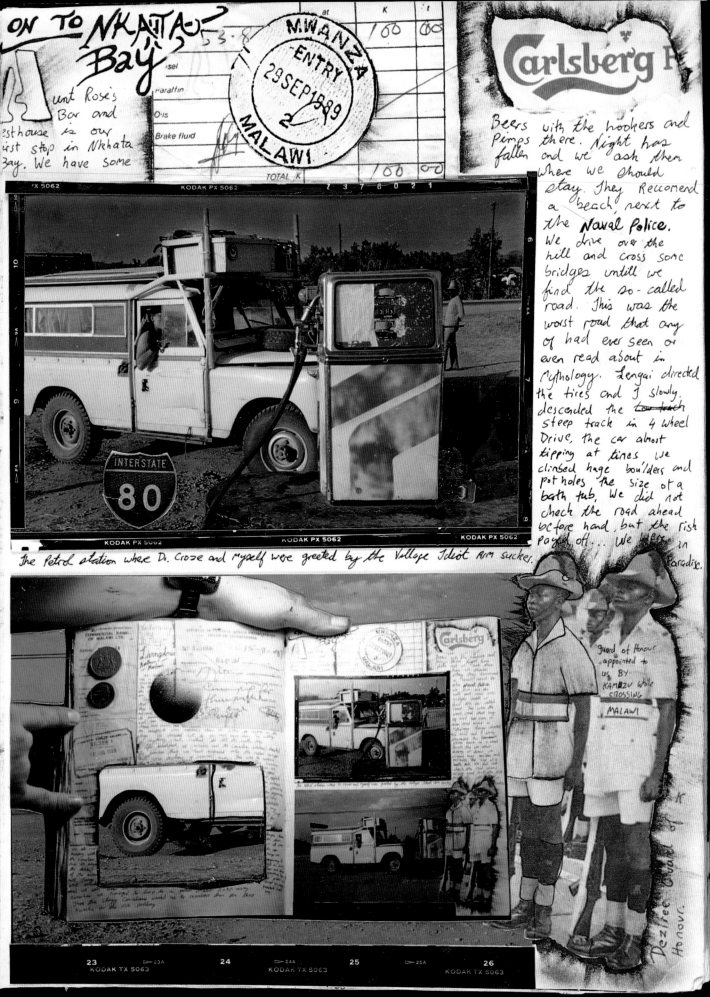

ON TO NKATA Bay

Aunt Rose's Bar and Guesthouse is our first stop in Nkhata Bay. We have some

MWANZA ENTRY 29 SEP 1989 2 MALAWI

Carlsberg

Beers with the hookers and Pimps there. Night has fallen and we ash them where we should stay. They Reccomend a beach, next to the **Naval Police**. We drive over the hill and cross some bridges untill we find the so-called road. This was the worst road that any of had ever seen or even read about in Mythology. Lengai directed the tires and I slowly descended the ~~too track~~ steep track in 4 wheel Drive, the car almost tipping at times we climbed huge boulders and potholes the size of a bath tub. We did not check the road ahead before hand, but the risk payed off... We ~~were~~ in Paradise.

INTERSTATE 80

The Petrol station where D. Cross and myself were greeted by the Village Idiot Arm sucker.

Guard of Honour appointed to us BY KAMUZU While CROSSING MALAWI

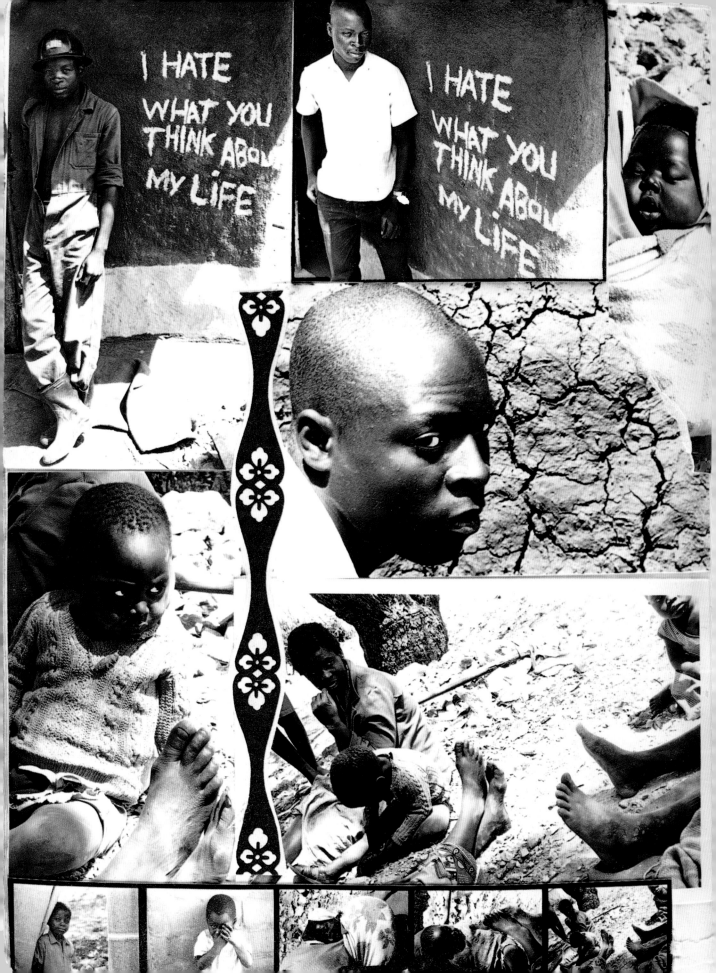

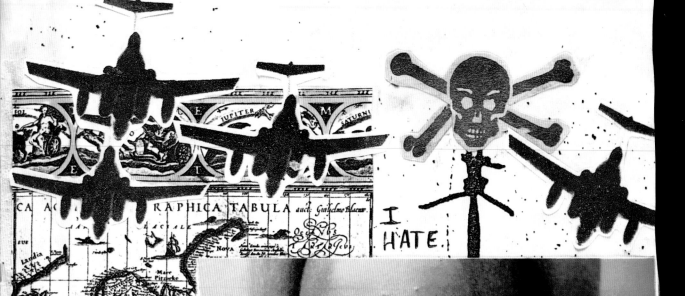

RAPHICA TABULA *auct. Giuljelmo Blaeu.*

I HATE

I HATE.

Versexer die publiek se veiligheid.

LOOP | DOUBLE LOOP

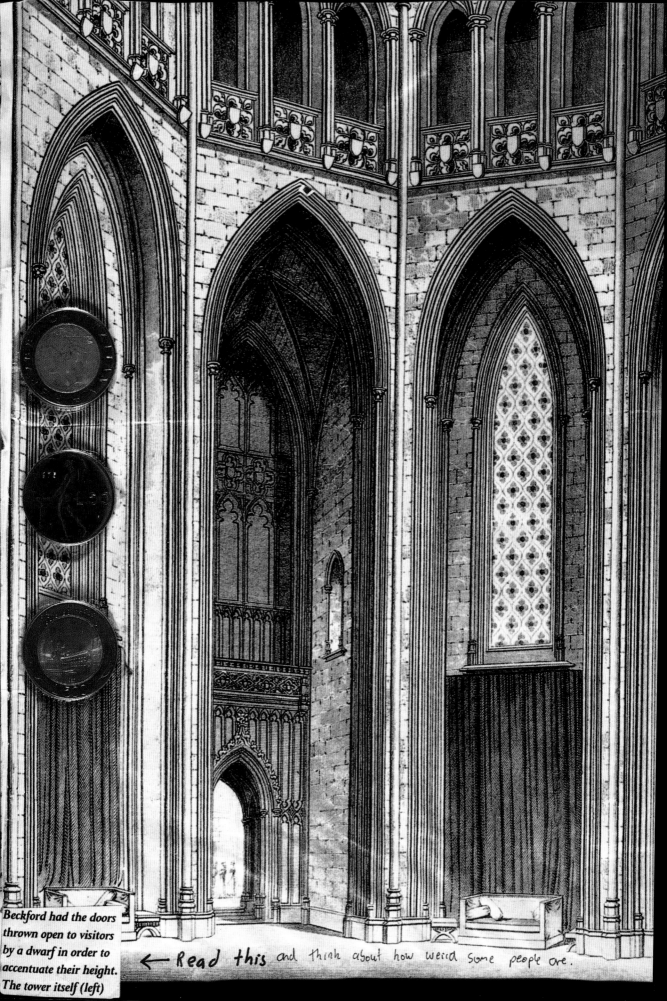

Beckford had the doors thrown open to visitors by a dwarf in order to accentuate their height. The tower itself (left)

← Read this and think about how weird some people are.

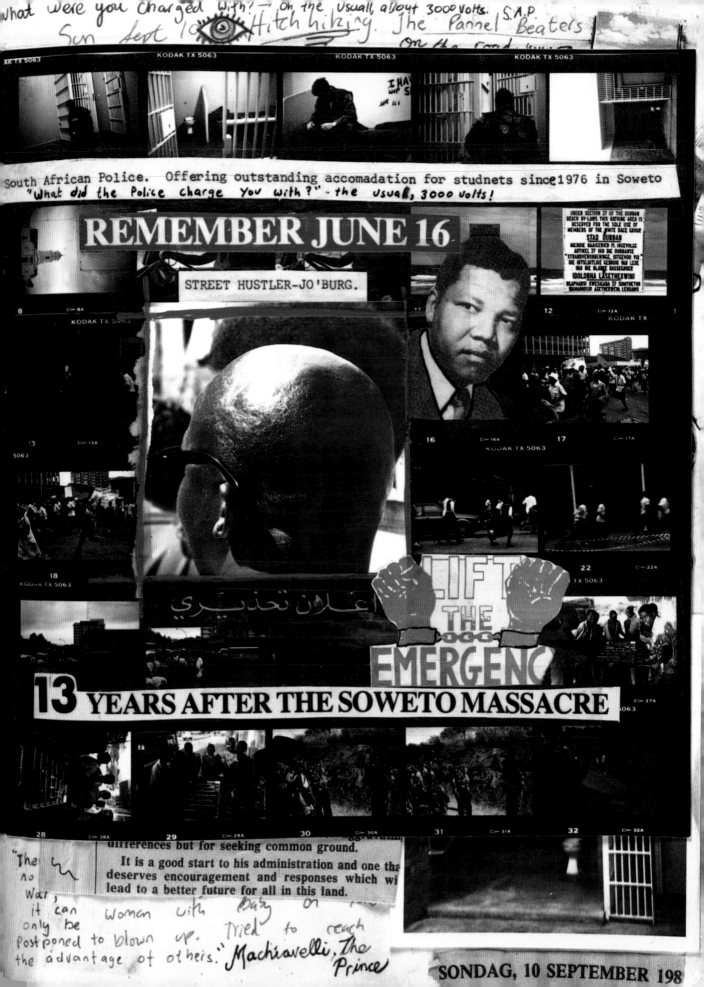

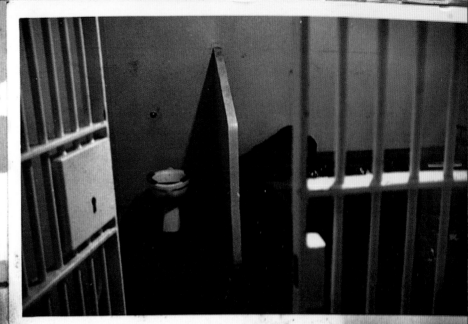

South African
— Police —
offering accomodation
to students since
— 1976 —
in
SOWETO

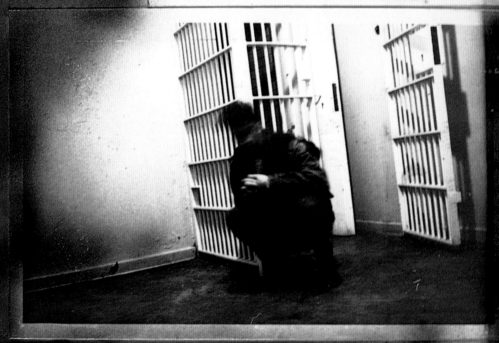

CELL 5

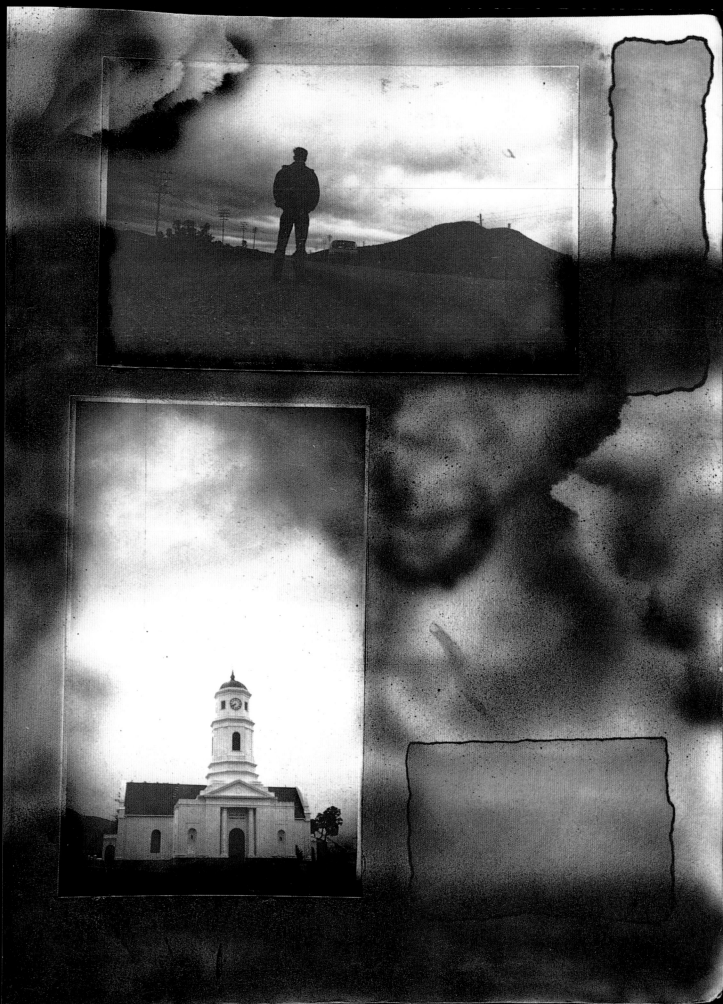

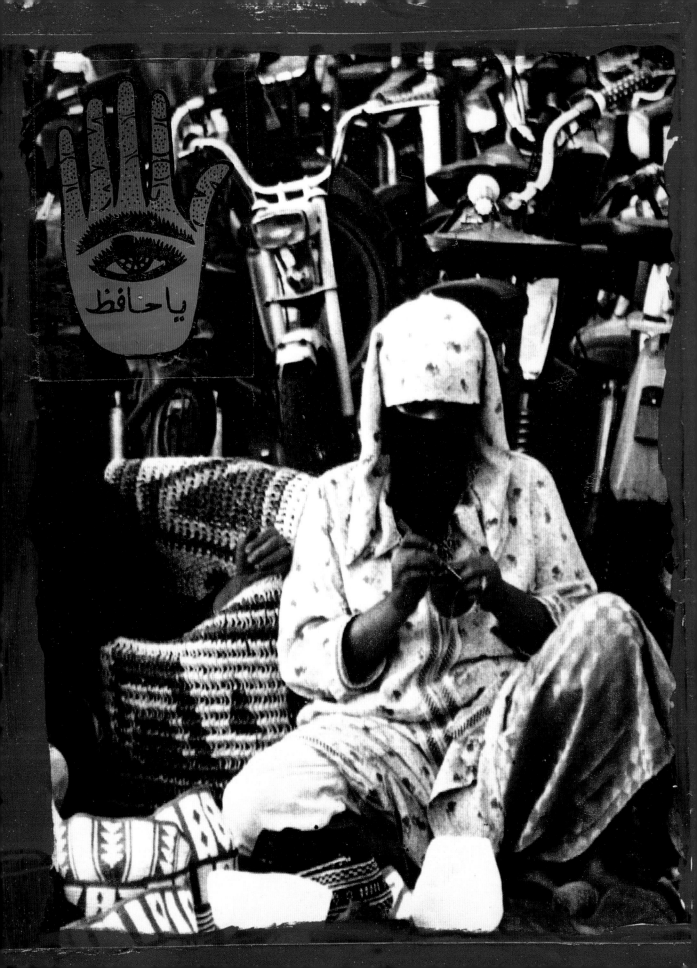

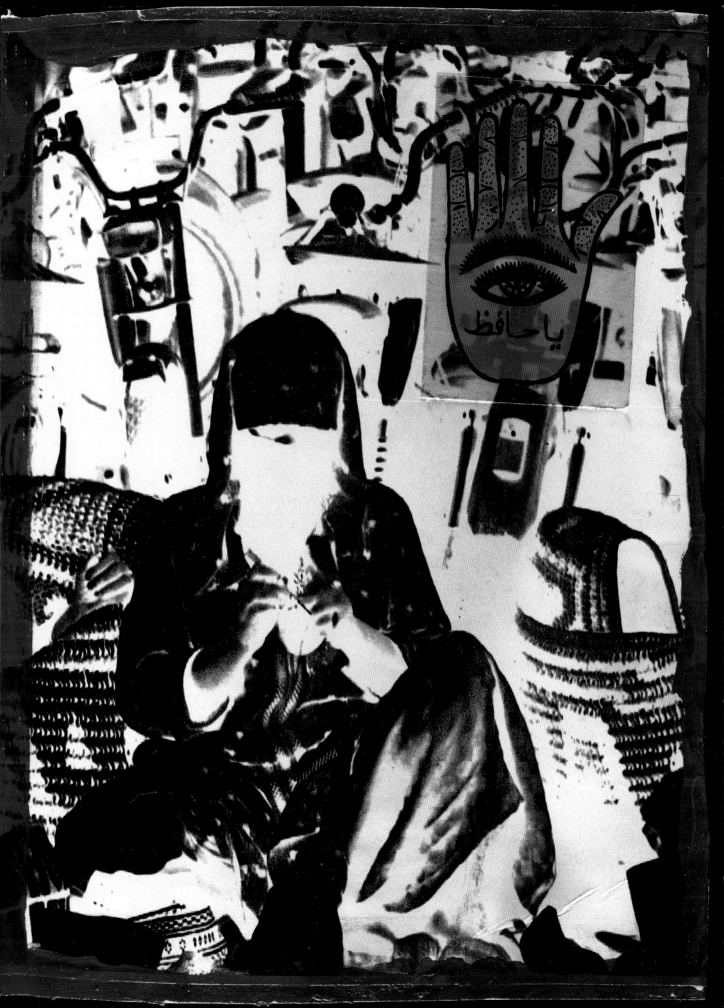

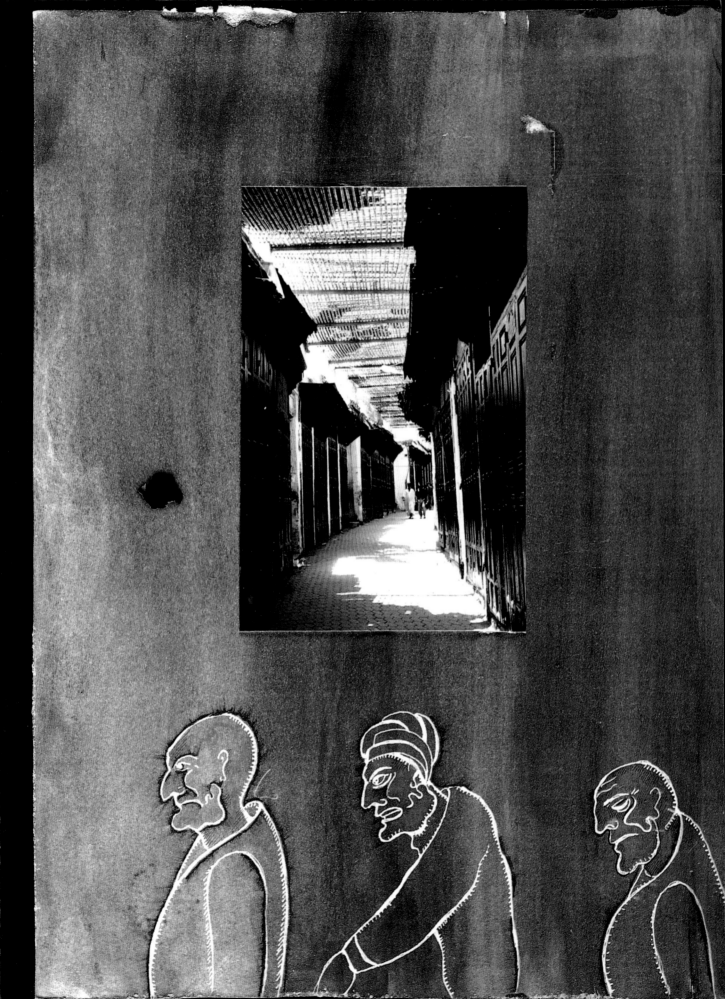

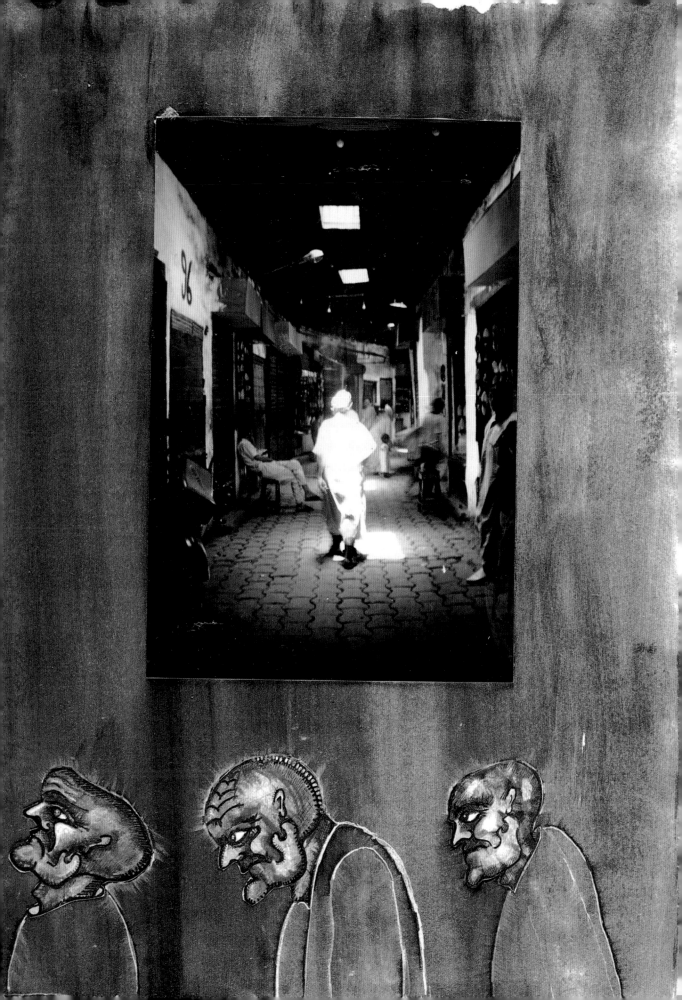

a. The grand "Bazar". Roasting of brochettes.

b. Casablanca Berber market

Note facial
tattoo;
I. forehead.
II. under chin.

21

LA MANO

41

LA ROSA

I. amber beads above.

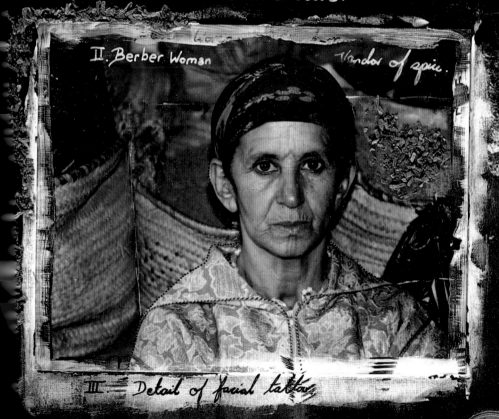

II. Berber Woman Vendor of spice.

III. Detail of facial tattoo.

POTIONS OF LUST

PERVERSION

D'UN

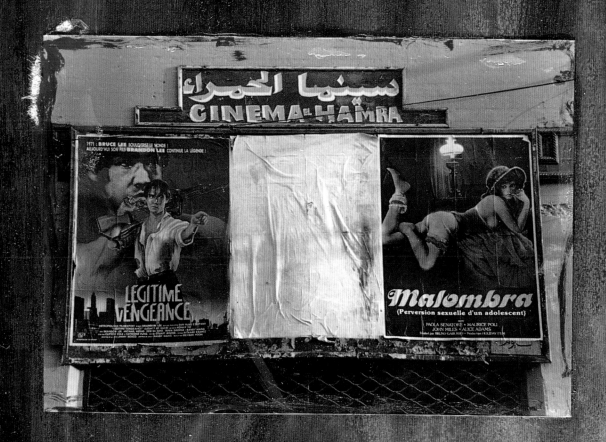

SEXUELLE

ADOLESCENT

EL BORRACHO

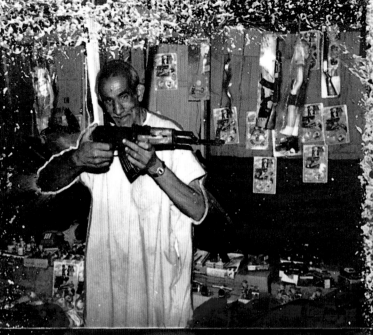

EL SOLDADO

Stark, Raving Mad and armed to the teeth

LA MUERTE

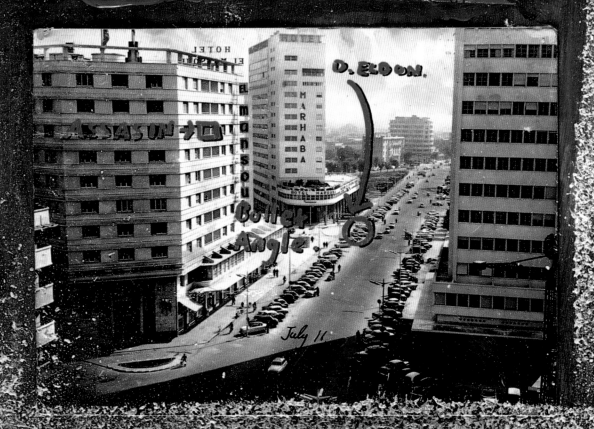

four hours and twelve positions in the...

"Hôtel Amour" in the... an immaculate conception and... The now famous... Perversion Sexuelle d'une adolescente.

This is not a preposition. Just put your feet-up, kick back and watch the sincerity burn away.

Long Live the ideals of Liberté Égalité and Safari.

Hôtel

Amour

yes, we have wings... but some don't know why...

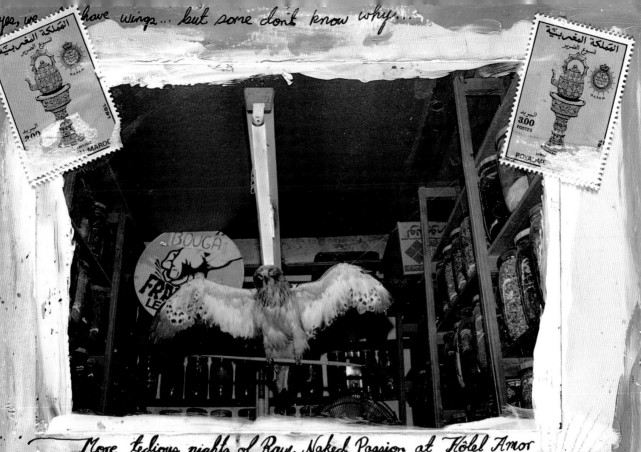

More tedious nights of Raw, Naked Passion at Hôtel Amor

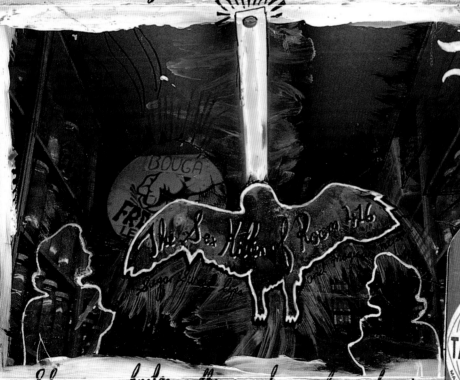

She was a hunter-gatherer and a victim and carrier.
The Sex Kitten of Room 416

Hôtel Amor

Devant la plus belle Plage

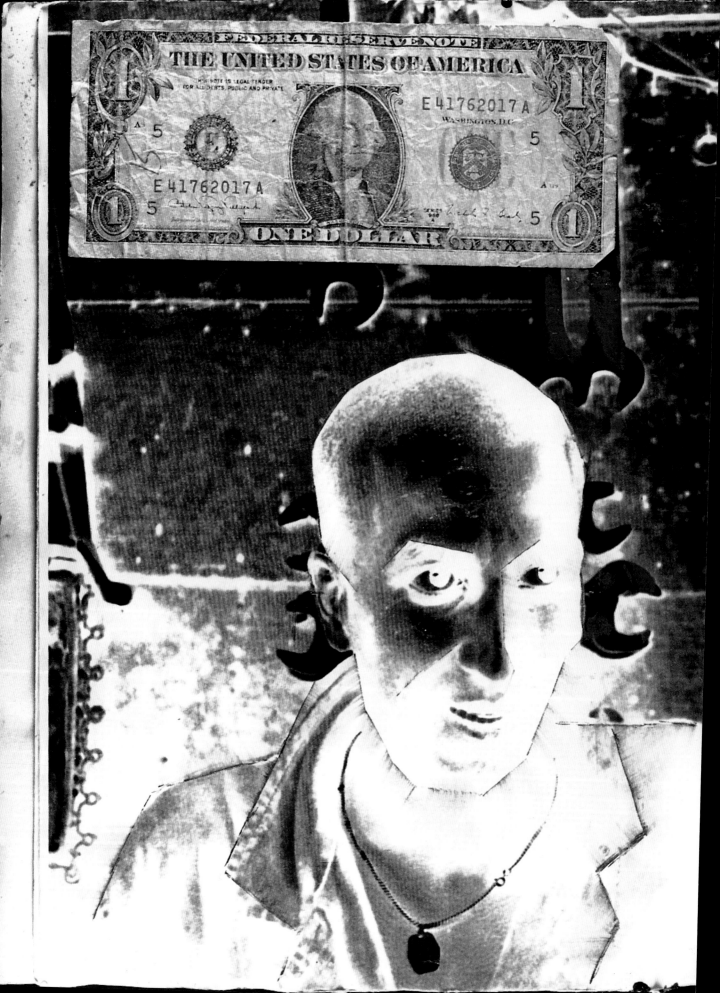

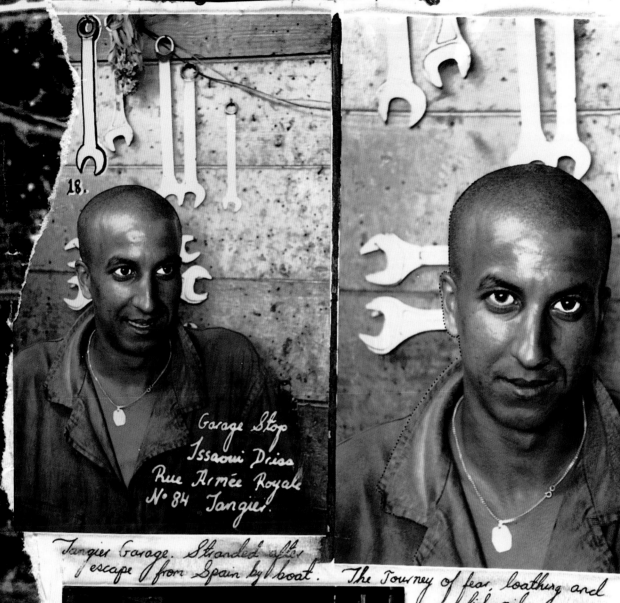

18.

Garage Stop
Issaoui Driss
Rue Armée Royale
Nº 84 Tangier.

Tangier Garage. Stranded after
escape from Spain by boat.

The Journey of fear, loathing and
fish oil.

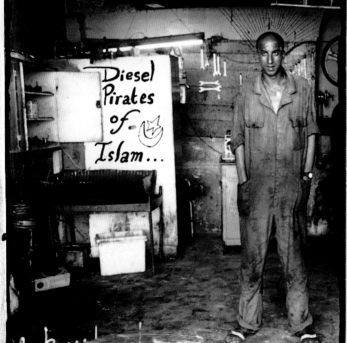

Diesel
Pirates
of
Islam...

The Northern gate of Africa
Tangier 1991

Fathers of black magic # 2

Fathers of black magic #2

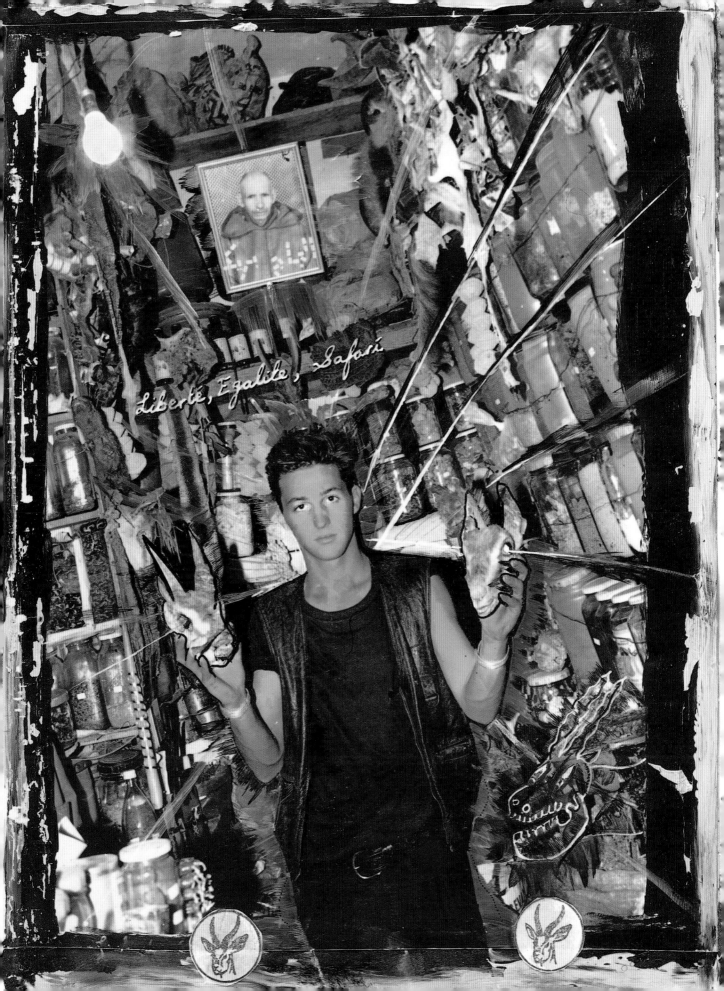

Liberté, Egalité, Safari

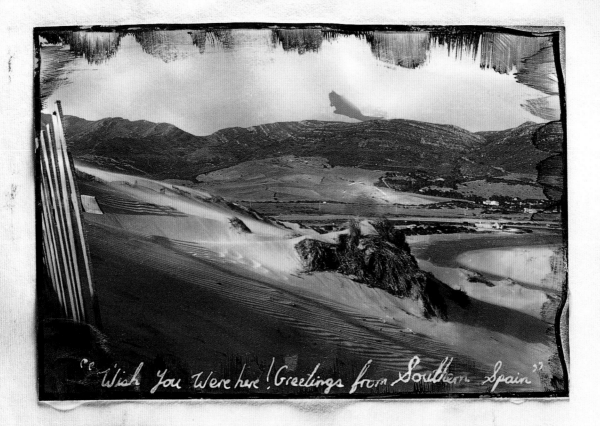

"Wish You Were here! Greetings from Southern Spain"

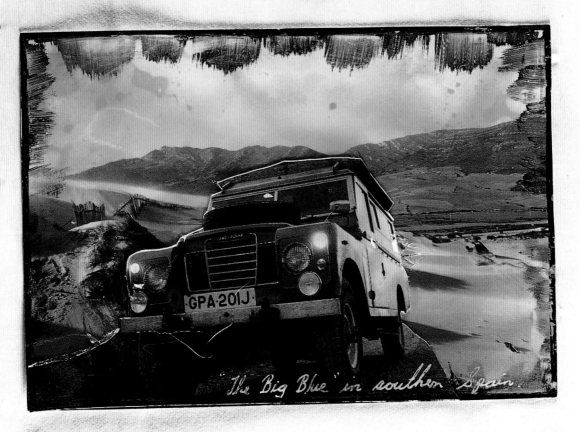

"The Big Blue" in southern Spain.

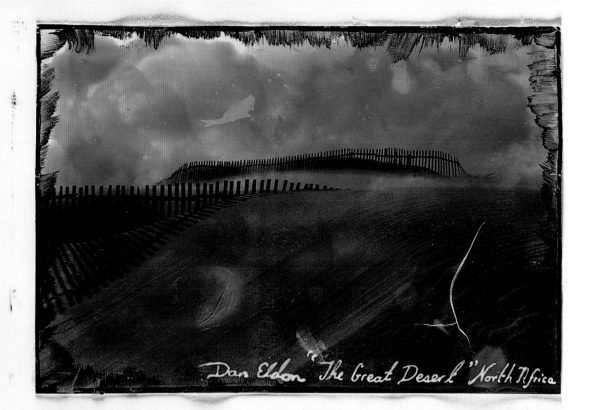

Dan Eldon "The Great Desert" North Africa

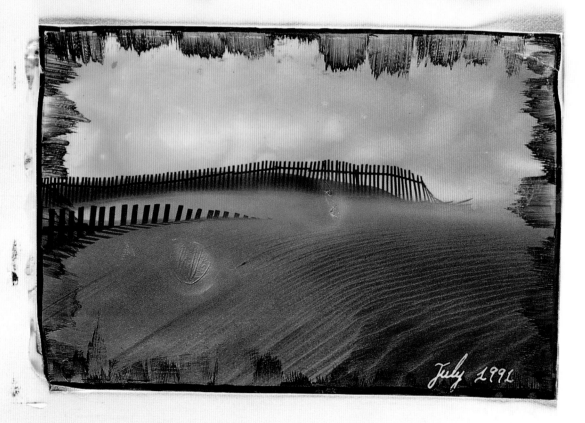

July 1991

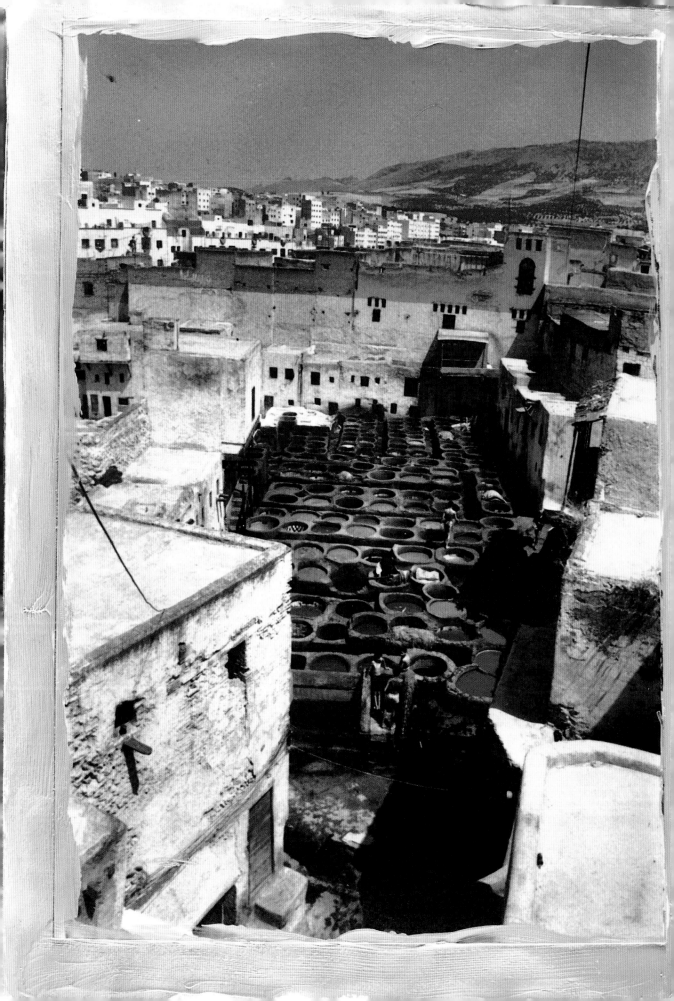

ELDON OFFICE PRODUCTS
Division of Eldon Industries
Carson, California 90749

NEW YORK

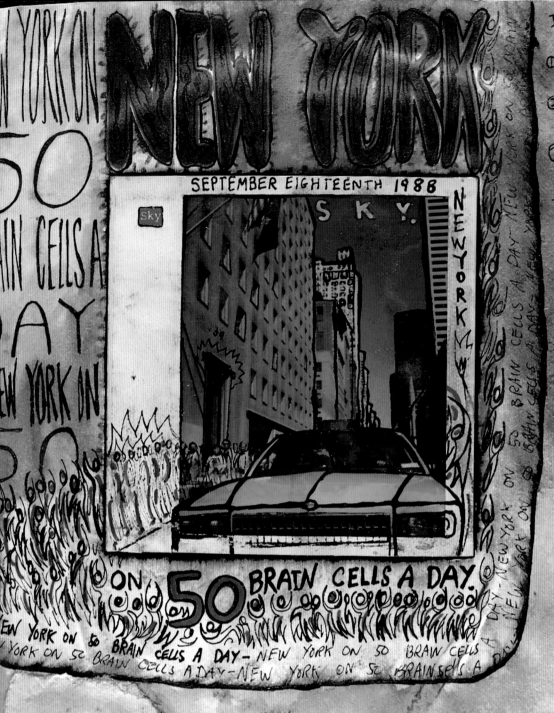

SEPTEMBER EIGHTEENTH 1988

Sky

SKY.

NEW YORK

ON 50 BRAIN CELLS A DAY.

NEW YORK ON 50 BRAIN CELLS A DAY - NEW YORK ON 50 BRAIN CELLS A DAY - NEW YORK ON 50 BRAIN CELLS A DAY - NEW YORK ON 50 BRAINSELLS A DAY - NEW YORK ON 50 BRAIN CELLS A DAY

I have 3 things
here –
① My house,
(400$ per month)
② My book
(100 pages)
③ My Head.
(2 eyes)

I share my
house with a
room...
I'll...
my b... with
y.......
my head is

MY
OWN

New York on
50
Brain Cells a
DAY.

a guidebook.

New York on 50 Brain Cells a Day...

A Guidebook.

BLOW YOURSELF UP

Great gift idea!

BLOW YOURSELF UP

BLOW YOURSELF UP

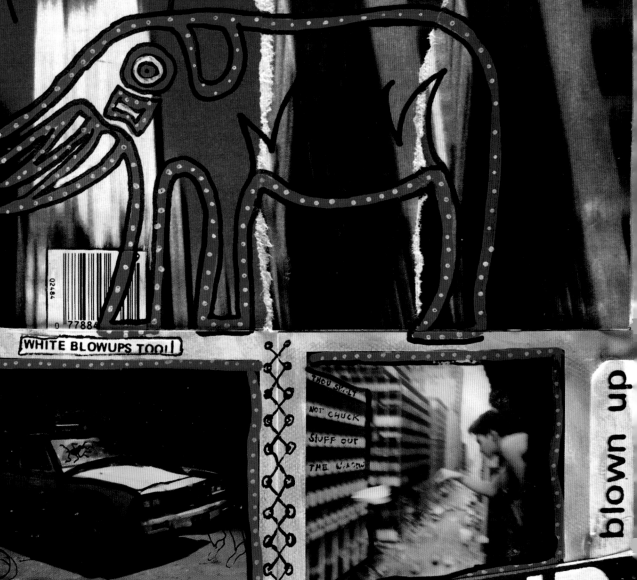

WHITE BLOWUPS TOO!!

THOU SHALT
NOT CHUCK
STUFF OUT
THE WINDOW

blown up

BLOW YOURSELF UP

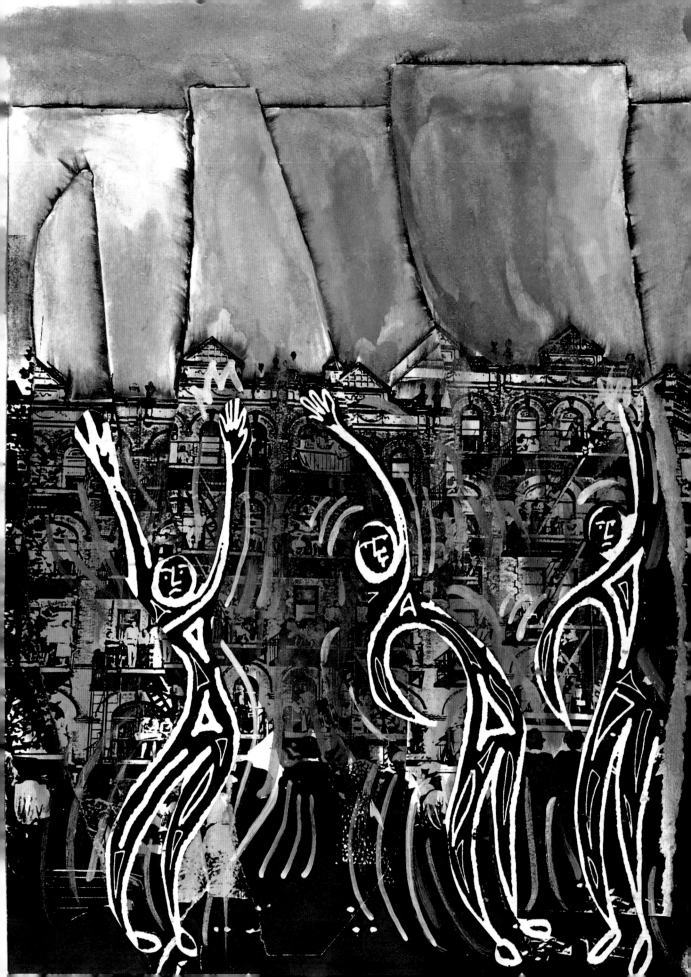

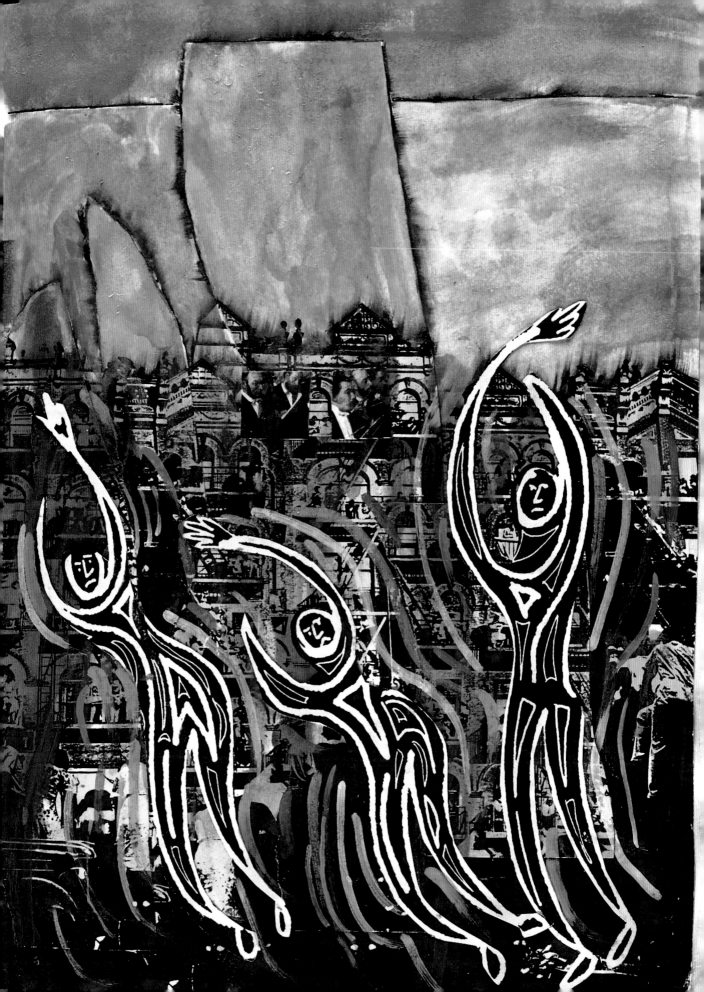

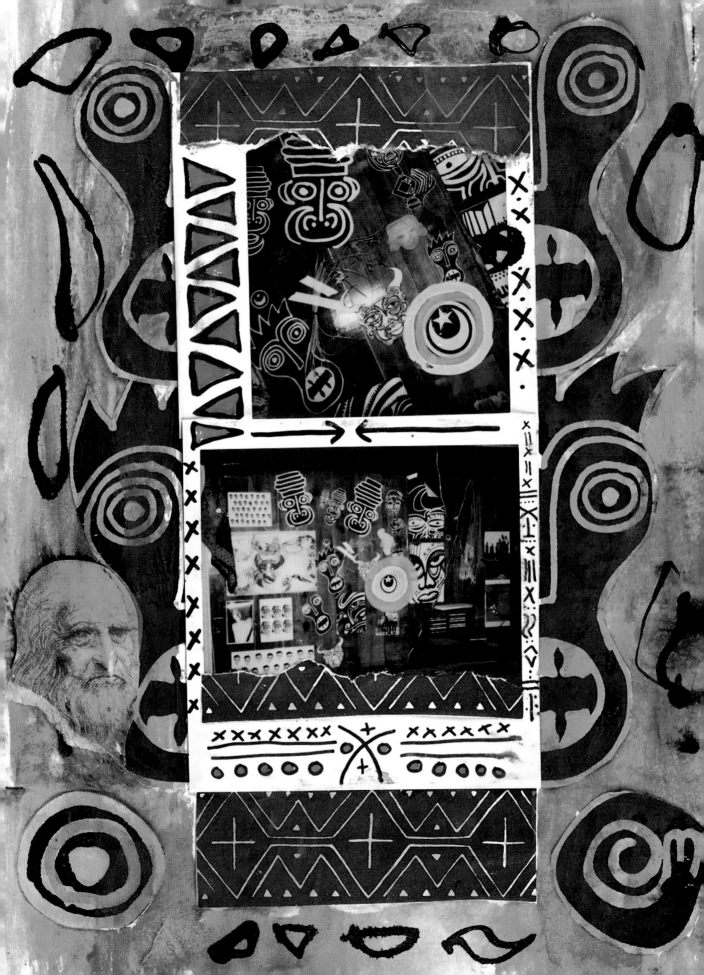

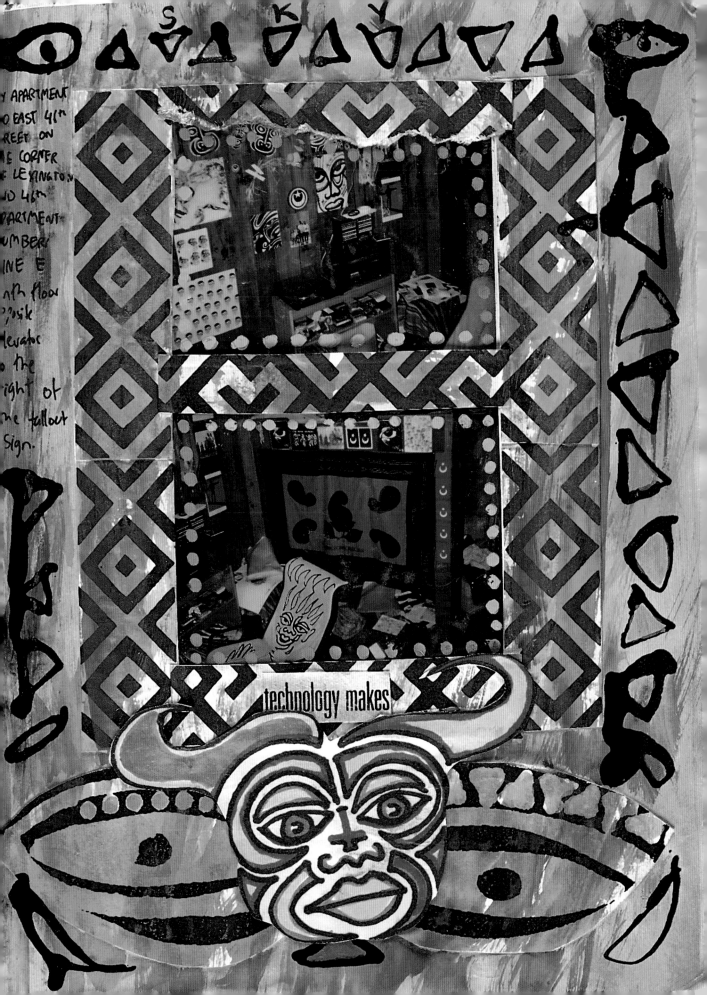

technology makes

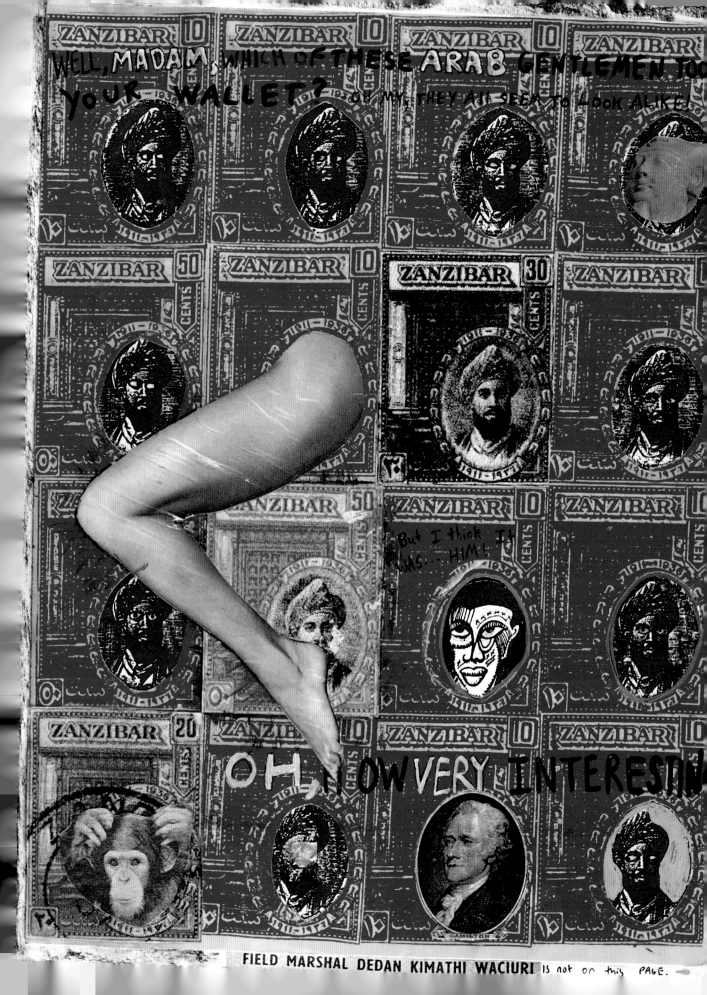

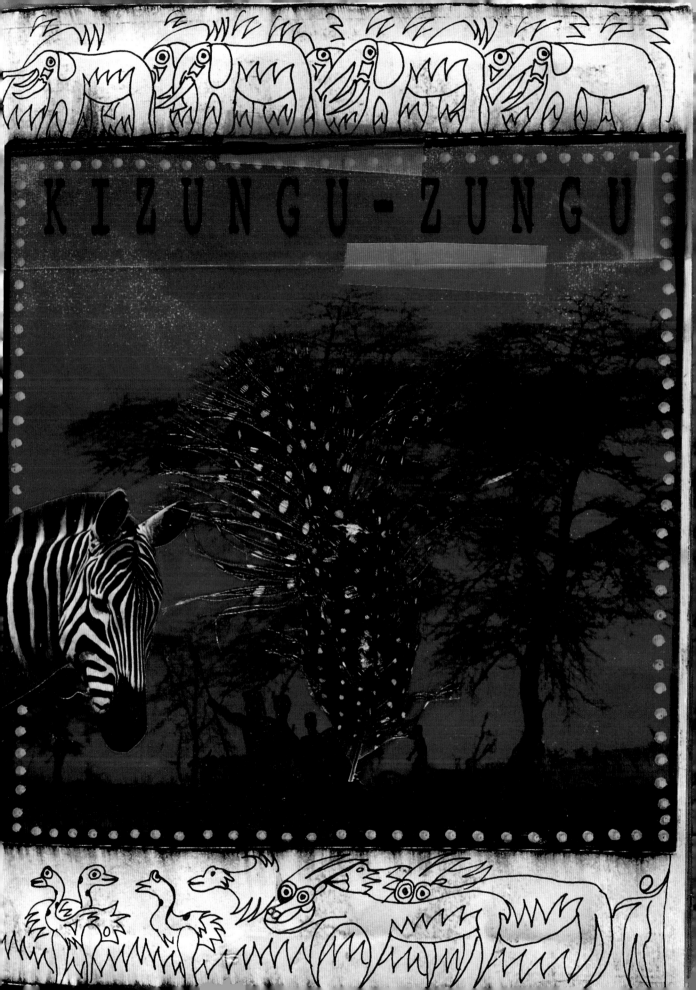

KIZUNGU - ZUNGU

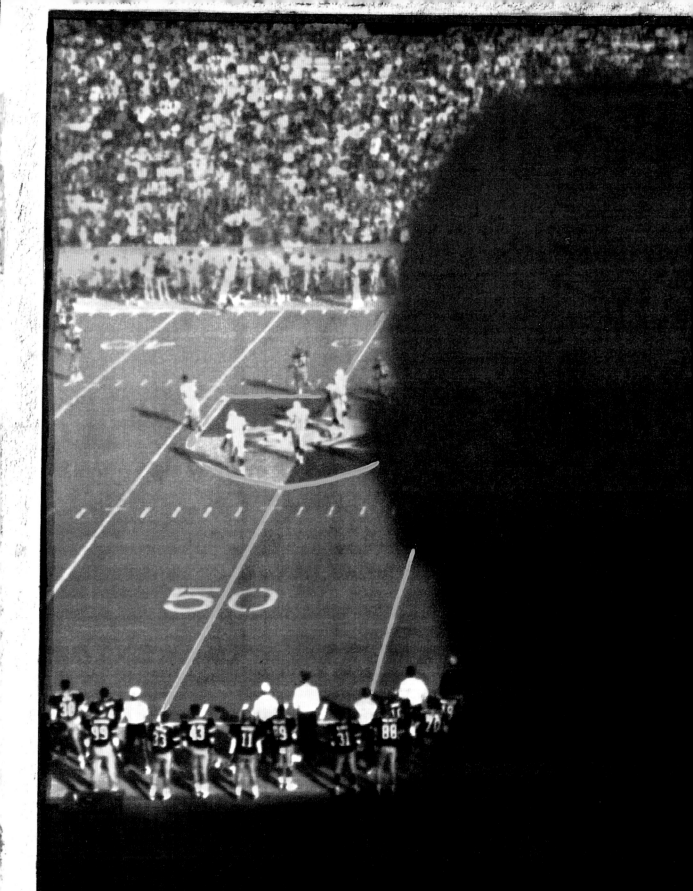

West Point. Army cadet football

game-V.I.P. Stand. Officer's Head.

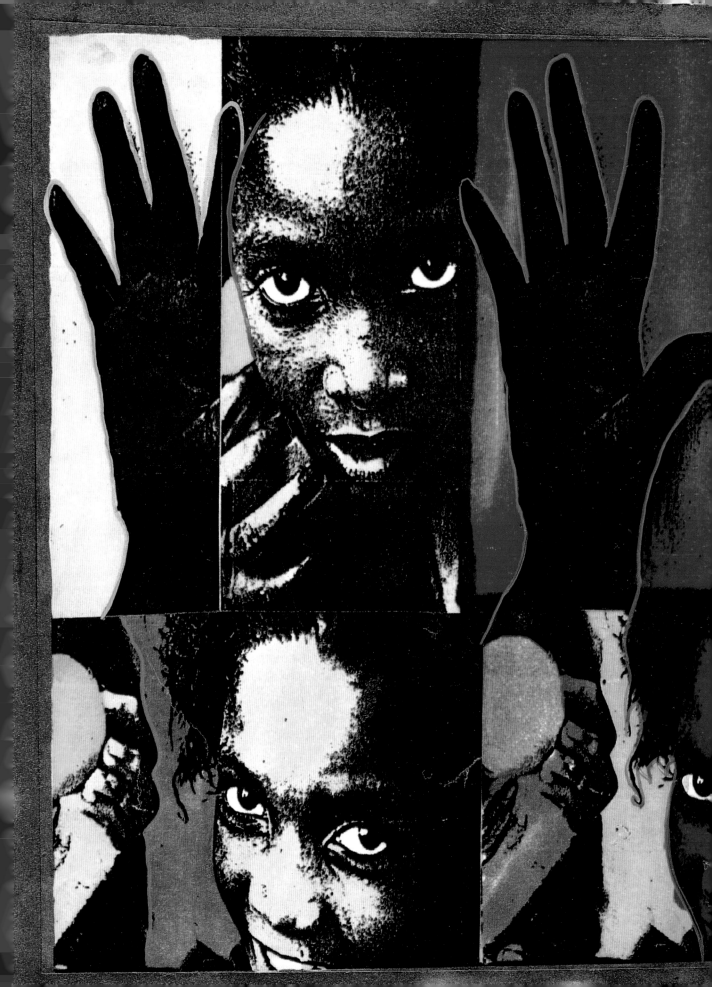

MATINDONI ISLAND, LAMU - WEDDING PREP.
DECORATING HANDS WITH HENNA

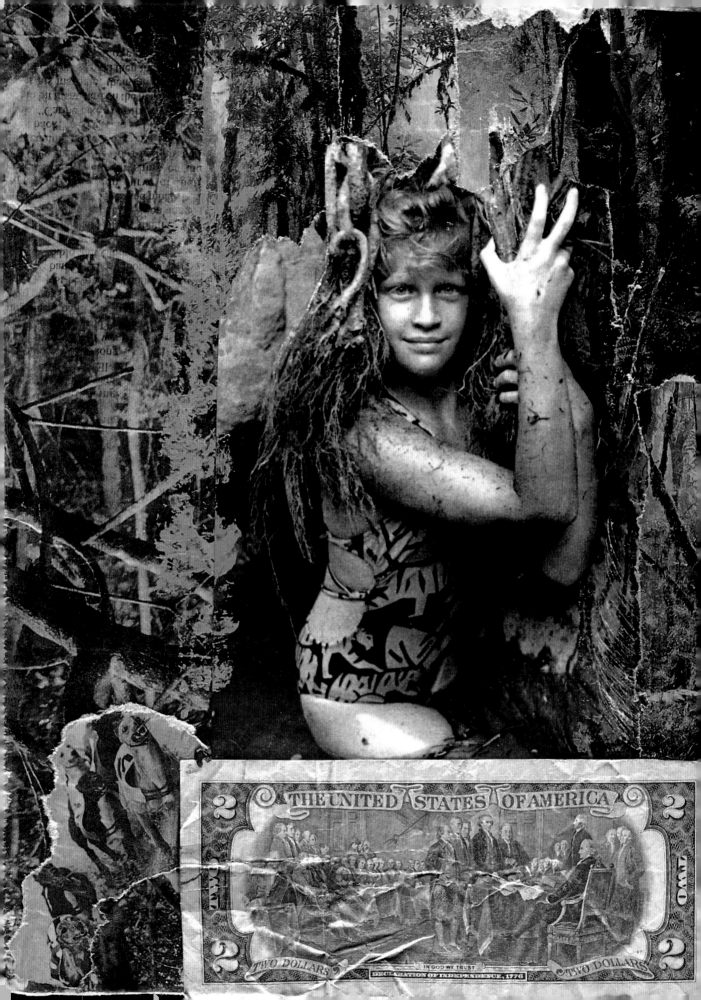

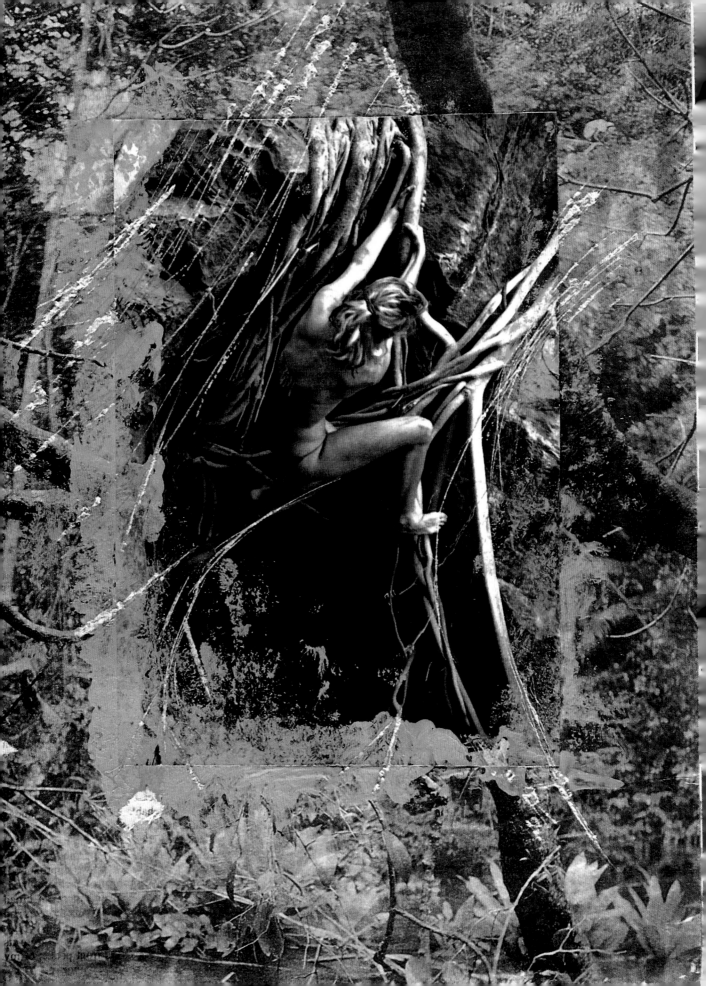

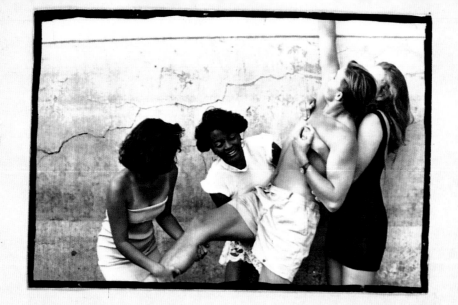

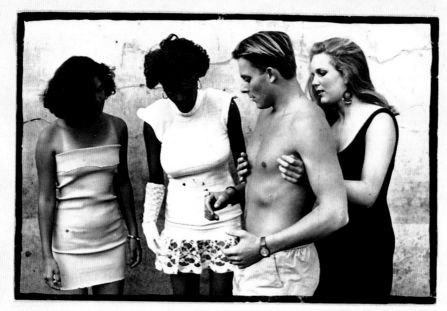

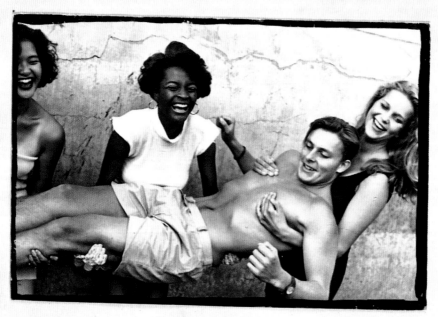

DEZIREE SAFARIS

TEAM Deziree "free at last" Voyages - The Search for clean water in a swamp

"Energy, sincerity, clarity of vision, creativity"

Mission Statement for... Safari as a Way of Life.

" To explore the unknown and the familiar, distant and near,
~ look for solutions - not problems ~
and to record in detail with they eyes of a child, any
NOTE: There is little difference between being lost and exploring.
beauty, (of the flesh or otherwise) horror, irony, traces
of utopia or Hell. Select your team with care,
but when in doubt, take on new crew and give them
a chance. But avoid at all costs fluctuations of sincerity
with your best people. "

It is therapeutic to apply a well toned, beautiful naked body onto one's own flesh at least twice a day in tropical or non tropical climes.

The most important part of vehicle maintenance is clean windows so if you are broken down you will enjoy the beauty of the view. Also, ensure that electronic devices to play music are properly serviced. The more music you like the happier you will be.

create. Avoid eating nasty food when the taste can easily be improved by sauces. It is foolish and hazardous not to dance in Africa. some Sauces and clean water.

New York London Nairobi Rome Yokohama Paris

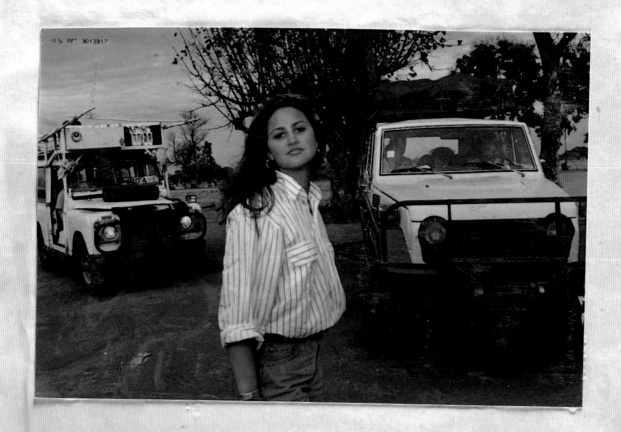

US PAT 3013917

PRINTED IN U.S.A

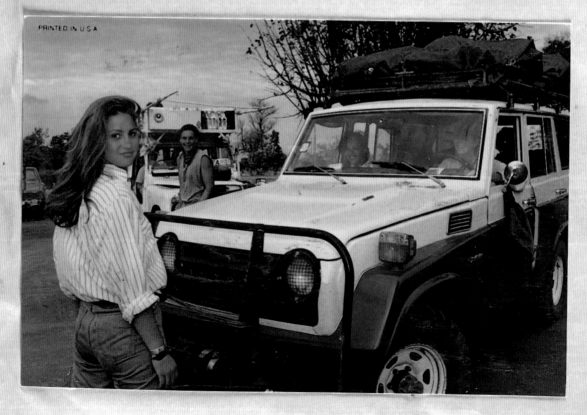

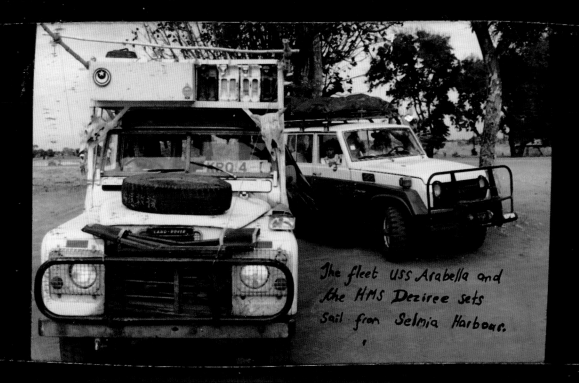

The fleet USS Arabella and the HMS Deziree sets sail from Selmia Harbour.

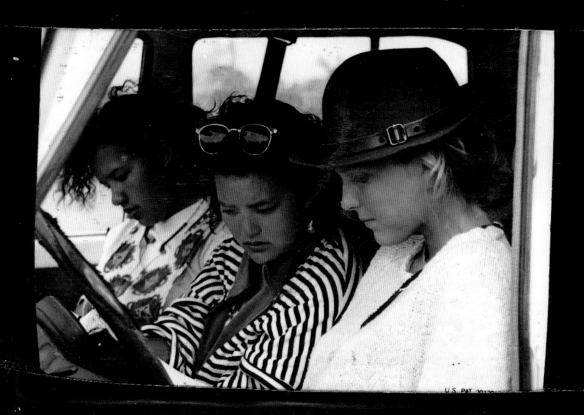

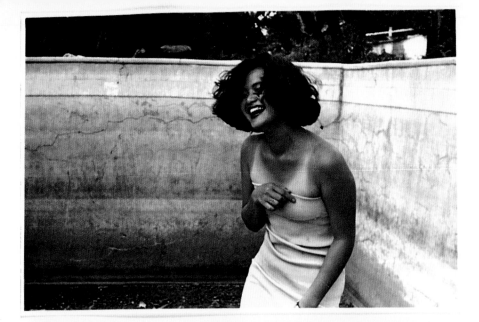

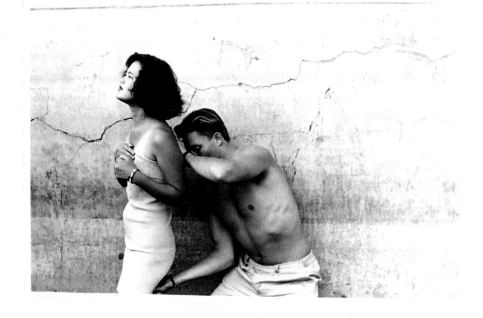

DEZIREE SEX SAFARIS

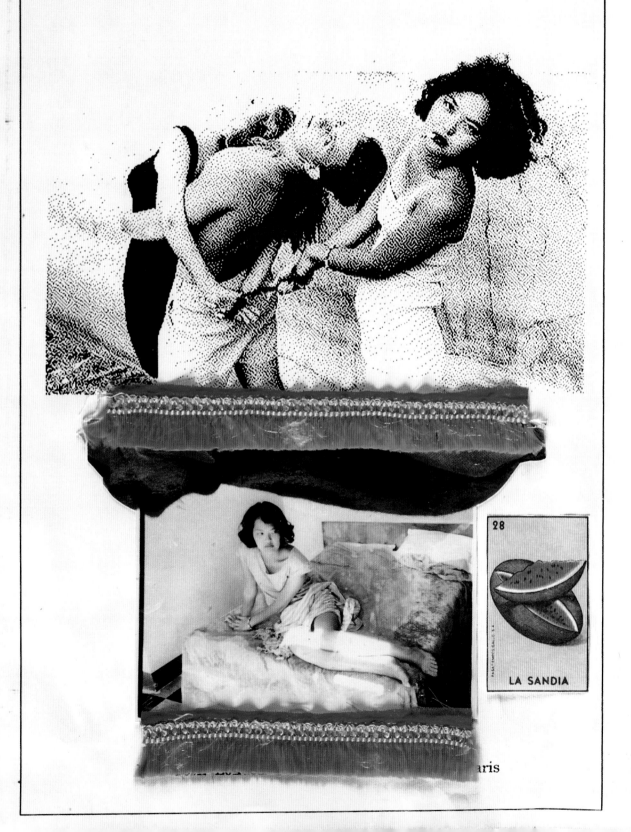

28

LA SANDIA

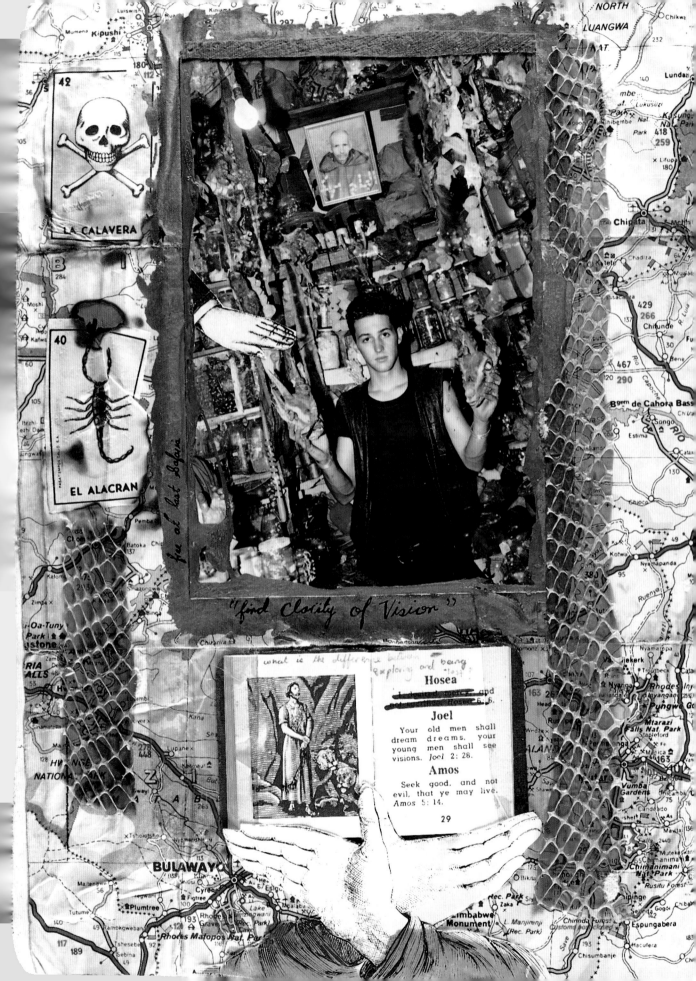

LA CALAVERA

EL ALACRAN

42

40

"find Clarity of Vision"

Hosea

Joel

Your old men shall
dream dreams, your
young men shall see
visions. *Joel 2: 28.*

Amos

Seek good, and not
evil, that ye may live.
Amos 5: 14.

29

DEZIREE SAFARIS

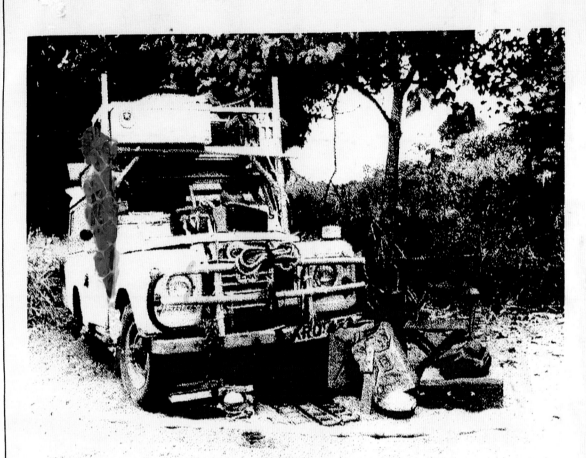

what is the difference between exploring and being lost

"The journey is the Destination..."

"free at last" Safari Company...

TEAM DEZIREE
★ BOX 53441 ★
NAIROBI, KENYA

New York London Nairobi Rome Yokohama Paris

The very
sea did
rot - o christ

we stuck
nor breath
nor motion
as idle
as a
painted
ship
upon a
painted
ocean.

The very
deep did rot o christ
That ever this
should be.
Yea, slimy things
did crawl with
legs, upon the slimy sea.

water, water everywhere,
and all
the board
did shrink
Water, water
everywhere
nor any
drop to
drink.

Samuel
Taylor
Cockridge

76 CASABLANCA - S/S Djenné de la Compagnie Paquet

DEZIRE SAFARI

.37 CASABLANCA Parc Lyautey

The Wines and Messing Committee wish to remind members that there is a **book**
in the diningroom for members' comments - good or bad: preferably the former.
It is almost unbelievable, but it is true that there have been instances of
childish vandalism in the book also an obscenity: the Committee are appalled
and trusts that this will never happen again.

FUCK off

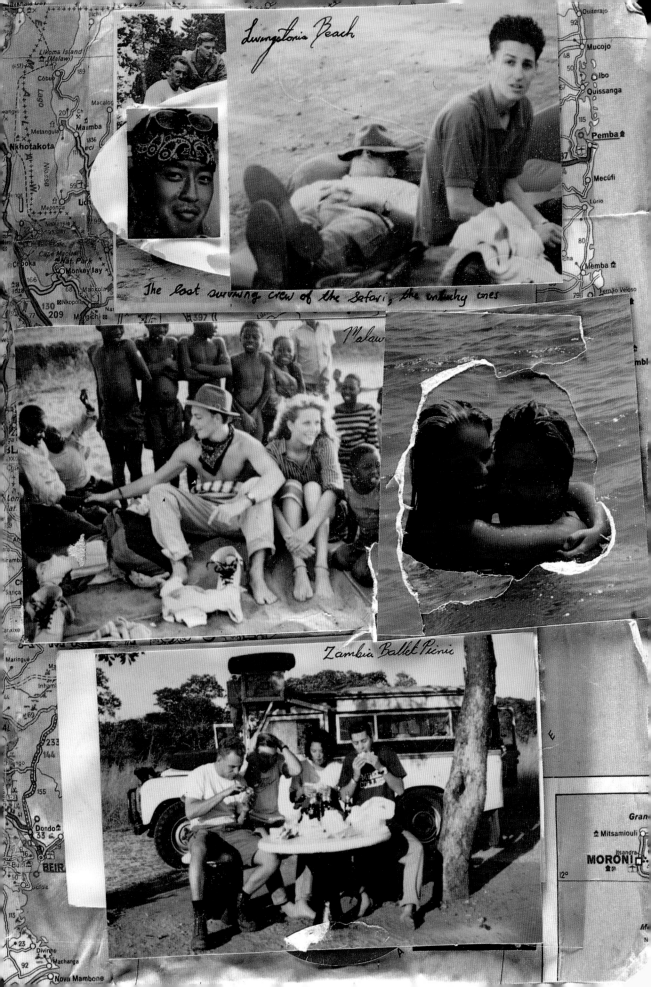

Livingstone Beach

The last surviving crew of the Safari, the unlucky ones

Malawi

Zambia Ballet Picnic

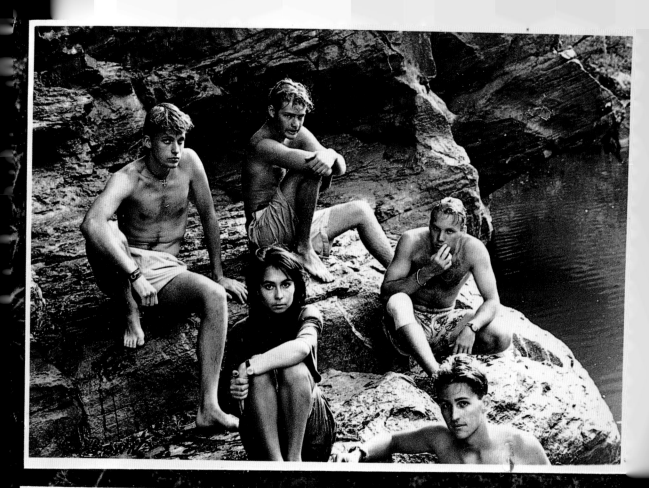

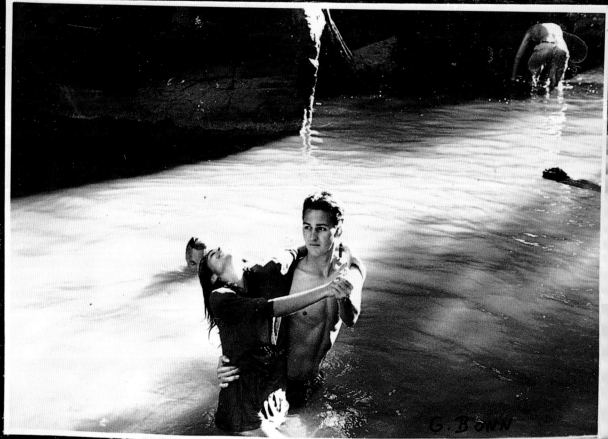

G.Bonn

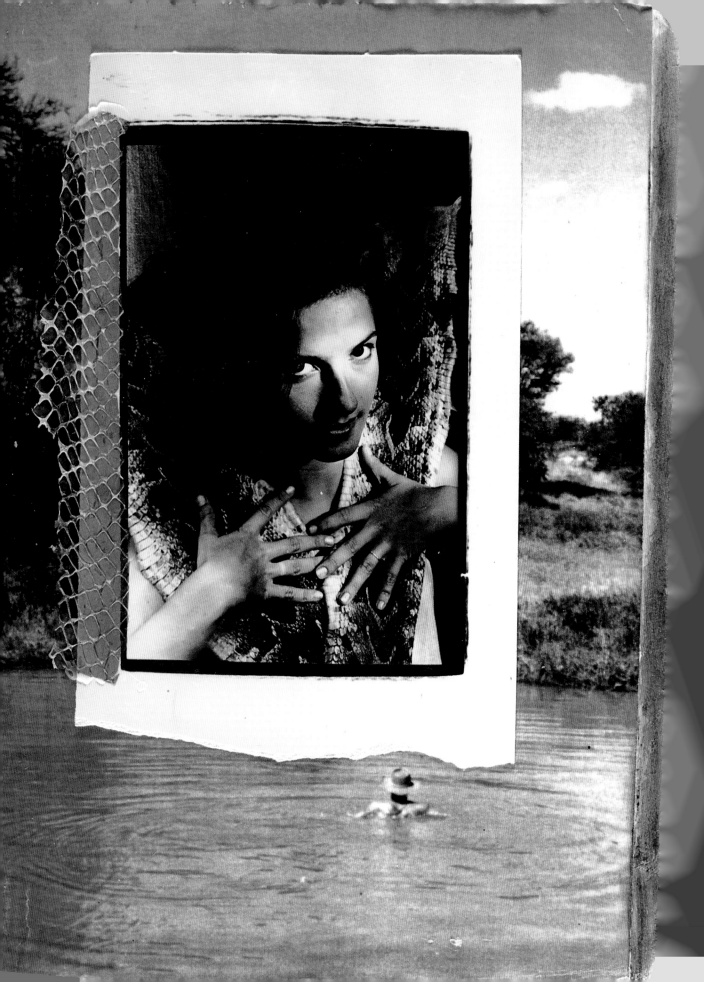

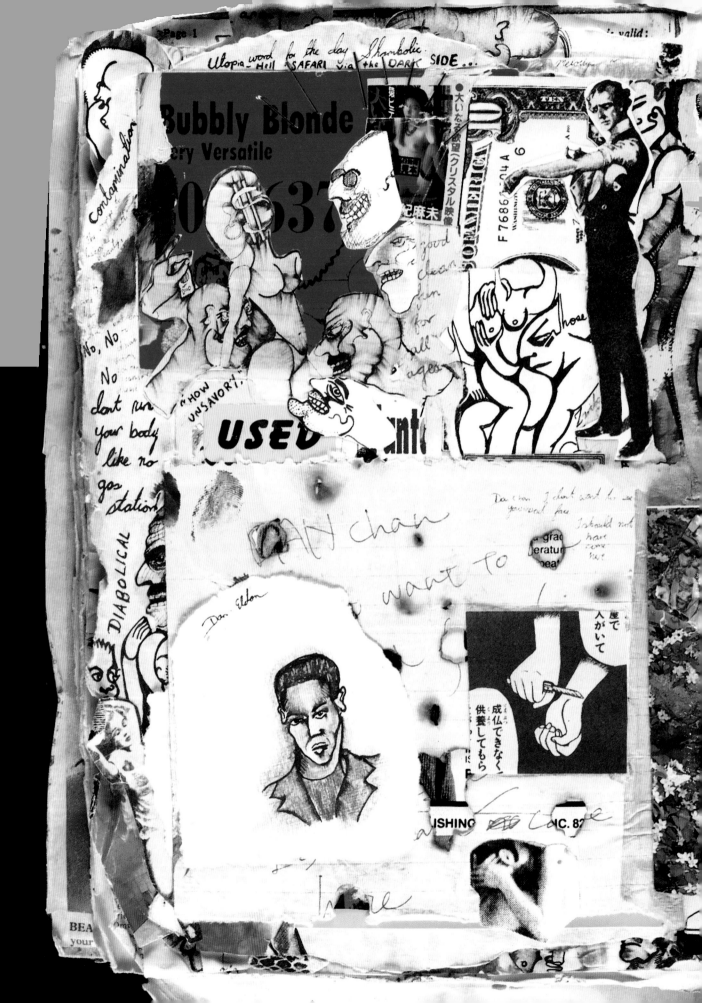

preservation. The fact is that <u>a man who wants to act
virtuously in every way necessarily comes to grief among
so many who are not virtuous</u>. Therefore if a prince
wants to maintain his rule he must learn how not to be
virtuous, and to make use of this or not according to

CHRISTMAS 1914.

Afrique du Nord.
Dan Eldon

Grunt Grunt

HELP THE *ZAMBIA* POLICE HELP YOU

lean and hungry look

She's been married so many times she's got rice marks on her face.

Stray pigs killed in town clean-up

By SUNDAY NATION Correspondent

n estimated 500 stray pigs in hika town were yesterday poisoned by the municipal public health department.

The poisoning order was issued by the Thika divisional environ ent committee when it met un er the chairmanship of the Dis rict Officer (1), Mr Ombasa Omweno, early last week.

on after the three-hour poi g exercise at Kang'oki g site, the carcasses were buried using an army bulldozer from the 12th Engineering Battalion.

Municipal council mploye led by the town clerk Mr J. N Ngaine and the municipal Public Health Officer, Mr C.M Karuga, watched as the noisy animals died one after another after eat ing the poison.

The exercise was also wit nessed by the Kiambu Dis Environment Officer Nakhali Waopembe.

Mr Omweno said

ger posed by the stray pi had been feeding h industrial waste

Otum at Ka Mur pa

"There was not one single thing that he found undeserving of contempt."

a.

b.

Plate XVI. Dan Eldon, 1992.

Turkish Brothel

Three second fuse of desires
a nervous twist of lust invisible
SHE LAUGHED LIKE A GIANT ↑ HAND
TICKLED HER
Voluptious spasm.

Marte Odden

'Jeff'

Chris Nolan

Akkochan

Ryan Bixby

Chaka Chaka

Hayden Bixby

'Rocco'

Kariuki J.M. Kibera Rd., Box 41244	Nairobi	565679
Kariuki J.M. Ndumberi Rd., Box 631 Kiambu	Kariuri	22220
Kariuki J.M. Ol Donyo Lengai Rd., Box 30001	Nairobi	796256
Kariuki J.M.	obi	564124
Kariuki J.M.B.	obi	798272
Kariuki J. Maina	obi	792817
Kariuki J.N. Bo	sos	114
Kariuki J.N. Bo	uru	51257
Kariuki J.N. Bo	uru	566772
Kariuki J.N. Bo	uru	22570
Kariuki J.N. Da	obi	882890
Kariuki J.N. L	obi	795664
Kariuki J.P. Bo	ret	22400
Kariuki J. Thait	ado	21153
Kariuki J.W.B.	obi	795095
Kariuki Jack W	obi	505615
Kariuki Jackso	atta	98
Kariuki Jackso	eri	88
Kariuki Jairus		
Kariuki James	cho	82
Kariuki James,	uri	41980
Box 510	itu	22831
Kariuki James,	obi	761519
Kariuki James,	obi	727726
Kariuki James M. Muhoho Ave, Box 30213	Nairobi	505468
Kariuki James M. Muyeyu Rd, Box 47748	Nairobi	764545
Kariuki James N. Accra St, Box 386	Kisumu	41389
Kariuki James Nganga F, Box 410 Kiambu	Karuri	41769
Kariuki James T, Box 34177	Nairobi	593426
Kariuki Mrs Jane W. Box 414 R	Thika	21472
Kariuki Jane W	Nyeri	2938
Kariuki Miss Ja	obi	565125
Kariuki Jeremi	Nairobi	797983
Kariuki Jesse W	Baricho	50
Hse.	Nyeri	4323
Kariuki Jimmy,	Kitui	22337
Kariuki Joan W	Nairobi	790318
Kariuki John, Fa	Nairobi	540371
Kariuki John C.		
Box 51314 N	Karuri	32472
Kariuki Dr John	Mombasa	43773
Kariuki John K	Nairobi	748243
Kariuki John K	Karuri	40478
kariuki John M	Nkubu	79
Kariuki John N	Nyeri	2087
Box 72748	Nairobi	506261
Kariuki John N	Nairobi	724295
Buru Buru P	Nairobi	791454
	Karuri	40911
Kariuki John N, Limuru Rd, Box 32722	Nairobi	749184
Kariuki John N, Mandera Rd, Box 30680	Nairobi	43630
Kariuki John W, Jamhuri Est, Box 11360	Nairobi	569151
Kariuki John W, Ngong Rd, Box 30316	Nairobi	569617
Kariuki Johns	obi	798355
Kariuki Jones	irobi	796267
Kariuki Jones	irobi	506871
Kariuki Josep	Nyeri	592481
Kariuki Josep	Thika	22997
Box 97167	mbasa	316224
Kariuki Josep	airobi	797184
Box 74253	irobi	767646
Kariuki Josep		522891
Kariuki Josep	diani	8Y6
Kariuki Josep	airobi	810077
Kariuki Josep	irobi	790066
Kariuki Mrs J		
Box 30271		540892
Kariuki Josph	aruri	41846
Kariuki Josph	irobi	802357
Kariuki Josph	irobi	501253
Kariuki Joyce	mbasa	311289
Kariuki Mrs Joyce T, Kenyatta Ave.		
Box 33	Embu	20114
Kariuki Julius M, Mirema Drv, Box 70220	Nairobi	803888
Kariuki Julius W, Mutulu Ave, Box 20425	Nairobi	501931
Kariuki Justus, Mairoini/Kagicha Rd.,		
Box 30 Oth	riaini	79
Kariuki Justu	airobi	798290
Kariuki K Eh	aruri	32404
Kariuki K Ge		
Box 54613		506009
Kariuki K.Wi	Thika	22523
Kariuki Kaba		
Box 6	riaini	78
Kariuki Kahu		
	erian	83
Kariuki Kam	goma	20224
Kariuki Kam	airobi	792678
Box 43474		
Kariuki Kigo	wara	122
Kariuki Kiirc	mbasa	471032
Kariuki (Dr.	Nyeri	2768
Box 4597		
Kariuki L.Nc	Nairobi	340044
Box 6000		
Kariuki Kim	airobi	556232
Box 2090		
Kariuki Kimunyu, Giagatika Rd.	Kitale	20191
Box 153 Karatina		
Kariuki Kinutha J.E. Kinoo Village.	Nyeri	71525
Box 50204		
Kariuki Kirubi, Box 30079	Nairobi	592229
Karie Kiruthu & Son, Box 32	Nairobi	43129
Kariuki Kuban M, Box 1944	Nyeri	71242
Kariuki L.Nginyi, Box 40943 Nbi	Nakuru	42614
	Nairobi	40233
	Karuri	40218
Kariuki Mrs L.W. Box 26697	Mombasa	472367
Kariuki Laban, Box 28640	Nairobi	47471
Kariuki Laban Ba	Mombasa	494607
Kariuki Laban, Box 28640	Nairobi	568458
Kariuki Lucy N, Rhapta Rd, Box 14205	Nairobi	61913
Kariuki Lucy W, Box 11808	Nairobi	792507
Kariuki M, Box 194 Ruiru	Donyo Sabuk	7Y7
Kariuki M, Box 41703	Nairobi	760762
Kariuki M.	obi	795456
Kariuki M.	irobi	728740
Kariuki M.	gana	114
Kariuki M.	basa	433086
Kariuki M.	kuru	40913
Kariuki M.	dori	16
Kariuki M.	hika	44293
Kariuki M.	ng'a	22343
Kariuki M.	kuru	41919
Kariuki M.	robi	798523
KARIUKI	**obi**	**541938**
Box 521	robi	791376
Kariuki Mr		
Box 333	hika	21792
Kariuki Mis	kuru	3170
Kariuki M.	robi	792117
Kariuki M.	robi	796425
Kariuki Ma	rnet	2059
Kariuki Ma	tale	20980
Kariuki Ma		
Box 996 Kitale	Cherangan	16
Kariuki Macharia J, Ol Enderti Rd.,		
Box 47692	Nairobi	791848
Kariuki Mrs Madelaine N, Kanyariri Rd.,		
Box 29102	Nairobi	592049
Kariuki Mrs		
Box 3327	Nairobi	28977
Kariuki Mrs		
Box 119	Ridge	3Y7
Kariuki Mad		
	arasha	49
Kariuki Mar	Nairobi	799190
Kariuki Mrs		
Box 57	anyuki	22093
Kariuki Mar	Nairobi	798844
Kariuki Mar	chakos	21039
Kariuki Mrs		
	Nyeri	71936
Kariuki Mat	Nairobi	504316
Kariuki Mbi	Karuri	41399
Kariuki Mic	airobi	565086
Kariuki Dr.	akuru	41941
Kariuki Mir	airobi	729398
Kariuki Mur	robi	796736
Kariuki Mur	robi	791851
Kariuki Muraya J, Muhoho Ave, Box 57873	Nairobi	500954
Kariuki Murithi F, Stadium Rd, Box 106	Nyeri	4575
Kariuki Mwangi, Kamangu, Box 42960 Nbi	Karuri	32535
Kariuki Mwangi Advocates, Box 468	Nyahururu	22285
Kariuki Miss Naom Stadium Erav Box 420	Nakuru	41761
Kariuki Mwa	Nairobi	798107
Kariuki N, Bo	Nakuru	45876
Kariuki N.E.	Nairobi	505907
Kariuki N.G.	Nairobi	765014
Kariuki N, Hu	Taveta	109
Kariuki N.J.	Nakuru	42667
Kariuki N.J.	Kisumu	41331
Kariuki N.P.	Labururu	22264
Kariuki N.W.	Nairobi	767223
Kariuki Naha	Nairobi	796661
Kariuki Ndeg		
Box 10492	Nairobi	592047
Kariuki Ndig	Nyeri	4506
Shop, Kim	Nyeri	2389
Kariuki Ndira	Nairobi	793733
Kariuki Ndira	Embu	20064
Kariuki Neks	Nairobi	791678
Kariuki Nena	Nanyuki	22502
Kariuki Nephat K, Box 192 Othaya	Nyeri	52064
Kariuki Nganga G, Ft Smith Rd.,		
Box 29138	Nairobi	593291
Kariuki Ngenye, Njumbi Rd, Box 53514	Nairobi	48654
Kariuki Ngotho, Jamhuri Est, Box 21632	Nairobi	569729
Kariuki Ngugi, Box 72262	Nairobi	520155
Kariuki Ngure J, Harambee Ave.,		
Box 179	arissa	2273
Kariuki Nick		
Box 5270	Karuri	41991
Kariuki Njoc		
Box 4375	Nairobi	332399
Kariuki Njor	airobi	569639
Kariuki Njuc		
Box 4518	airobi	568057
Kariuki Dr. C	Nairobi	729398
Kariuki Nya	Embu	20179
Kariuki Nyri		
Box 650	Nyeri	2658
Kariuki Rev		
Box 4170	airobi	40321
Kariuki One	airobi	503952
Kariuki P.G.	airobi	792313
Kariuki P.G.	airobi	766520
Kariuki P.G.	airobi	504302
Kariuki P.G.	mbasa	494184
Kariuki P.J.	airobi	799665
Kariuki P.J.	airobi	582196
Kariuki P.K. Lwr Kabete Rd, Box 30333	Nairobi	582651
Kariuki P.Kihara, Waguthu,		
Box 71 Banana Hill	Karuri	40321
Kariuki Dr.P.M, M.B,Ch.B,D Ar Med.,		
Buru Buru Ph.III, Box 42075	Nairobi	791932
Res. Loresho Est.,	Nairobi	582685
Kariuki Dr.P.M, Box 43759	Nairobi	891295
Kariuki P.N, Matumbato Rd, Box 56205	Nairobi	725077
Kariuki Miss P.W, Box 68094	Nairobi	302864
Kariuki Patrick N, Box 45537	Nairobi	882366
Kariuki Paul N, Box 34003	Nairobi	799634
Kariuki Paul S, Box 51702 Nbi	Kahuro	64
	Karuri	32488
Kariuki Peter, Box 43 Kikuyu	Karuri	22209
Kariuki Peter K, Box 70502	Nairobi	

Some Members of Team Deziree 1990 Kenya - Malawi.

Eli Tatum. New York

Chris Nolan Mardiake, camera man,

Lengai "Kadogo" Croze

Daniel Robert Eldon

Amy Louise Eldon

Akiko Tokyo Rose

RYAN SCAB BIXBY

HAYDEN Southern
Belle Le Anne Bixby

Robert Goby Gobright

SOUTH PASADENA

Chaka Chaha

WADE ADAMS

AJ. HANS

It is true liberty is precious - so precious that it must be rationed. —Lenin

WE ARE SORRY FOR ANY TEMPORARY INCONVENIENCE.
A sign posted by Ukraine officials on a statue of Lenin that has not yet been demolished

100000000
ONE HUNDRED MILLION

over the past one hundred years one hundred million people died from war

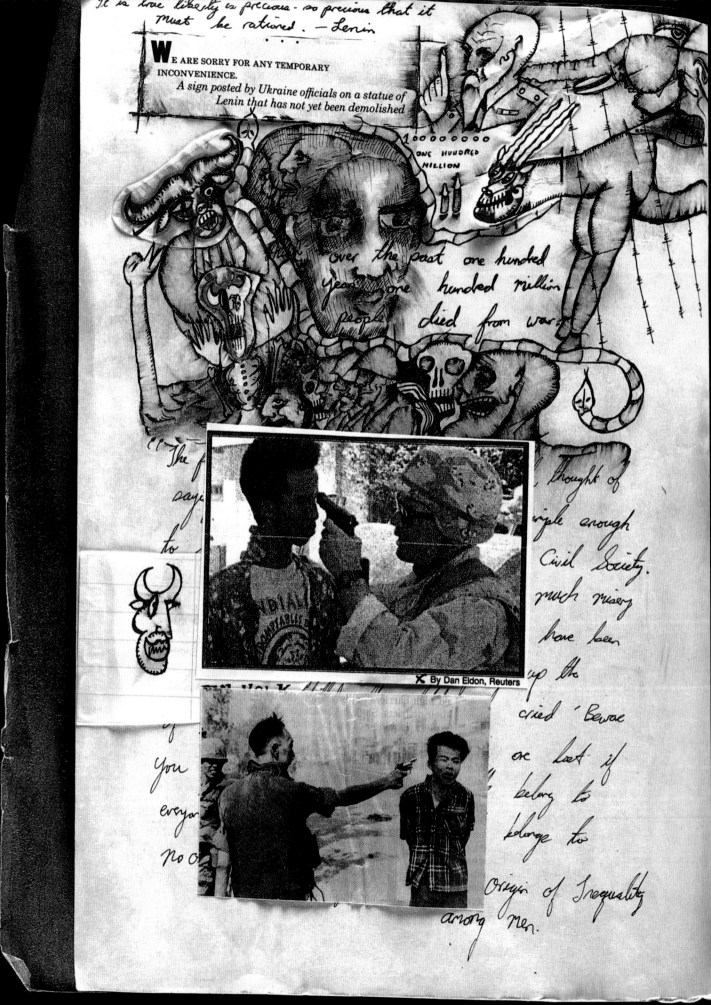

X By Dan Eldon, Reuters

thought of

simple enough

Civil Society.

much misery

have been

up the

cried 'Beware

are lost if

belong to

belong to

Origin of Inequality among Men.

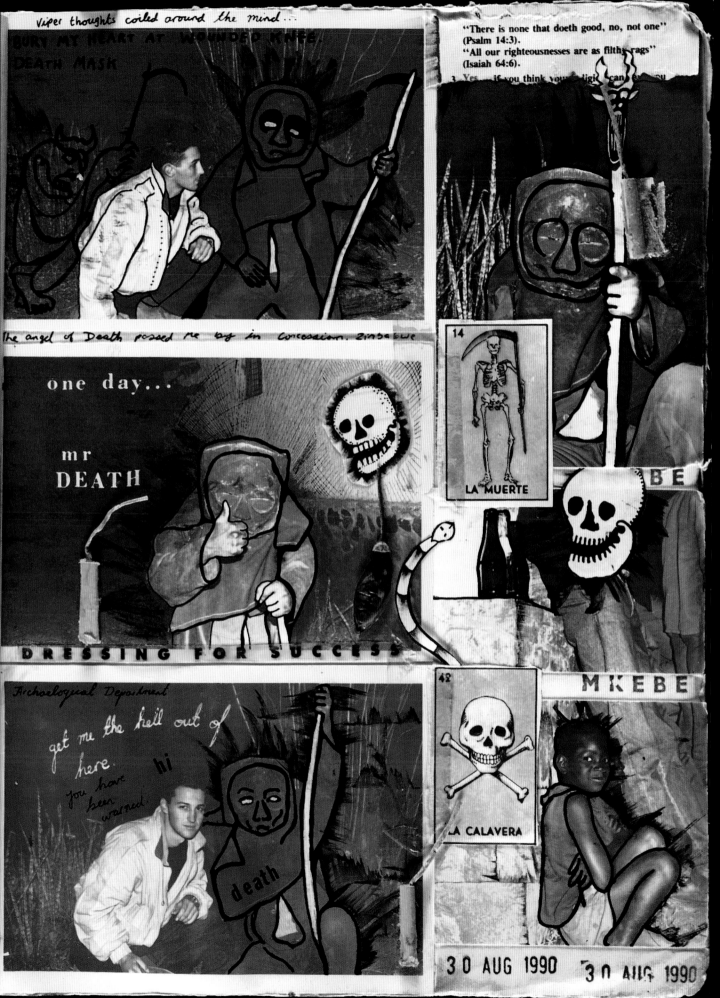

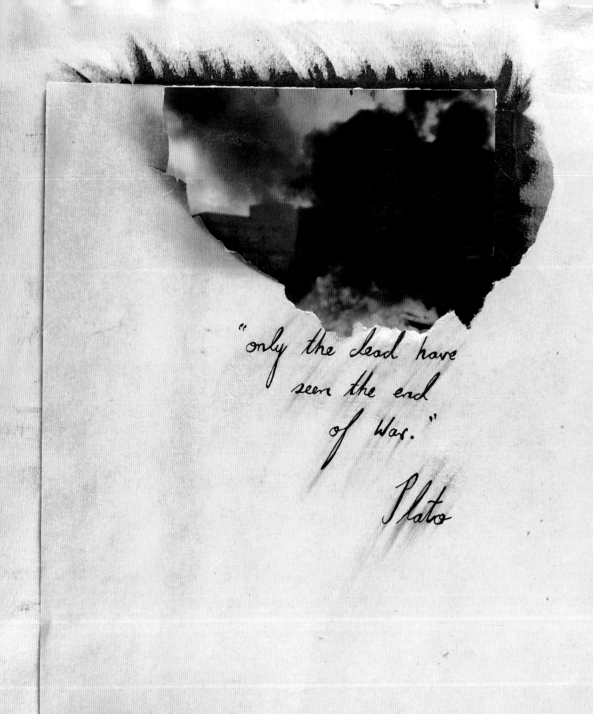

"only the dead have
seen the end
of War."

Plato

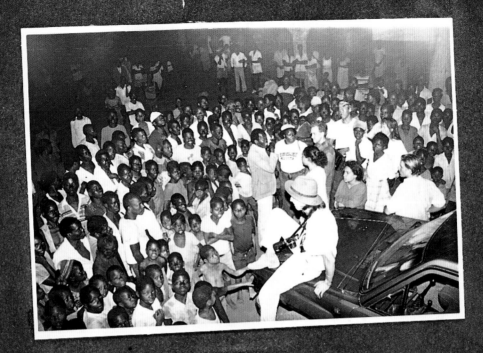

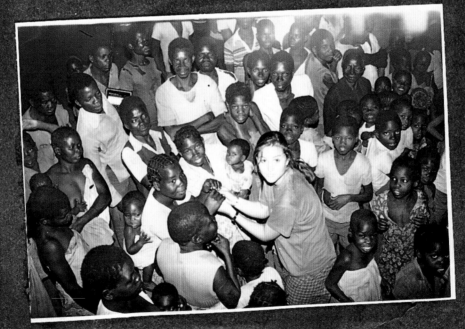

The Night of a Thousand Eyes

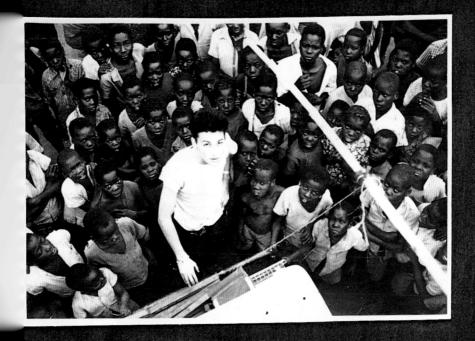

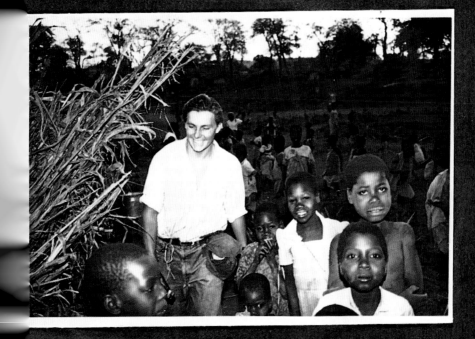

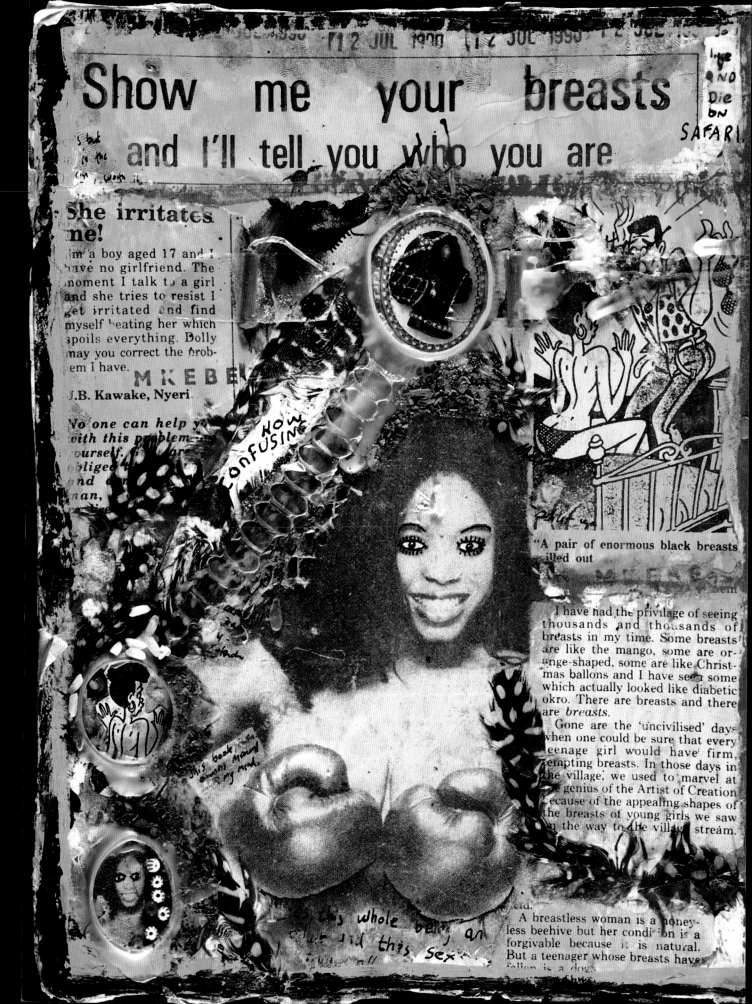

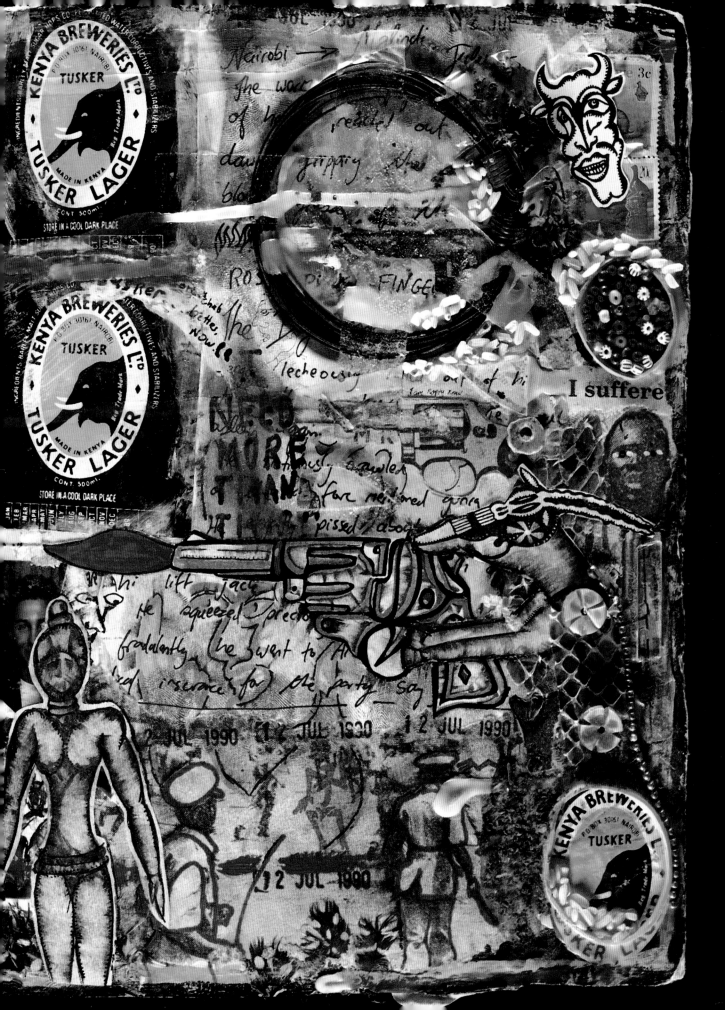

REMEDY

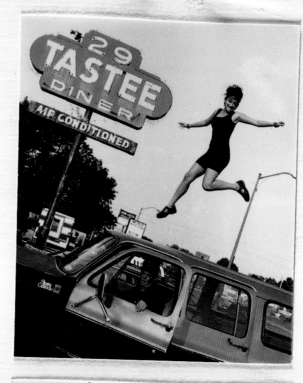

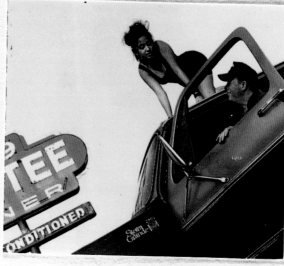

THE DEAD BOY

We arrived late but it did not matter, we were two hours early. We queued up in the peculiar Malawi style whereby you get inside - the person infront of you has been closed [?]... their way... [?]... saying that [?]... rental a New York... right [?]... no, they were forced to pay [?]... kwacha entrance fee.

Our first impressions... wow, what alot of Drunk [?]... but we soon realized that [?] over twice as many as we first [?]. The most notable of the [?] was a man called Skull, a Zambian national, a country not altogether unfamous for their drinking habits.

Amy found a young ruffian who had tried to jump a barbed wire fence, but his crotch was caught and shreded on the sharp barbs. He lay on the ground, vomiting chipuku, the beer of good cheer, as blood clotted around his rad- section.

Amy is a sympathetic person, (some perhaps would say too sympathetic) and she decided that [the] fellow needed medical attention and not the attention that the leering passes-by were giving gneously. She tracked down a police officer who [was] less than interested [and] less than [?]. Amy battled with [?] boy of the Kamuzu [?] administra[tion]. She demanded an [?] ambulance and a doctor for the boy. She [?] Deziree to [?] used body to hospital. In the end, some of his friends [?] him and drenched him in water.

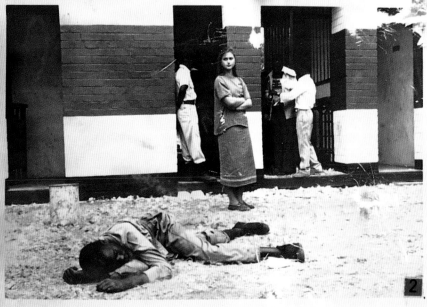

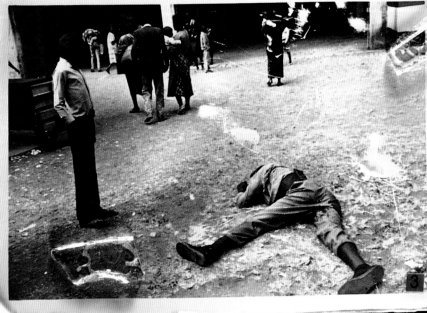

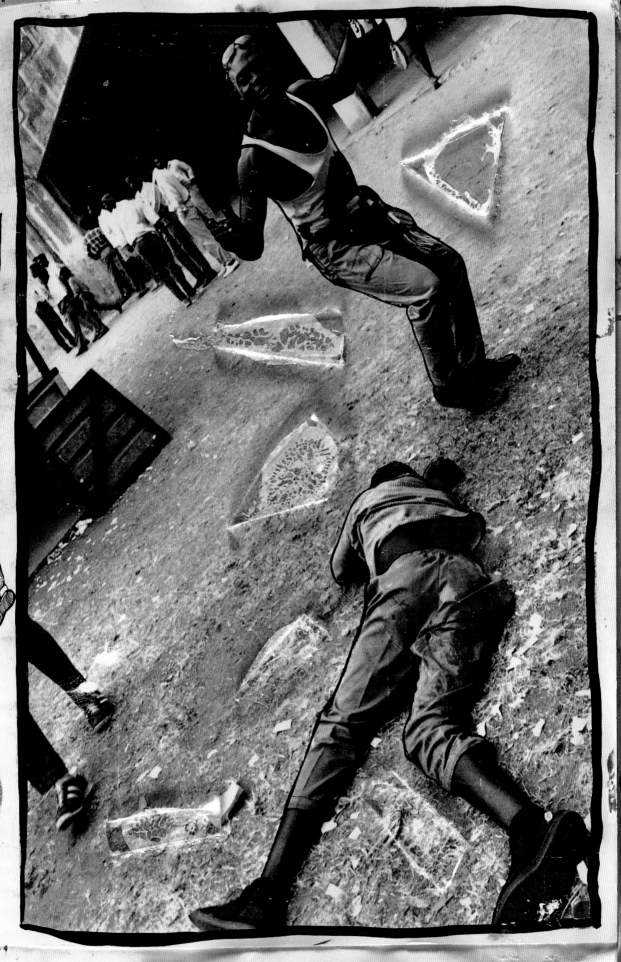

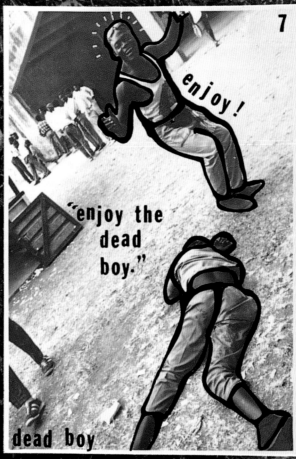
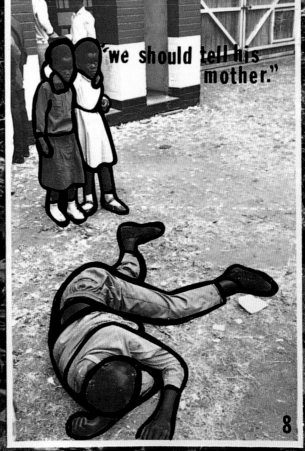

DEZIREE SEX SAFARIS

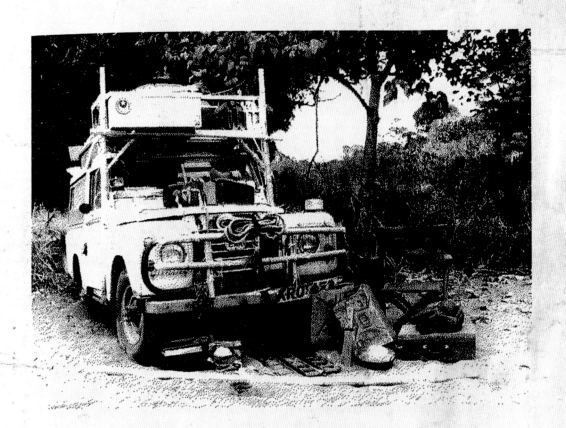

New York London Nairobi Rome Yokohama Paris

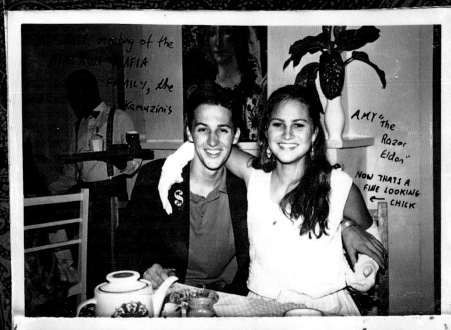

The last meeting of the MALAWI MAFIA FAMILY, the Kamuzini's

AMY "the Razor Eldon"

NOW THATS A FINE LOOKING CHICK

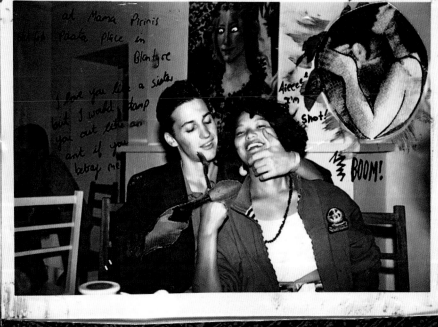

al Mama Pirini's best pasta place in Blantyre

I love you like a sister but I would stamp you out like an ant if you betray me

Aieee I'm Shot!

BOOM!

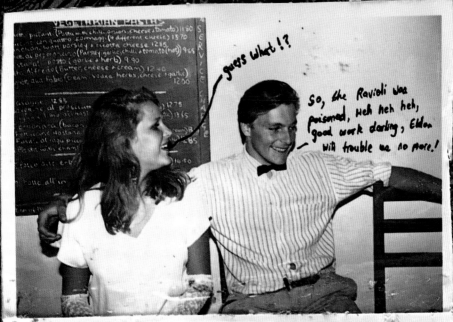
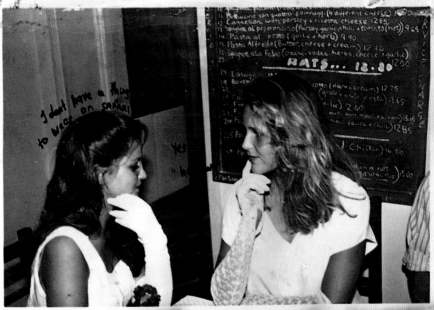

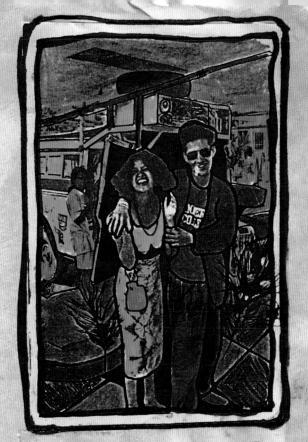

you eat my brains.

"evangelove"

feeling good was good enough for me...

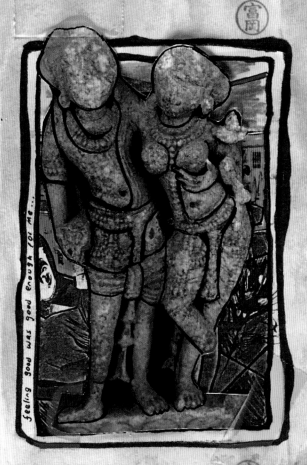

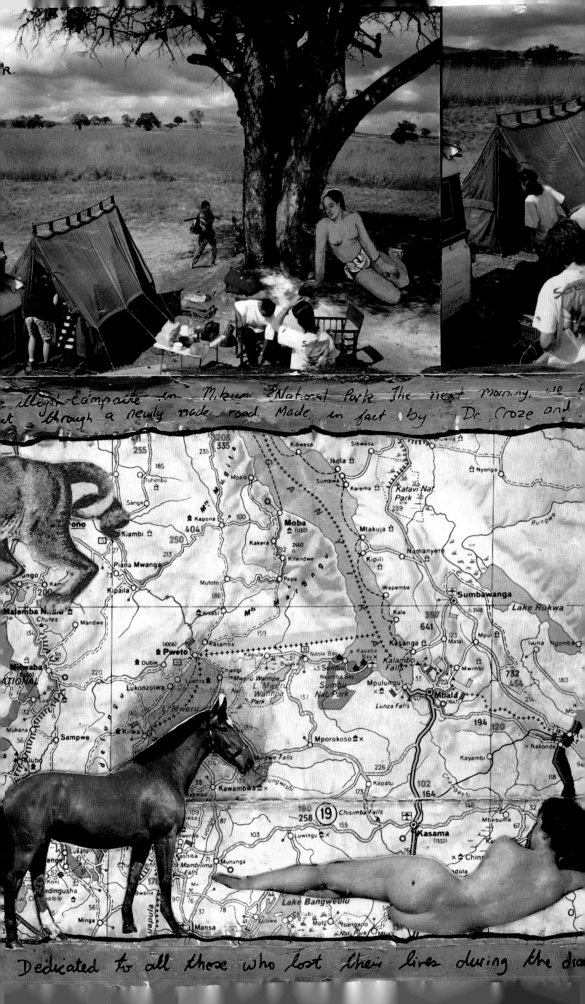

illegal campsite in Mikumi National Park. The next morning, we l
t through a newly made road. Made in fact by Dr. Croze and

Dedicated to all those who lost their lives during the dis

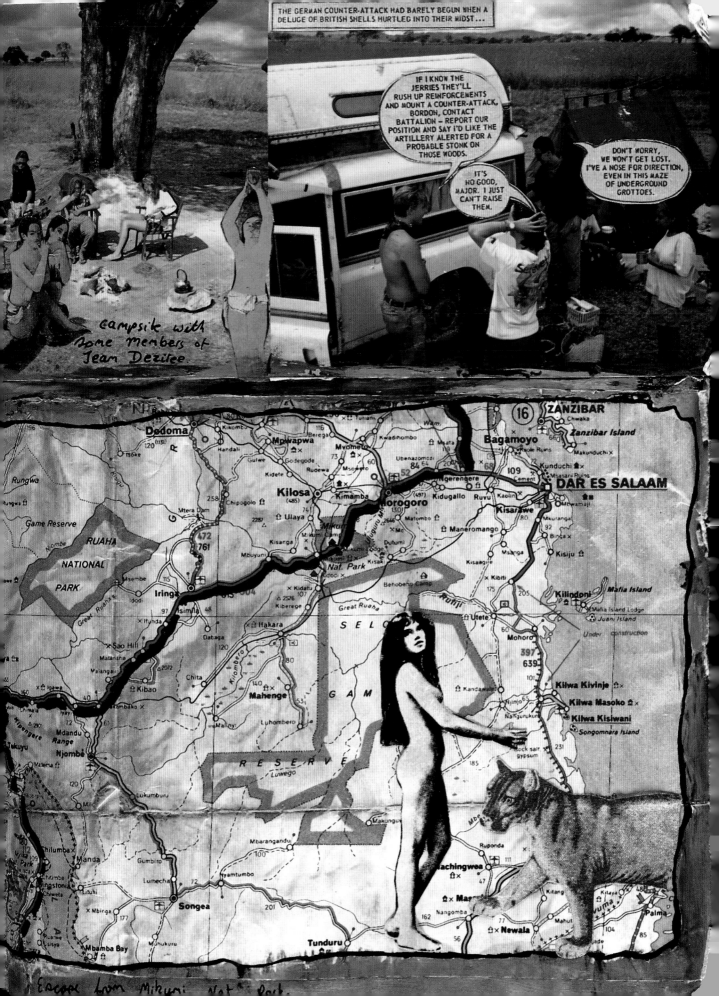

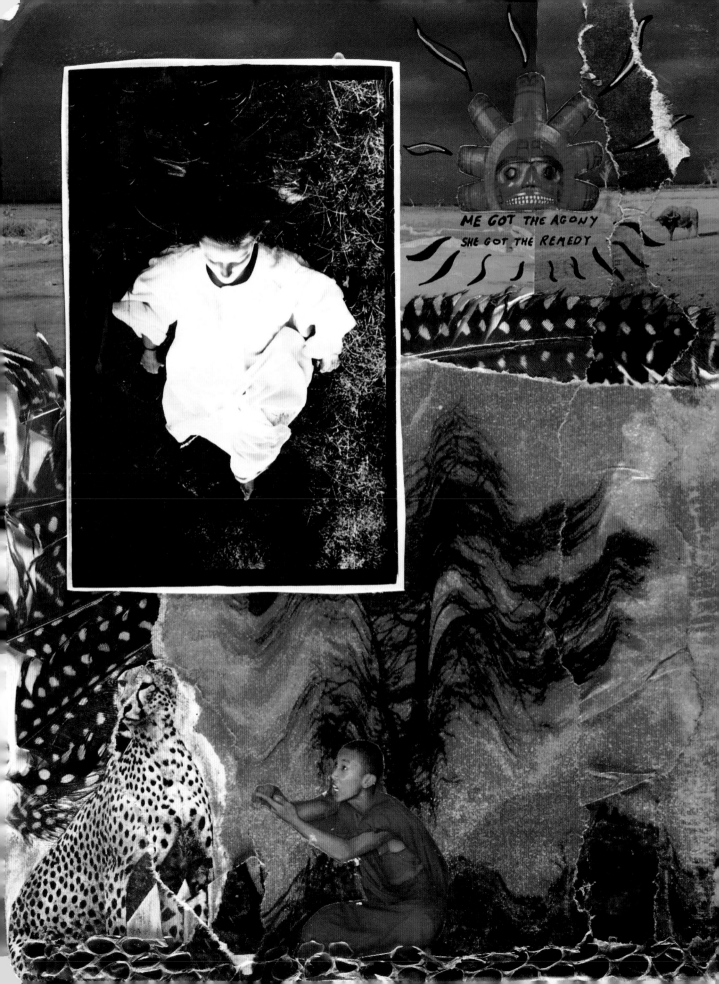

ME GOT THE AGONY
SHE GOT THE REMEDY

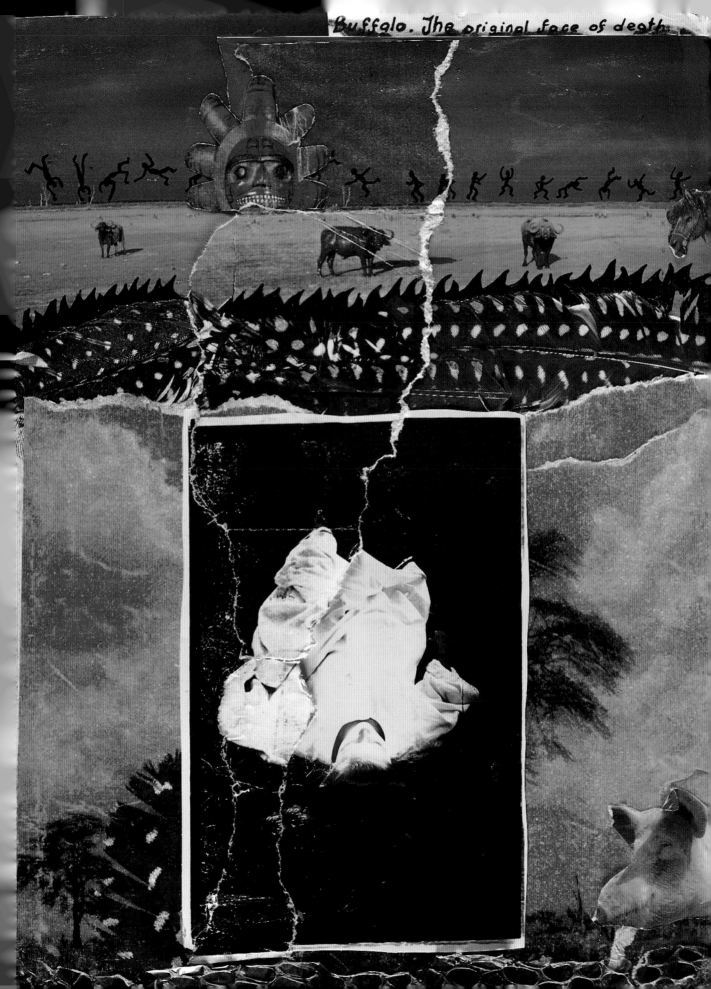

Buffalo. The original face of death.

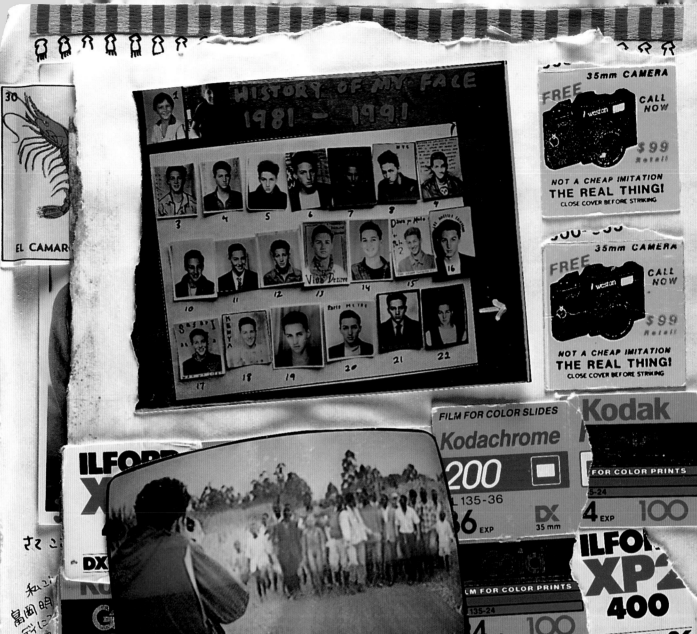

HISTORY OF MY FACE
1981 — 1991

30

EL CAMARO

FILM FOR COLOR SLIDES
Kodachrome
200
135-36
36 EXP
DX
35 mm

Kodak
FOR COLOR PRINTS
135-24
4 EXP
100

ILFORD
XP2
400
DX 135 36

ILFORD
XP2
400
DX 135 36

ILFORD
XP
DX
FILM FOR C
GA 135-24
24 EXP

Kodak
Gold
FILM FOR COLOR PRINT
GA 135-36
36 EXP

Kodak
EKTAR
1000
24 EXP
35mm
CJ 135-24
FILM FOR COLOUR PRINTS
FILM POUR COULEUR COULEUR

Gold
FILM FOR COLOR PRINTS
GA 135-24
24 EXP
100

XP2
400
DX 135 36

23

135-36
NEOPAN
1600
Professional
FILM FOR BLACK & WHITE PRINTS

ILFORD
XP2
400
DX 135 36

Kodak
EKTAR
1000
24 EXP
35mm
CJ 135-24
FILM FUR FARBBILDER
PELLICOLA PER STAMPE A COLORI

Kodak
Gold

ILFORD
XP
40
DX 135

さく
私は
島岡明
マリンデイに
買いまし
驚き
はイカを
と言いた

結局
が料理
瞬く
おして
マーニイ
これお
って

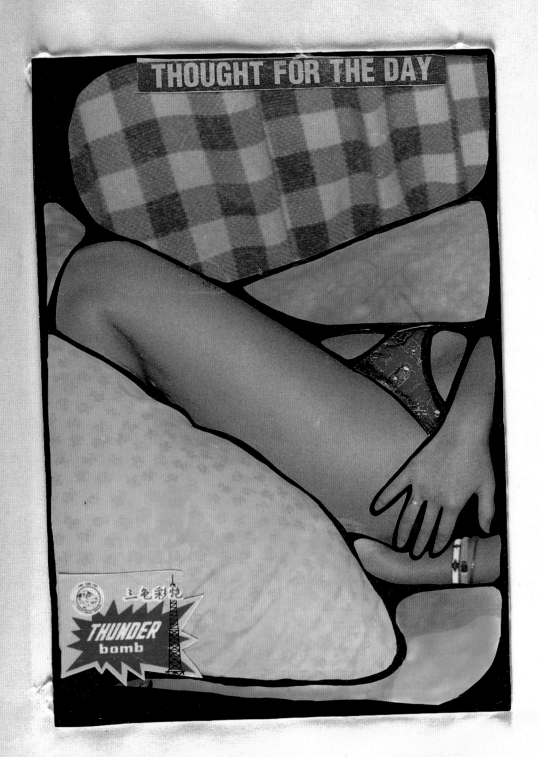

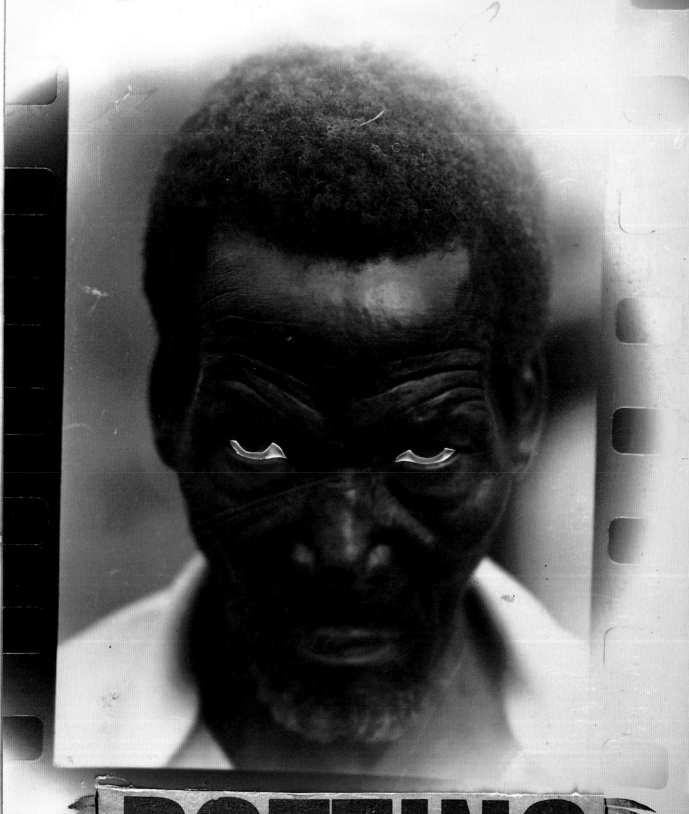

ROTTING

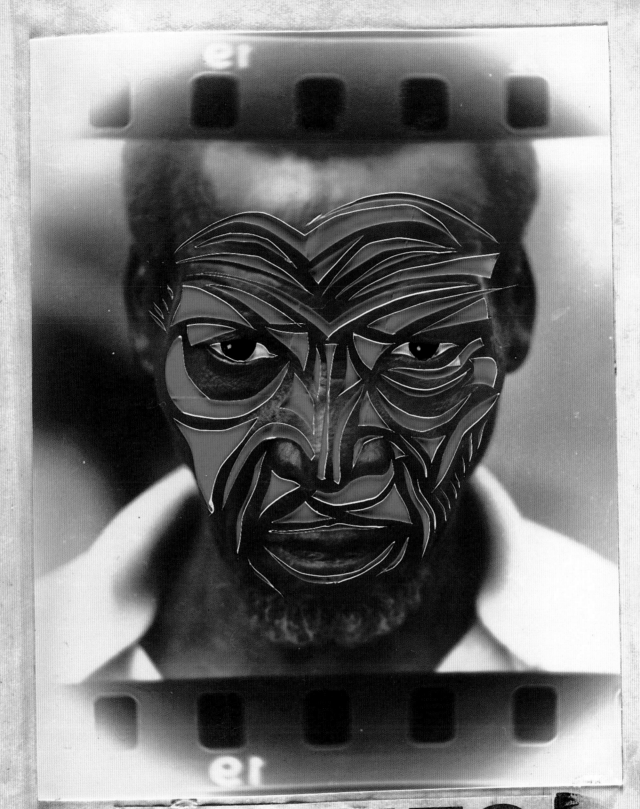

BODIES

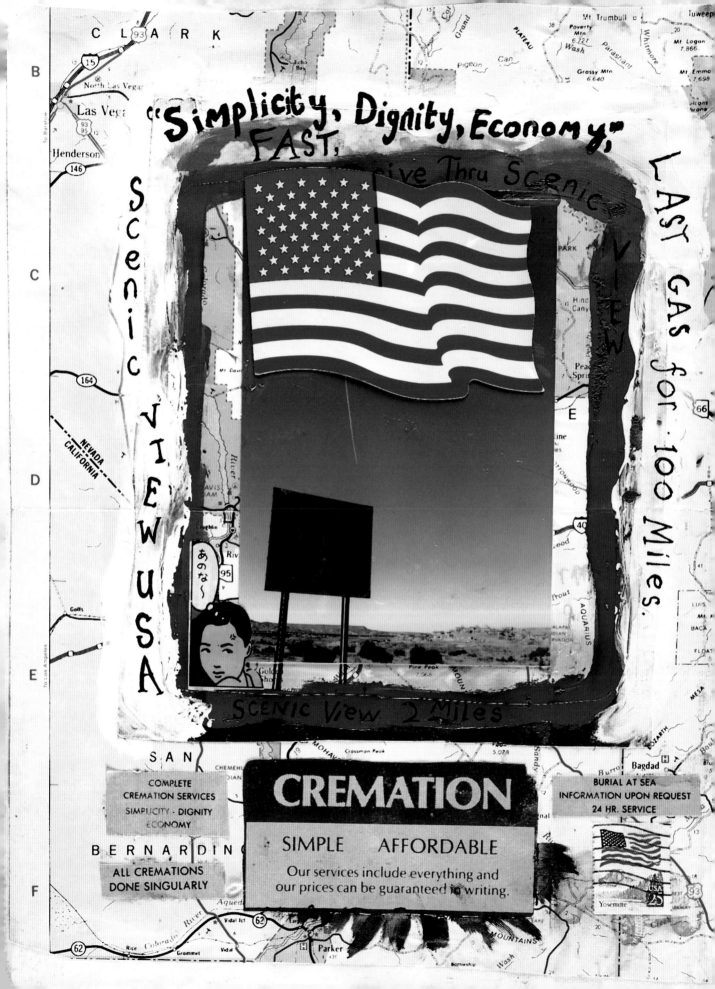

Scenic View, Arizona.

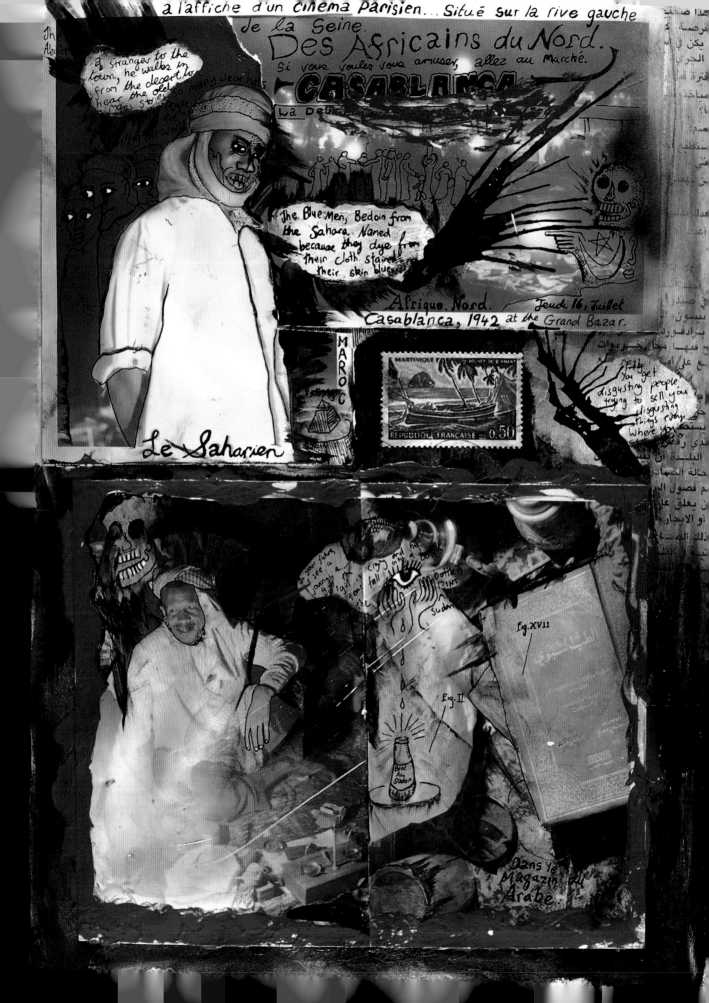

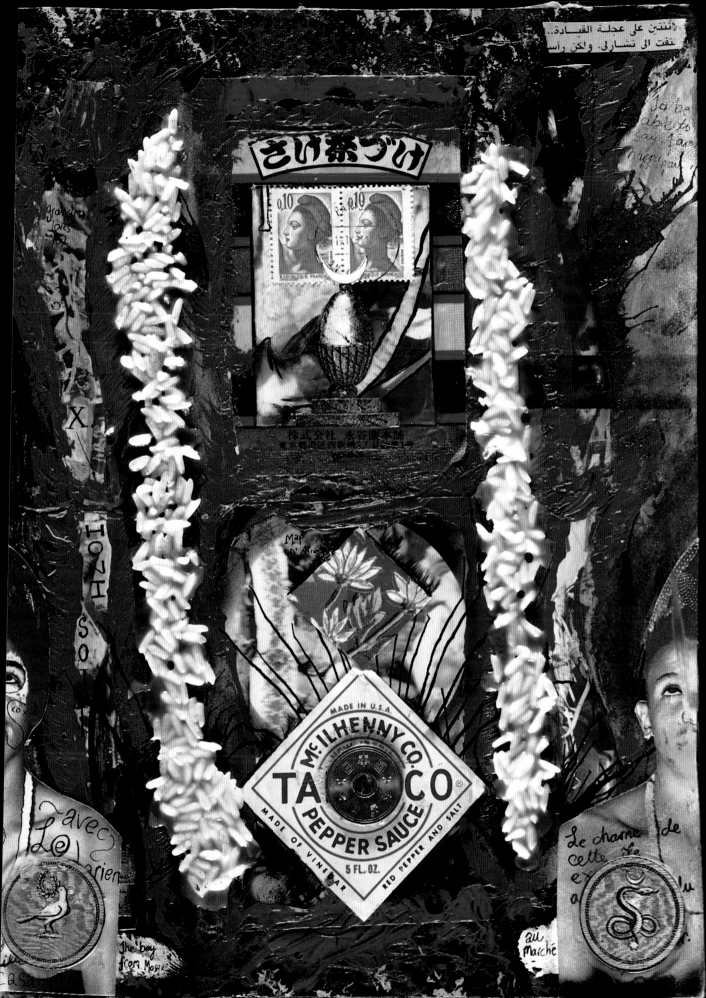

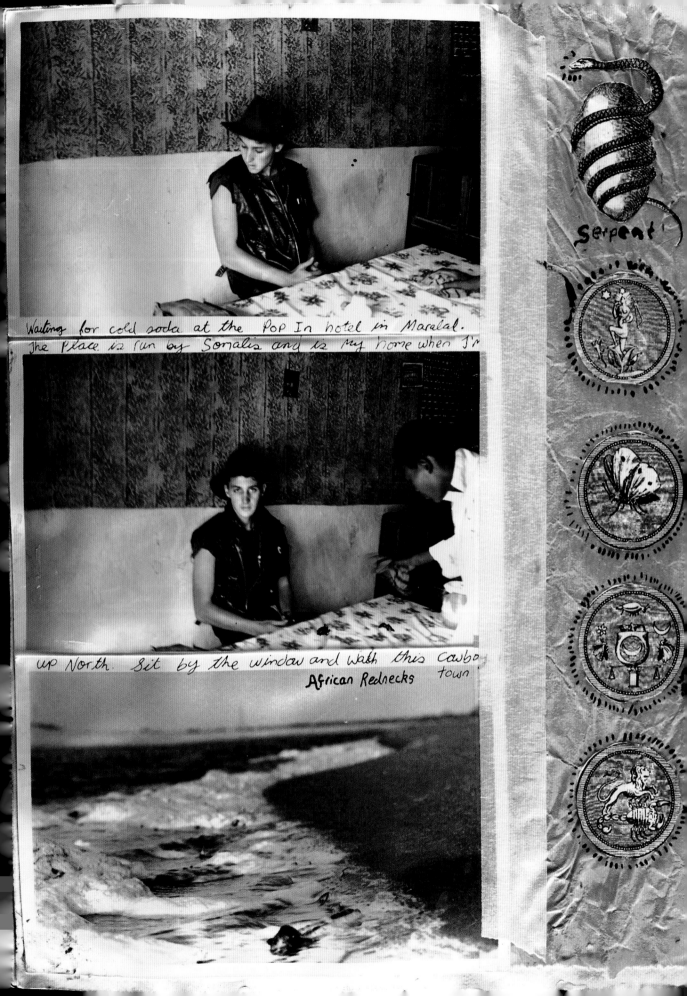

Waiting for cold soda at the Pop In hotel in Maralal.
The place is run by Somalis and is my home when I'm

up North. Sit by the window and watch this Cowbo
African Rednecks town

Serpent

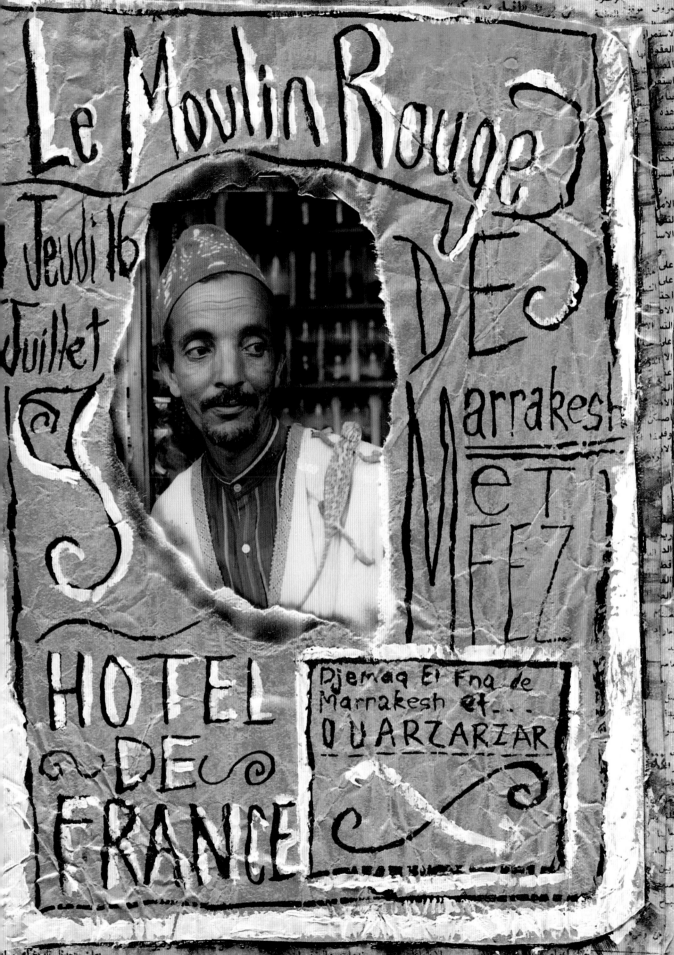

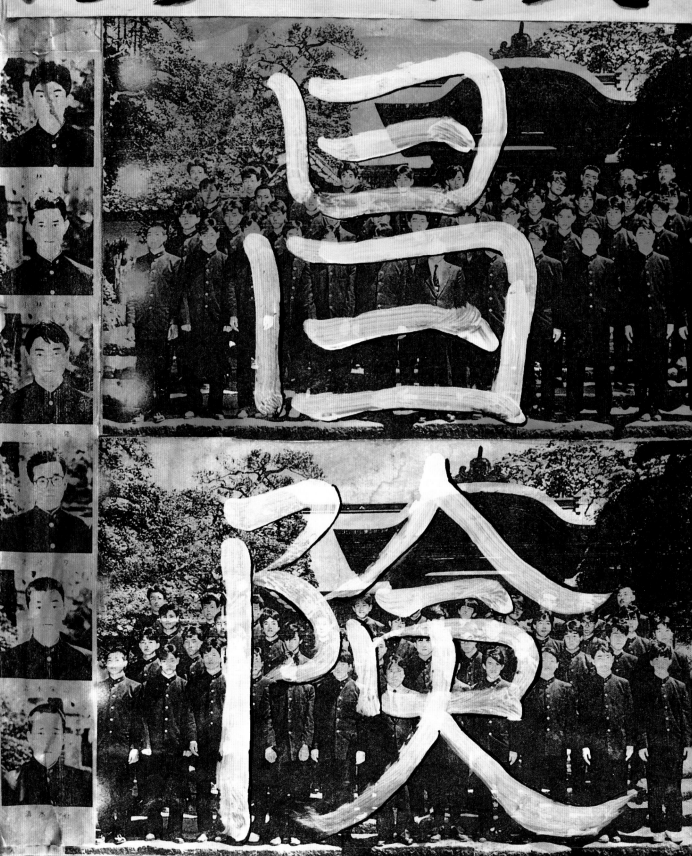

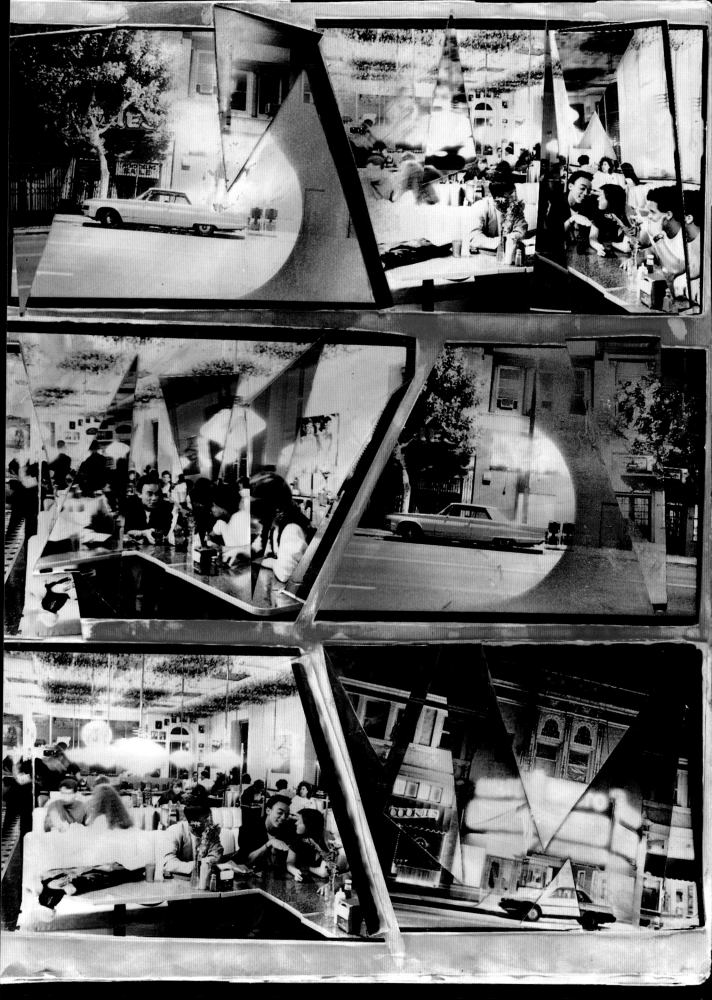

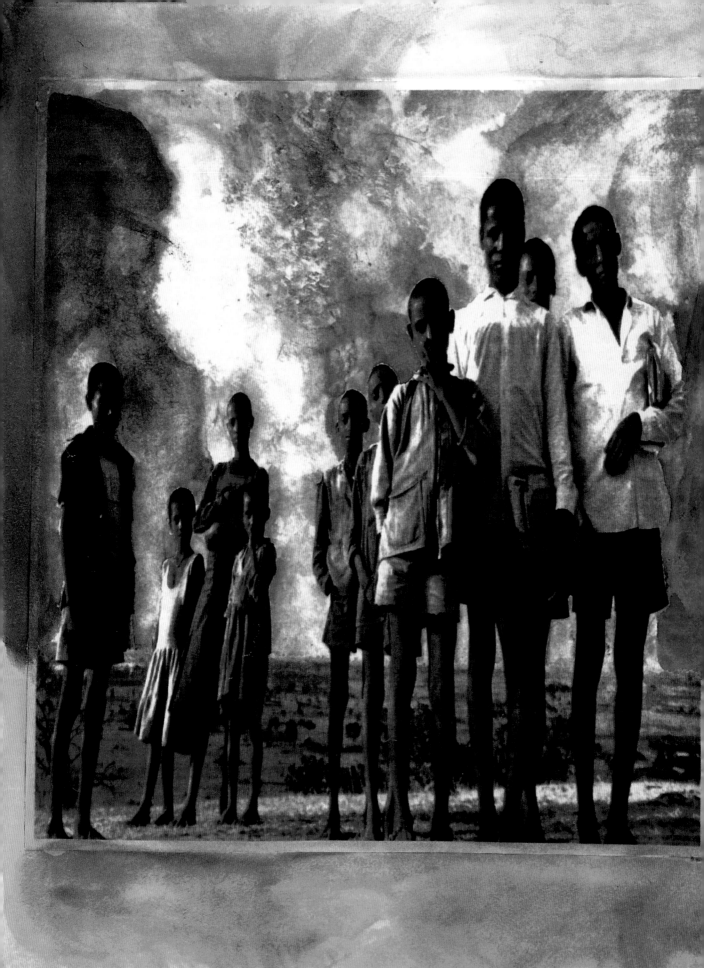

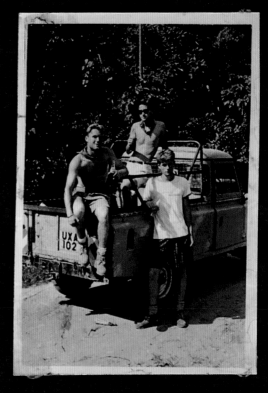

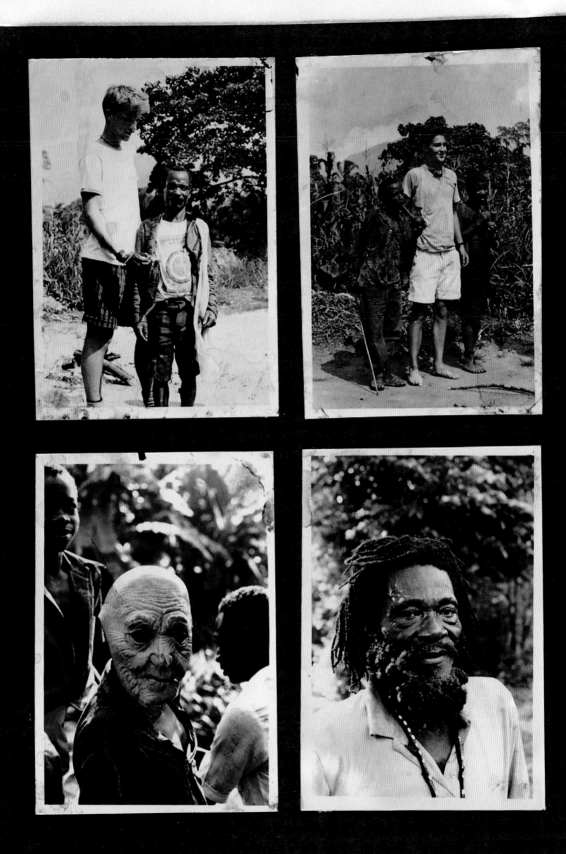

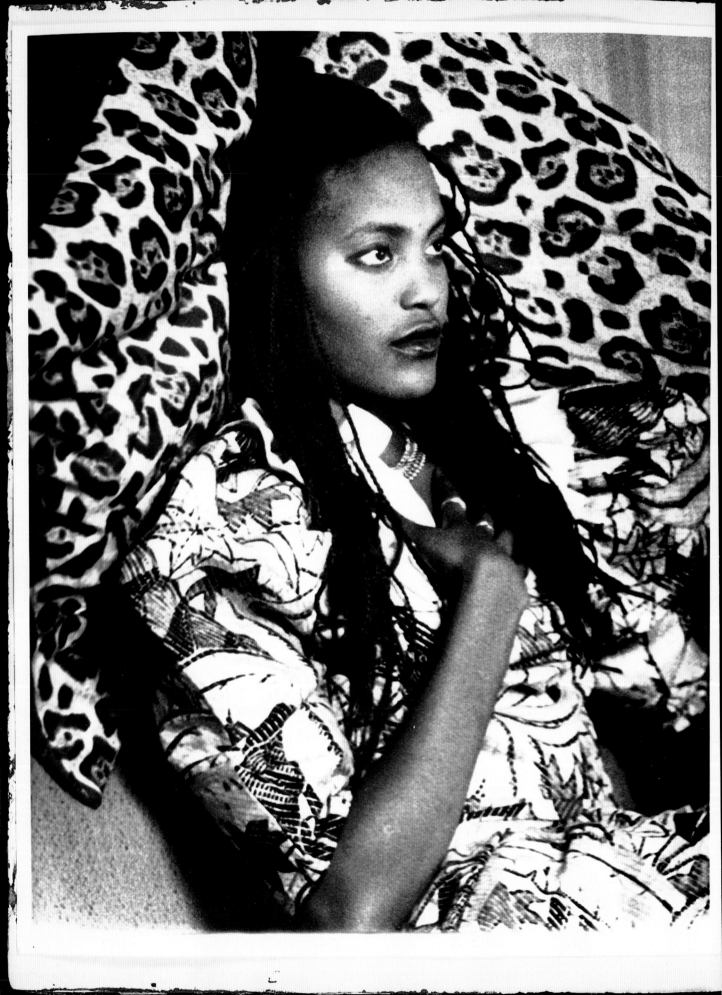

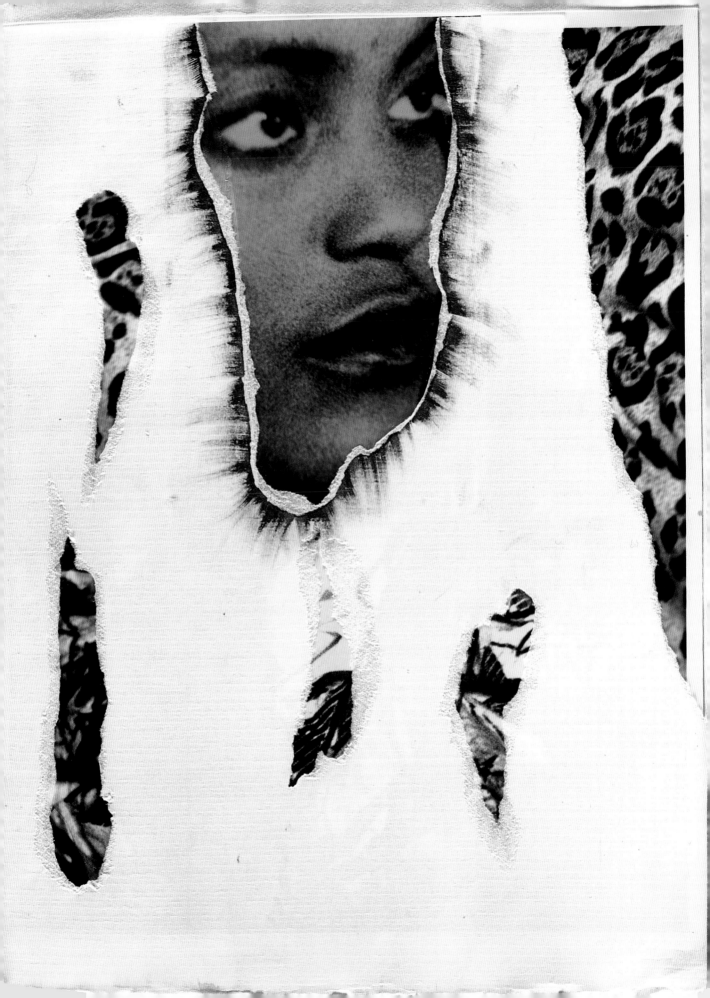

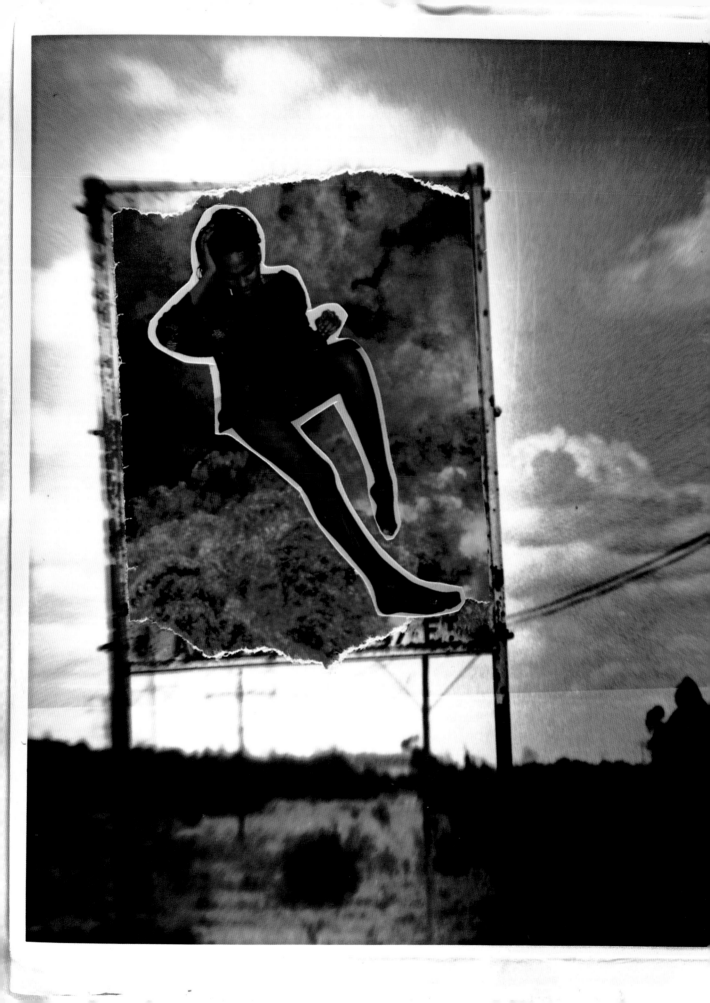

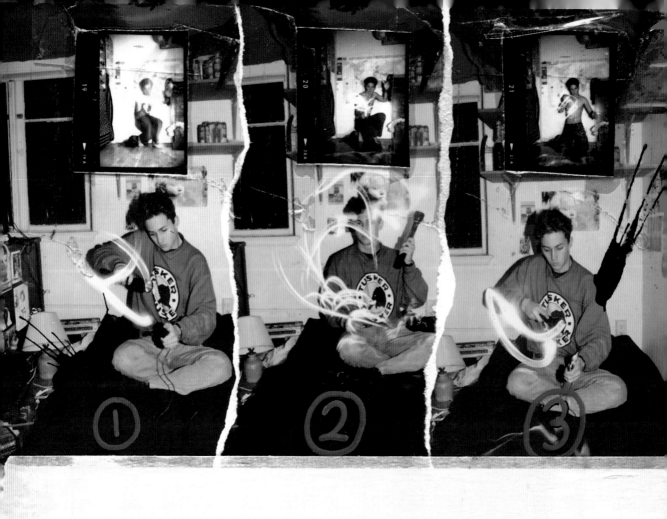

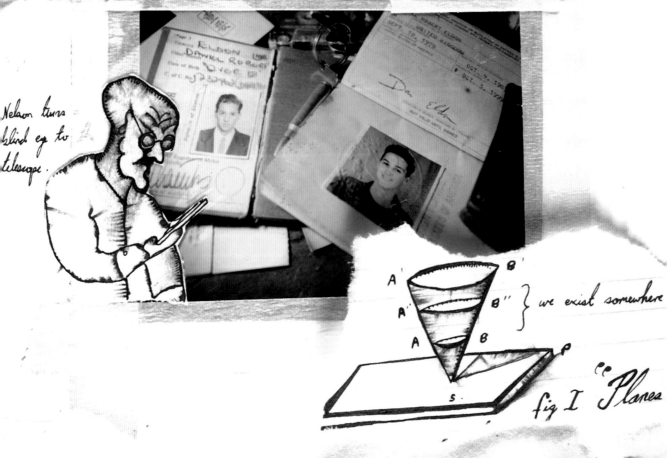

Nelson turns
blind eye to
telescope.

we exist somewhere

fig I "Planes"

Interesting facts of the day: "Your mother is so ugly that when the tide went out...

...Whitman's Fight...

...Late Oct. 1991. "Desert"

Photos right: from the ill fated expedition to view the thousands of Yellow umbrellas planted in the desert north of Los Angeles. We arrived in the middle of the worst storm in recent history. The night that we went ... one ... umbrella ... was up ... wind ...

Yellow umbrellas.

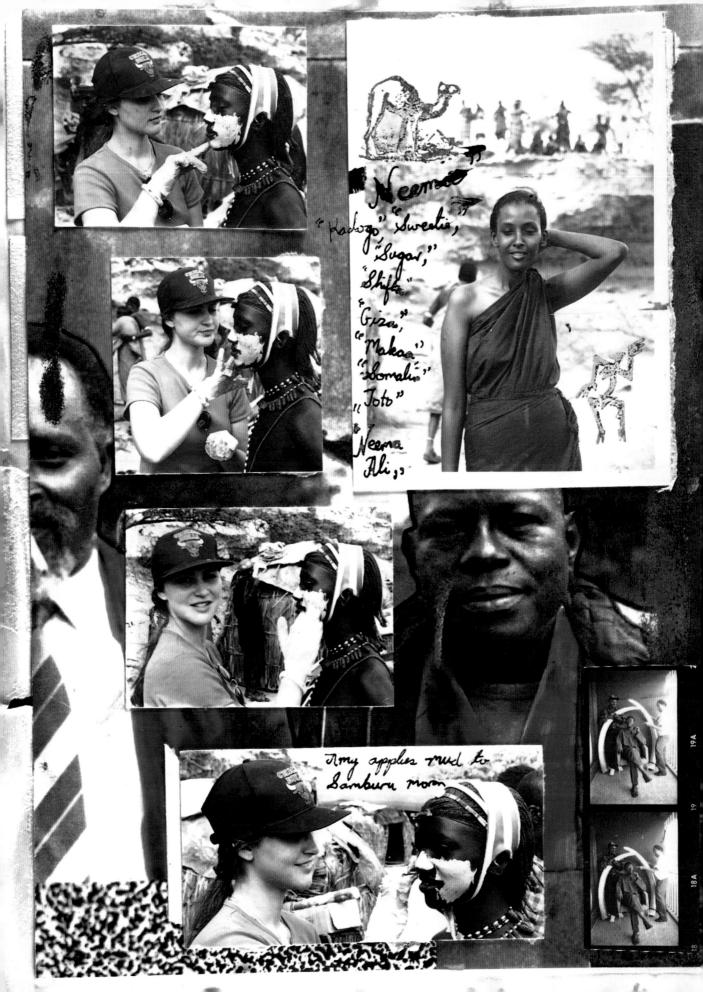

"Neema"
"Kadogo" "Sweetie,"
"Sugar,"
"Shifta,"
"Giza,"
"Makaa,"
"Somali,"
"Toto"
"Neema
Ali,"

Amy applies mud to
Samburu moran

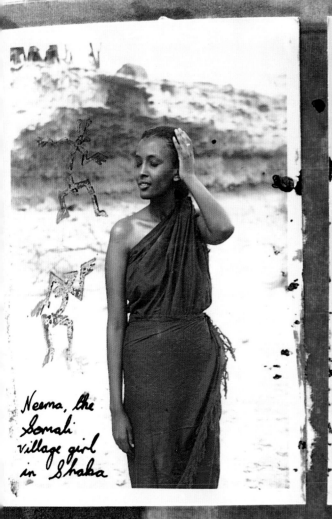

Neema, the Somali village girl in Shaba

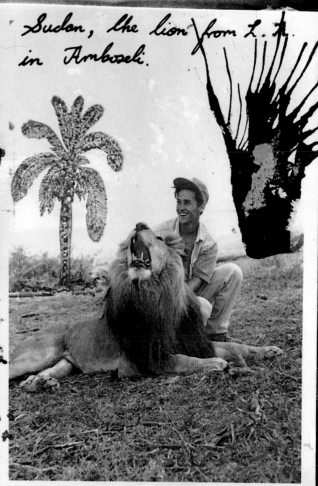

Sudan, the lion from L. A. in Amboseli.

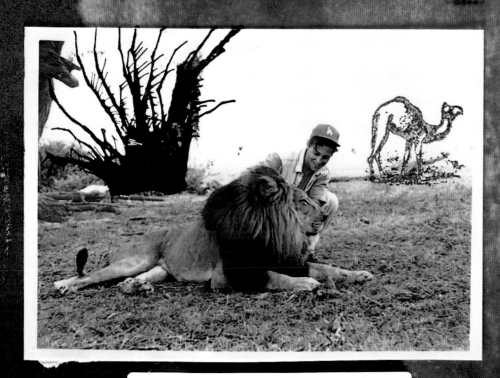

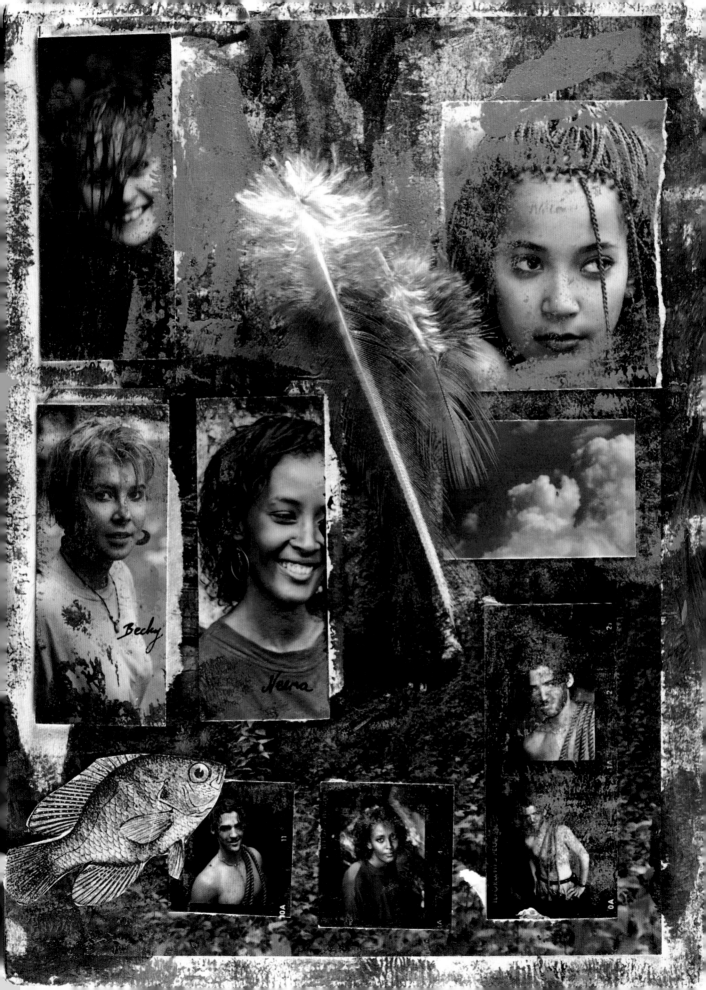

Becky

Neira

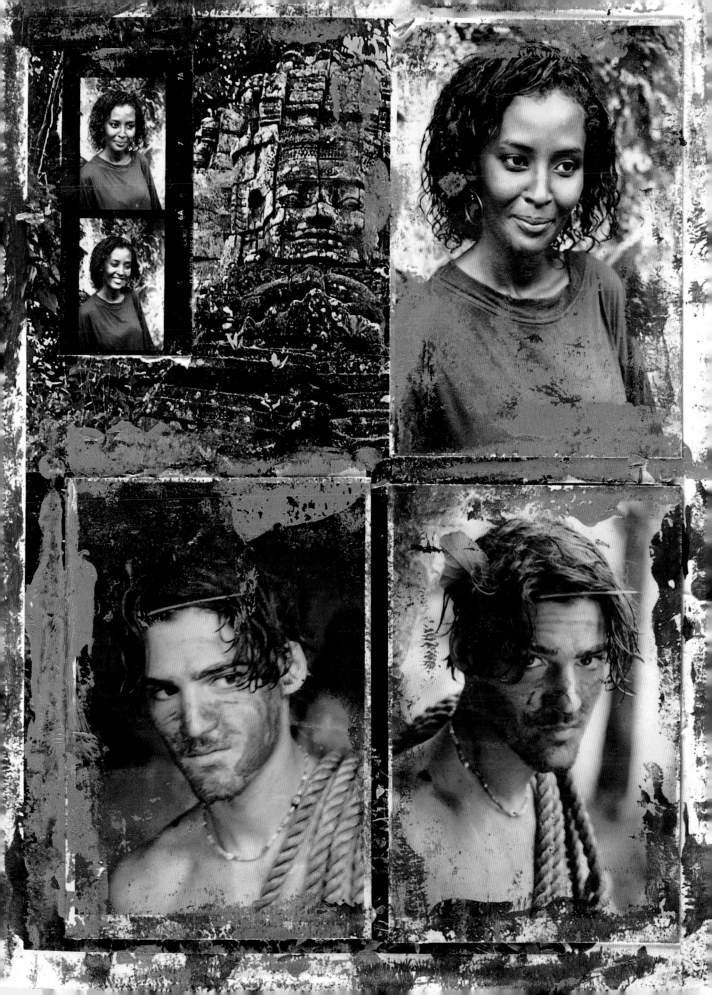

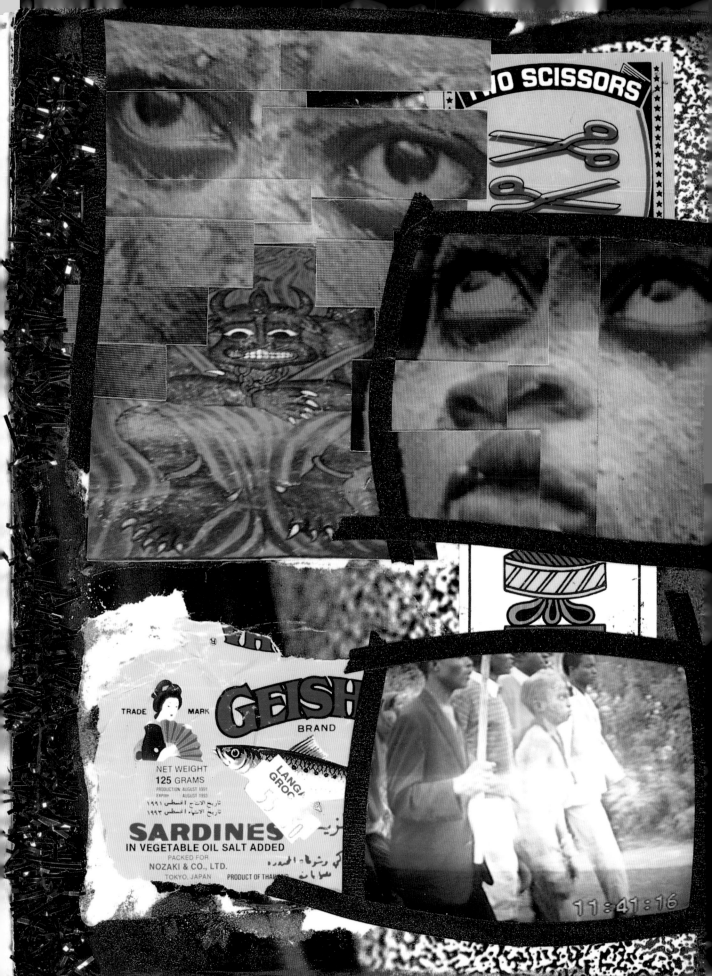

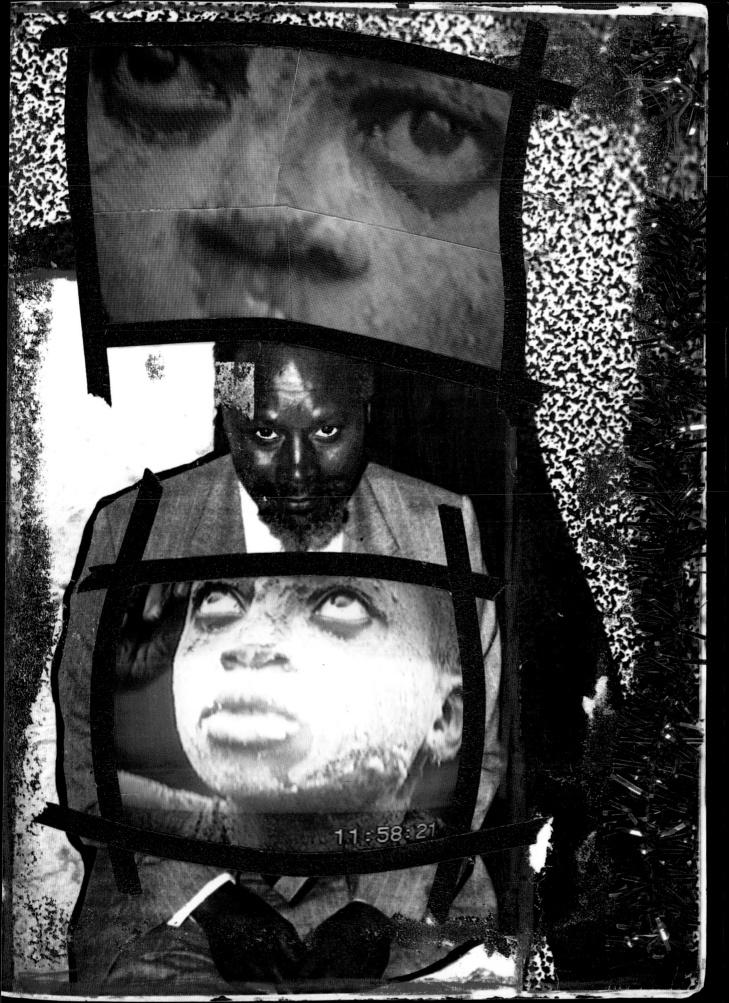

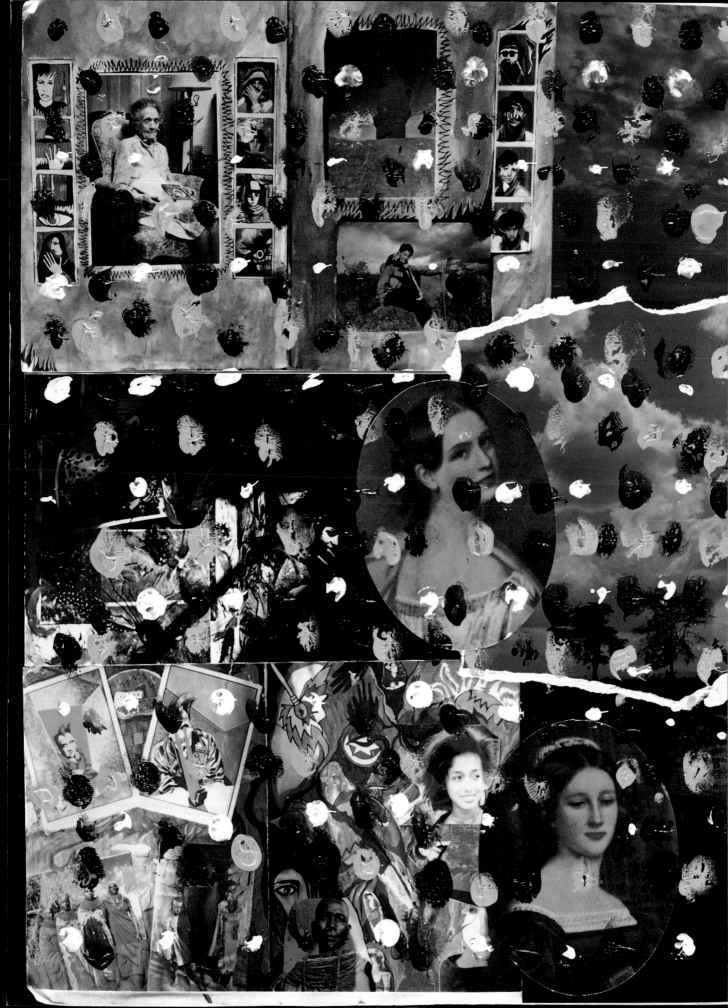

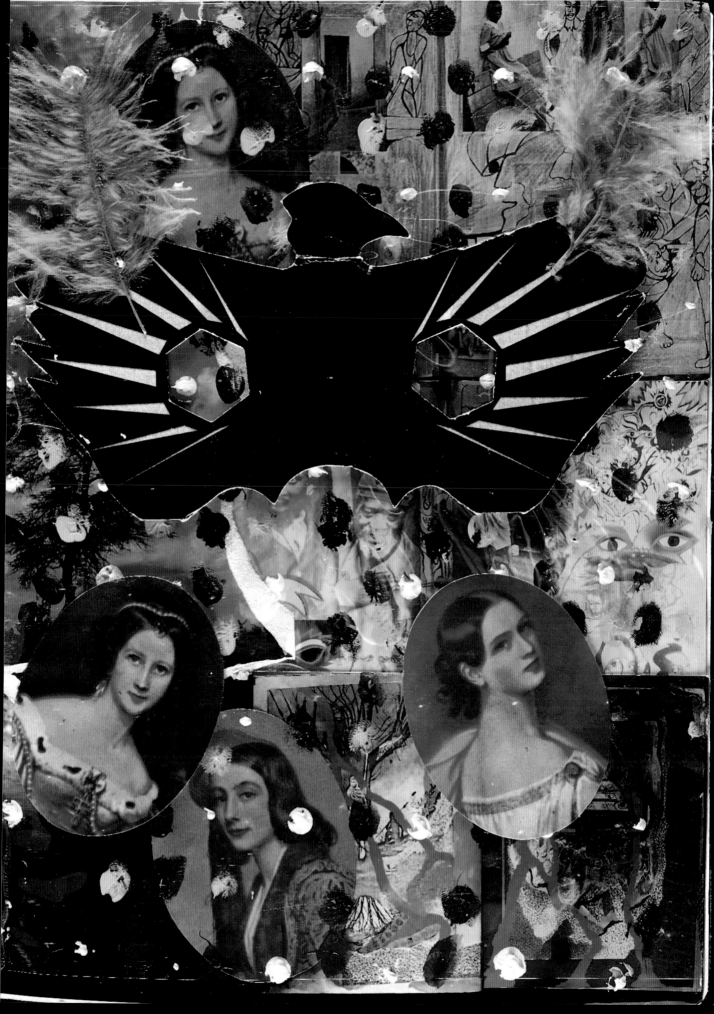

CARNIVAL

33 LA ARAÑA

34 EL SOLDADO

35 LA ESTR...

S A L S A

42 LA CALAVERA

43 LA CAMPANA

44 EL CANT...

LA PALMA

52 LA MACETA

53

EL A...

EL GORRITO

22 LA BOTA

12 EL DIABLITO

3 LA DAMA

28 LA SANDIA

12 EL VAL...

PARA LA MUSICA LATINA!

FESTIVAL!

EL CAZO

46 EL SOL

47

48

49

50 EL PESCADO

L VENADO

51 LA PALMA

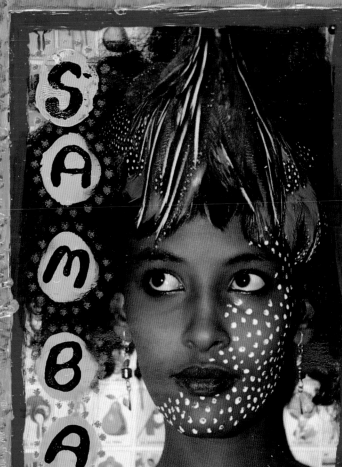

SAMBA!

GRAN FABRICA DE NAIPES
DE TODOS ESTILOS

GALLO
de
Don Clemente
PASATIEMPOS GALLO, S.A.
Apdo. postal 250 Querétaro, Qro.

LA RANA

32 EL MUSICO

EL PAJARO

LA ROSA

38 EL APACHE

EL MELON

MARILYN Y NEEMA !!

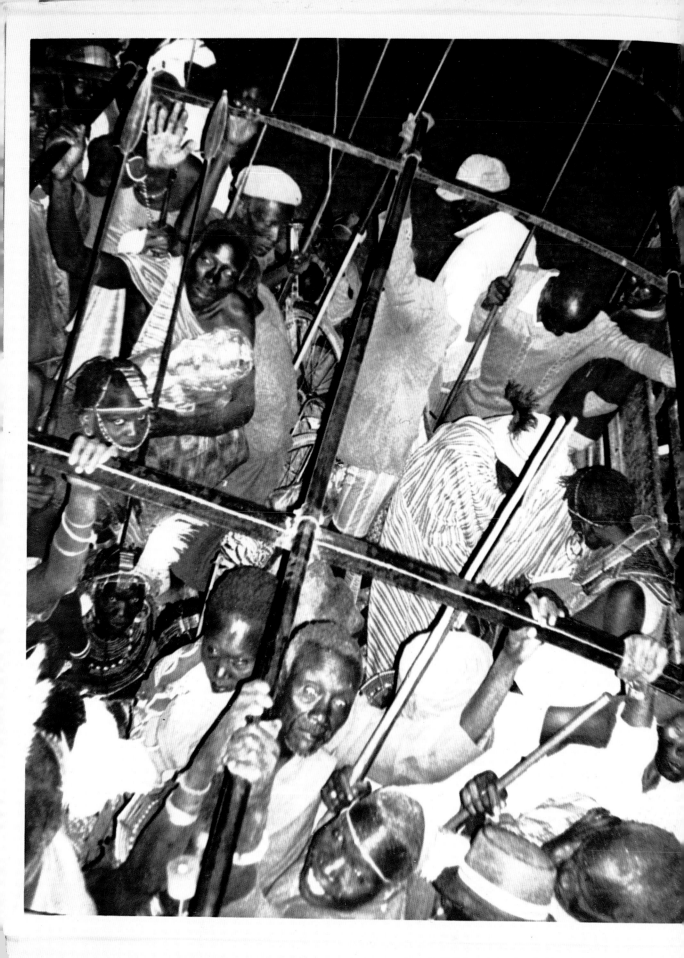

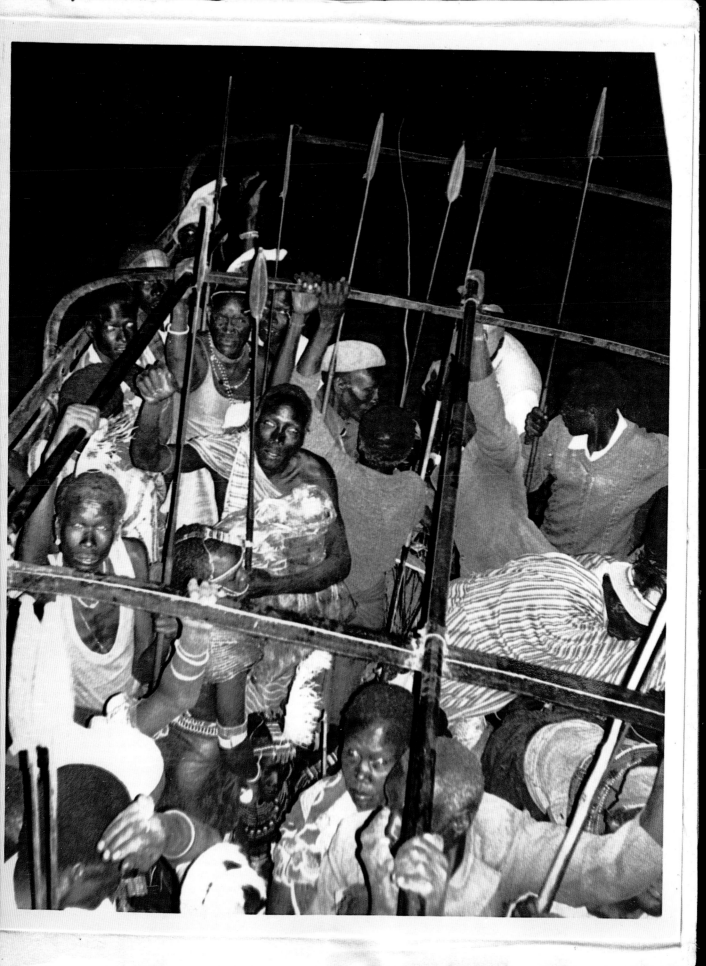

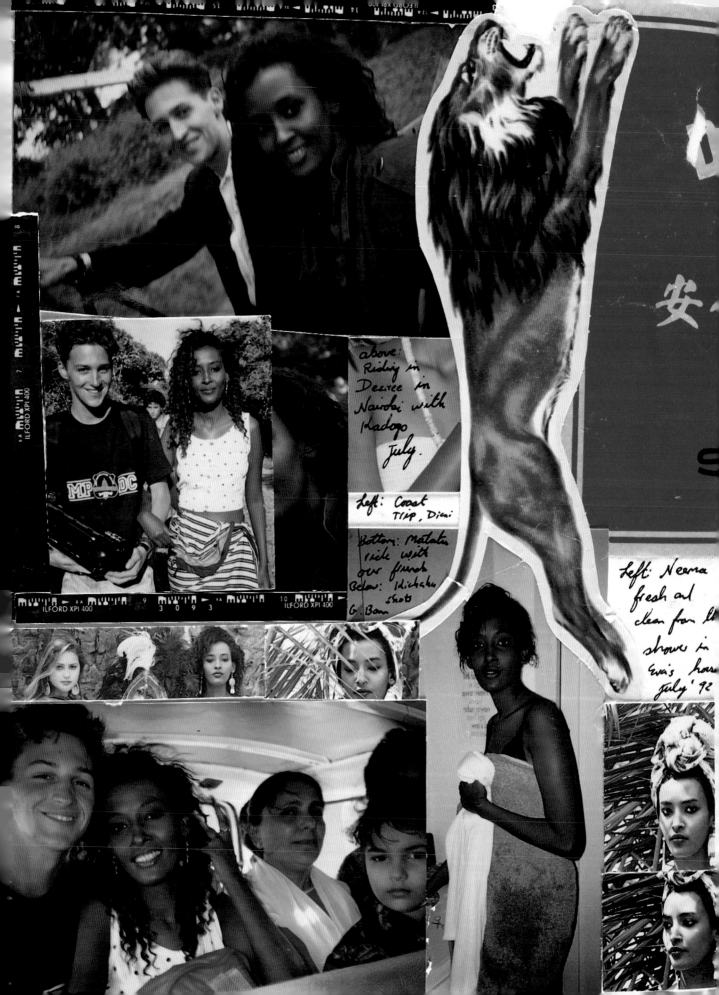

above:
Riding in
Desiree in
Nairobi with
Idadogo
July.

Left: Coast
Trip, Diani

Bottom: Matatu
ride with
our friends
Below: Kikhaki
shots
G. Barn

Left: Neema
fresh and
clean from the
shower in
Eva's house
July '92

ILFORD XP1 400
ILFORD XP1 400
3093

UBLE HAPPINESS

火柴

AFETY MATCHES
中國製造 MADE IN CHINA

Below, Roberta's ranch, Nathen Kenya

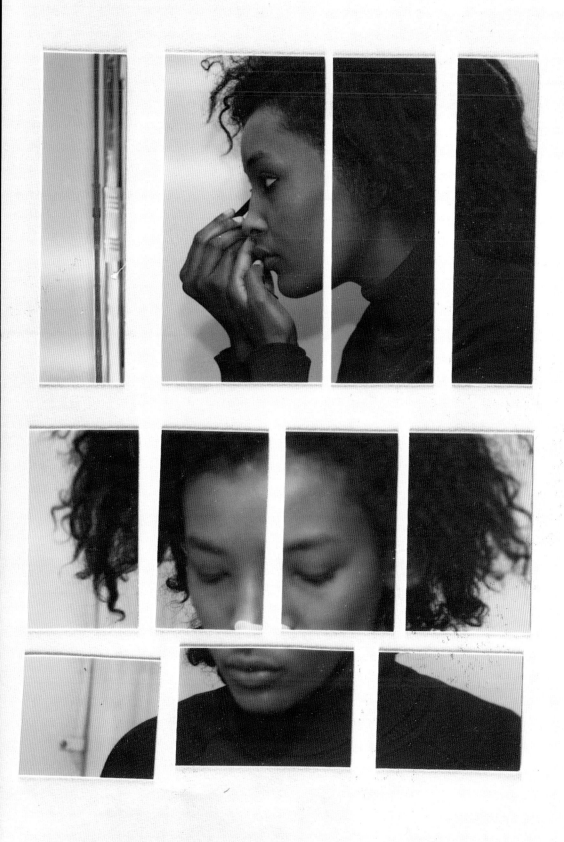

Stockholm, Sweden ~ in "our boat"

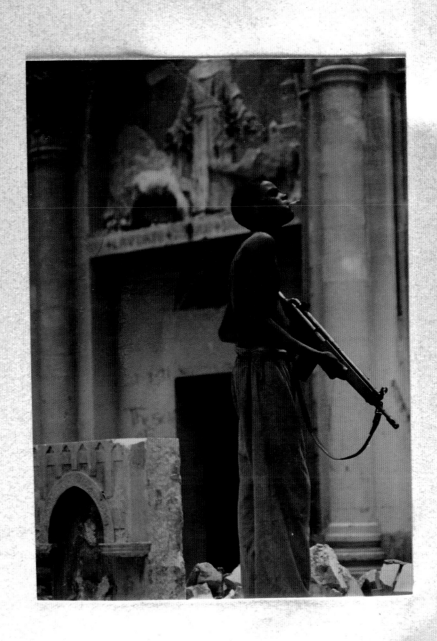

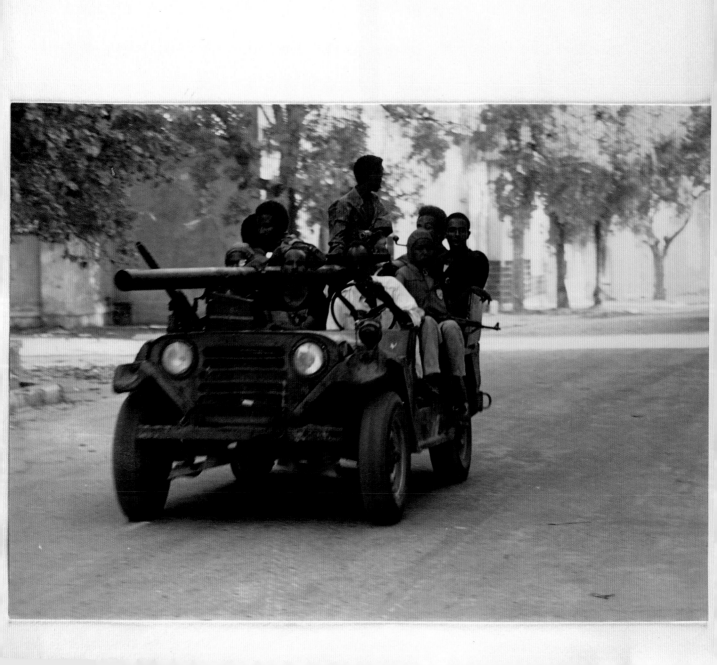

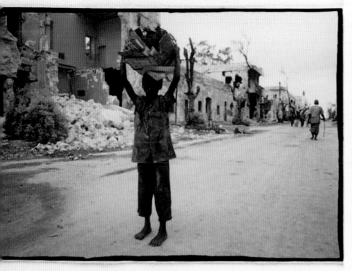 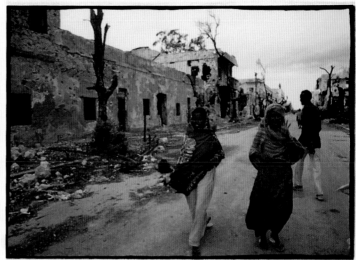

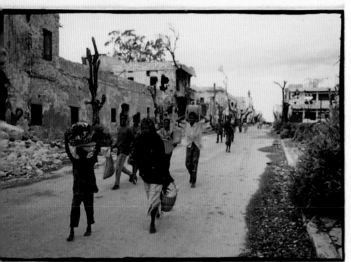 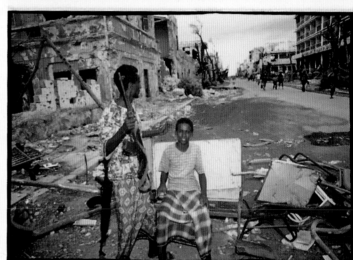

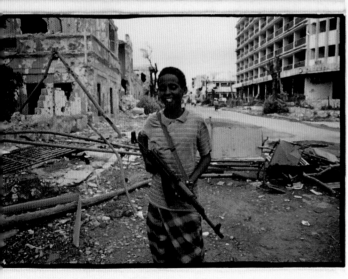 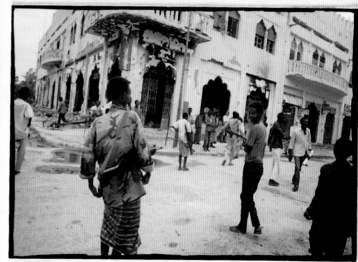

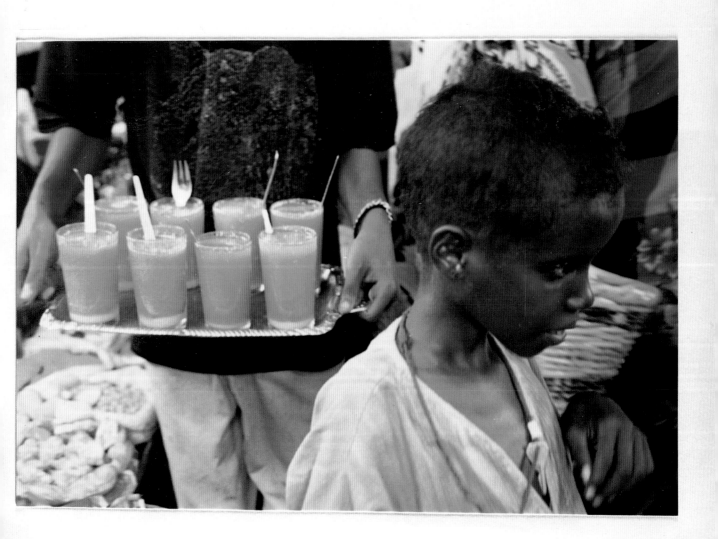

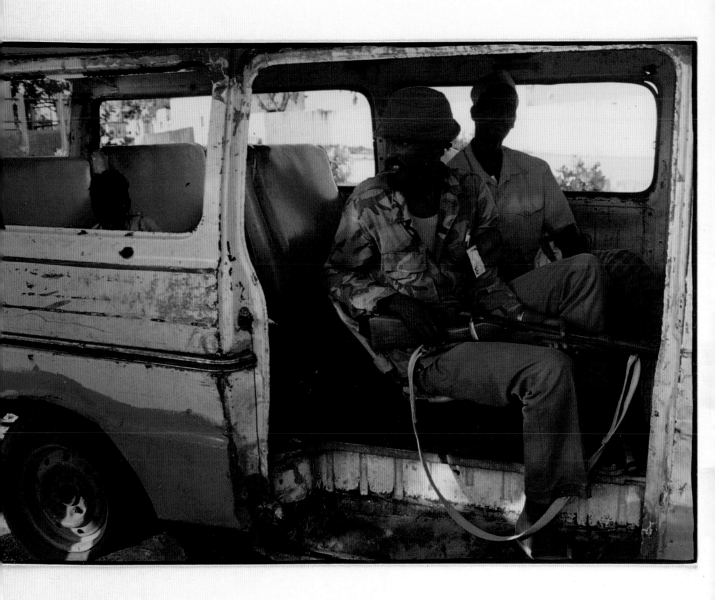

In thanking all the people who helped shape Dan's perspective on the world, I have tried to imagine who he would have pointed out as being the most significant. I know his thanks would have gone first to his father, Mike, who worked patiently with Dan, aged six, to create magical stamp albums. That year, he also taught him how to use his first camera, instilling in him a lifetime habit of picture taking. The two shared an outrageous sense of humor, the ability to make puns in a variety of languages, and a strange inability to carry a tune.

Artists and photographers were frequent visitors to our Nairobi home: the famous duo Angela Fisher and Carol Beckwith were our most popular, lending not only tips on shutter speeds, but more importantly, teaching Dan how to simultaneously befriend and photograph people of diverse cultures. Photographer David Coulson and intrepid explorer Wilfred Thessiger were other early influences, along with Liza MacKay, who, together with Doria Block, were the first people to take Dan's art seriously.

Dan loved Kati Korppijaakko, then Art Director of *Mademoiselle* magazine, who bravely hired Dan, aged only seventeen, to work in her office. It was Kati and her lively young staff who gave Dan free use of the photocopier and encouraged him to believe in his talent. When Dan decided to found Student Transport Aid, he was assisted by friends around the world, including Adrian House, who encouraged Dan to go on a great safari across Africa. It was an adventure that was to affect the lives of fourteen young people, who became some of Dan's closest friends and most patient subjects. He shared a special bond with each one of the multinational members of Team Deziree: Eiji Shumizu, Akiko Tomioka, Chaka Chaka, Roko Belic, Marte Rambourg, Jeff Worden, Chris Nolan, Lengai Croze, Ryan Bixby, Hayden Bixby, Robert Gobright, Jeff Gettleman, Eli Tatum (chief crepe-cook), and his fifteen-year-old sister, Amy.

Dan treasured his childhood friends, most of whom are featured in his journal pages. They include Marilyn Kelly, who appears frequently, first as a child of twelve, last as a gorgeous young woman of eighteen; Soya Gecaga, Robi Ancilotti, Phoebe Vreeland, Saskia Geissler, Anselm and Katrinika Croze, Laure Diaz, the Weisel brothers, Mikey G, Claire Johnson, Daire O'Reilly, Jean Marc Andre, Pierre Burton, Jonathan Seale, Annathea Henton, Carolyn Roumeguere, Carla Benson, Patrick Falconer, Amy Branch, Mike White, Long Westerlund, Jeff Wordon, Dawn and Darla Granger, Lara Leakey, Petra and Tara Fitzgerald, Andrea Lukasavitch, Guillaume Bonn, Neema Ali, and Dan's adopted Masai brother, Peter Lekarian.

Throughout Dan's brief career, journalist Maryanne Fitzgerald acted as a mentor and special friend to a young man she knew shared her humanitarian objectives. Dan's "photographer's eye" was first spotted by Sam Ouma, a brilliant photojournalist with the *Nation* newspaper in Kenya. Executive

ACKNOWLEDGMENTS

director Geoffrey Dudman encouraged Dan to aspire to be "another Fellini." As a young photographer in Somalia, Dan attached himself to talented veteran journalists and photojournalists, trailing after Corinne Dufka, Aiden Hartley, Andy Hill, and many others who generously shared tips with a rookie. The Nairobi Reuters Bureau Chief Jonathan Clayton took a chance on Dan by giving him a job as a proper stringer, and Reuters London staffers Pat Benic and Greg Bros patiently talked him through many difficult assignments. Dan was first inspired by one of Africa's legendary cameramen, Mohamed Amin, and later learned persistence and determination from another, Mohammed Shaffi, the only survivor of the tragic incident on July 12. Dan shared many challenges of life in Somalia—and the final moments before his death—with his friends and colleagues, Anthony Macharia and Hos Maina of Reuters, and Hansi Krauss of the Associated Press.

I know Dan would want a special mention of his oldest friend, Lengai Croze, who, as a tow-headed seven-year-old, protected Dan from class bullies, and, as a dashing young man, accompanied him on many safaris across Africa, coaxing Deziree to take on "just one more hill."

After Dan's death on July 12, 1993, I have to take over the thanks, first acknowledging the kind support of Maia Gregory, who was the first to help me organize the material necessary for a book based on Dan's journal pages. I am grateful to the memory of Anita Diamant, who believed so passionately in this project; to Kati Korppijaakko, now art director for *Glamour* magazine, who photocopied scores of journal pages as I wept beside her; and to Maryesta Carr, who nurtured my body and spirit. My love and thanks go to Mike Eldon, who told me never to give up; to Gaby, Ruth, and the memory of Bruno Eldon for their continuous encouragement; and to my inspirational parents, Russell and Louise Knapp, who made it possible for me to continue when I thought I couldn't go on.

I treasure the memory of Ruth Schaffner, the courageous director of the Watatu Gallery in Nairobi, who produced "The Show Goes On," the first retrospective of Dan's art, photography, and journal pages, together with her assistant, Rob Burnett. Leslie Wright of the Cedar Rapids Museum of Art organized the first American exhibit of Dan's work at her museum, which is now the permanent home for Dan's archives. I am deeply grateful to Dr. and Mrs. Semans, who funded the first American exhibition of journal pages at Duke University. It was there that Alex Harris asked permission to publish a selection of pages in his stunning magazine, *Doubletake*.

The article was seen by a young Saatchi & Saatchi advertising executive, Marcel Cairo, who courageously took a year off to research Dan's life for a feature film. Craig Walker saw the piece and contributed dozens of art and photographic books to help me understand Dan's work. Lisa Henson, then president of Columbia Pictures, read the *Doubletake* piece and decided Dan's story had to be told. My thanks to Naomi Despres and producer Janet Yang for joining forces with Lisa Henson and me to make a feature film inspired by the journals; and to Michael Costigan for his energy, creativity

and enthusiasm in realizing that dream. To Bruce Smith, Russel Fischer, Marcel Cairo, and Jan Sardi, I offer my heartfelt gratitude for their determined exploration of thousands of journal pages as they struggled to unravel the mysteries hidden within. I have been fortunate to have friends like Chris Conrad, Rebecca and David Flaeter, Martin Jarvis, and Ros Ayres, who befriended me on my arrival in Los Angeles, and who encouraged me to continue, no matter what.

Shortly after Dan's death, Debbie Gaiger created the book and exhibition, *Images of Conflict*, based on photographs by the three photographers who died together in Somalia. The exhibition, supported by Reuters Managing Editor Mark Wood and Associated Press Chiefs Lou Boccardi and Myron Belkind, has traveled to eight countries. Scores of people have been vital to the success of the events, including Professor Maristella Lorch of the Italian Institute, broadcasters Tom Brokaw and Dan Rather, Michael Buerk, Sir Brian Urquhart, and the presidents of Kenya, Cyprus, and Ireland. Canon John Oates of St. Brides Church, the famous journalists' church on London's Fleet Street, has been a continuing source of inspiration for our entire family. It was Canon Oates who offered to dedicate a young tree in the courtyard of his church in Dan's name, which also commemorates the "tortured people of Somalia." Veteran photographer Eddie Adams, one of Dan's heroes, has been unfailingly supportive of our attempts to inspire and encourage young photographers to pursue their highest objectives. Young photographer Patrick Whalen has been resourceful in helping me digitize Dan's collection of journal pages.

The book would not have been possible without the dedicated efforts of my hardworking agent, Jane Dystel; Steve Oliver, who painstakingly photographed the pages represented in this book; the staff of Chronicle Books, especially Karen Silver, who patiently guided me throughout the publishing process, and Laura Lovett, for designing a book that would make Dan proud.

There are countless other people around the world to whom Dan and I owe our appreciation. Forgive us for not including your name. You know who you are.

My greatest thanks are reserved for Annie Barrows, who recognized that Dan had an important message for people around the world. Annie is the true editor of Dan's journals; a feisty, funny, creative, and persistent individual, whose enlightened spirit mirrors Dan's and utterly pervades this book.

My final words are for my inspiration, Amy Louise Eldon, Dan's little sister, his favorite model, cherished confidante, and dearest friend. It is to Amy that this book is lovingly dedicated.

DEZIREE SEX SAFARIS

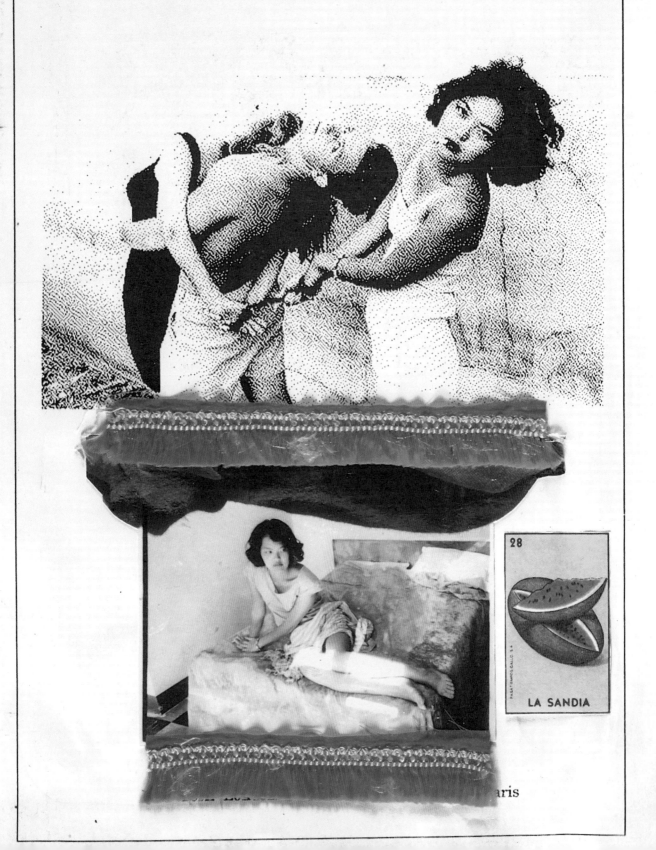

aris